Ze French Do It Better

Editorial Directors:
Gaëlle Lassée and Kate Mascaro

Editor: Sam Wythe

Translated from the French
by Kate Robinson

Design:
Atelier Choque Le Goff

Illustrations:
Hubert Poirot-Bourdain

Copyediting:
Lindsay Porter

Typesetting:
Thierry Renard

Proofreading:
Penelope Isaac

Production:
Titouan Roland

Printed in China
by Toppan Leefung

Simultaneously published in French as
Ze French Do It Better
© Flammarion, S.A., Paris, 2019

English-language edition
© Flammarion, S.A., Paris, 2019

editions.flammarion.com

19 20 21 3 2 1

ISBN: 978-2-08-020371-7

Legal Deposit: 04/2019

Ze French Do It Better

A Lifestyle Guide

Frédérique Veysset
Valérie de Saint-Pierre

Flammarion

BIENVENUE
An Introduction

"Ze French do it better...." What a declaration! Are they just showing off, or are they on to something?

Sure, they may think they're the crème de la crème, but the millions of tourists swarming through the Hall of Mirrors at Versailles and scrambling up the Eiffel Tower seem to agree.

Nature has been wildly generous when it comes to France: bordered by four different seas and sheltered by the massive Alps and Pyrenees mountains, the country boasts a bounty of local produce for foodies to savor, numerous regions to explore on foot, diverse

scenery for romantics to admire, and a wealth of museums and châteaux where the curious can give their eyes, smartphones, and sneakers a workout. As for the locals, they're always surprised that others think the French are arrogant and self-important. Honestly, they don't do it on purpose! Is it their fault that the wine is so good? Or that the Tour de France is so legendary? Can they be blamed for being so effortlessly slim, even though their baguettes are so crunchy? Should we hold it against them that their life is so good? Or that Mbappé is so fast? Or their vests so yellow?

So, what's their secret? How do they so easily enjoy one of the most divine lifestyles on the planet?

Well, there are as many answers as there are "tribes" in France, each one contributing its special touch to the fabric of French society. Whether they're urban or rural, suburban or country-dwelling, thrifty or high rollers, Frenchies are bound—sometimes unconsciously—by invisible ties rooted in a shared culture that includes, in no particular order, Brigitte Bardot, Notre Dame, Voltaire, Zidane, Chanel No. 5, Louis XIV, Louis Vuitton, the Champs-Elysées, Balzac, General Charles de Gaulle, Jean-Paul Gaultier, Christian Louboutin, champagne, Dior, Sartre, Françoise Hardy, Béatrice Dalle, Edith Piaf and Georges Brassens, Astérix and Obélix, Paul Pogba, Yasmina Reza, and Joey Starr.

Follow the French inside their world to discover their secrets for enjoying their unrivaled, but ultimately very accessible, way of life. This is France!

THE
CLASSIC
FRENCHY

VIVE LA FRANCE

"Ah, Monsieur is French? How extraordinary! What makes someone French?"
—Robert Kopp, after Montesquieu

Anyone can recognize a Frenchman. It's easy: he has—obviously—a baguette under his arm, a beret on his head, and, for reasons unknown, a glass of champagne in his hand. He comments on the stages of the Tour de France with a knowing air before joining a graceful French woman, who—messily coiffed but elegant, and incredibly thin despite the pyramids of macarons she inhales daily—leaves a trail of Chanel No. 5 in her wake. A friendly game of boules on the Champ-de-Mars, in the shadow of the Eiffel Tower, is planned, before wrapping up the evening in a lovely little Parisian bistro surrounded by eloquent intellectuals. Oh, and of course this beau monde finishes dinner with camembert!

The French fully accept this charming reputation, famous throughout the world. In fact, they love to play it up. Even the lyrics to the French national anthem "La Marseillaise" call citizens to "take up arms!" if necessary to defend and protect France and French values, including these ten distinctly French icons:

BAGUETTE

**CARRY A BIG STICK
AT FOURNIL DES CHAMPS**

Roland Feuillas's famed bakery stocks only 100 percent natural bread. An expert baker, Feuillas masters the entire bread-making process, turning marvelous freshly stone-ground heritage wheats into bread using a natural starter and a long fermentation time.

68, rue Pierre Charron, Paris VIIIᵉ

According to one legend, in the late nineteenth century, during the construction of the Parisian Métro system, Fulgence Bienvenüe asked a baker to make him a long loaf of bread that could be divided without a knife, in order to avoid the deadly fights that often broke out between laborers and slowed down work. And lo, the French baguette was born! The very same baguette that makes both the world's best sandwiches and the preferred snack of generations of French schoolchildren: a square of dark chocolate wedged in a hunk of day-old bread, to be chewed vigorously, cheeks bulging with the effort.

During World War II, yeast and starter dough were impossible to find, and fermentation, an essential step in the bread-making process, was boosted with additives. This bad habit stuck around after the war, practiced by bakers looking to save time and money; it eventually soured the baguette's reputation. The situation grew so serious that the government had to intervene, issuing a decree in 1993 that set strict criteria for the popular *tradition* baguette and limited the recipe to just four ingredients: flour, salt, water, and yeast. Cheap knock-offs were out; long fermentation was back in style. The baguette has since gained cult status, and can be fairly pricey if the baker thinks highly of himself. The French are back to standing in line for their baguette on Sunday morning and around 7 p.m. on a weekday, all of them happily sighing, "Oh, it's still warm!" And you can be sure that not a single one can resist sneaking a crumb or two on the walk home.

It's incredible, but true: no one liked the "Iron Lady" at first, not even Gustave Eiffel, who showed no interest when his design office initially presented him with the blueprints. In the end, the project for "the tallest tower in the world" captured the attention of the renowned engineer when he realized that it was the perfect opportunity to demonstrate his expertise. He won the competition to design a centerpiece for the 1889 World's Fair in Paris, beating out seven competitors, and engineers and acrobatic laborers set to work. A number of artists lambasted what poet Paul Verlaine referred to as the "belfry skeleton" that would "disfigure Paris," but letters of protest, petitions, and outright sarcasm couldn't stop the crowds from thronging to visit when it was finally completed. As the years passed, curiosity waned, and there was even talk of destroying the structure. By then, however, Eiffel went out of his way to protect the tower and installed a small meteorological observation station at the top. Later, the French army used it as a radio tower, and it played a decisive role in halting the German advance on the Marne River in 1914. The Eiffel Tower became indispensable as an antenna for the wireless telegraph and a relay mast for the newly invented telephone, and was used as a radio and television transmitter. In 1944, Hitler, spiraling toward defeat, ordered the tower destroyed, along with the entire city of Paris. Luckily, General Von Choltitz disobeyed his order. After the Liberation of Paris, the American army installed a radar antenna on the tower. In the 1960s the tower began to draw record-breaking numbers of tourists, which continue to this day. Most Parisians are allergic to the crowds and wait until the February lull to take their children on their first visit. They never grow tired of seeing it sparkle for five minutes each night; their #iloveparis Instagram posts are proof. On July 14, the French national holiday—which no one in France actually calls "Bastille Day"—it is the ultimate in chic to be invited to an apartment "with a view" to admire the traditional firework show in private. However, wedding photos in a poufy white dress with the Eiffel Tower in the background are far too clichéd for genuine Parisians.

② EIFFEL TOWER

Look around you. If you see checkered tablecloths, zinc countertops, mosaics, gently worn leather booths, wooden chairs, and home cooking on the table, then there's no doubt about it: you are in an authentic bistro (or someplace engineered to look like one—sometimes that's the problem). Bourgeois family-style cooking had fallen out of favor in recent years, but it's regaining popularity again, which comes as no surprise: it's convivial, generous, and economical. A bistro worthy of the name stirs up memories of dishes simmered slowly with the expert touch of a mother or grandmother. Those who mocked their down-home flavors a few years ago are now smitten. Simple and filling, this domestic culinary style has enchanted young chefs who adore reinventing classics like *oeuf mayonnaise* (deviled eggs) and *céleri rémoulade* (celery root remoulade). With a menu boasting dishes like calf's liver with parsley, andouillette sausage with fries, leg of lamb with flageolet beans, beef bourguignon and elbow pasta, vegetarians from around the world can keep on walking. Here, meat steals the show and is always served with a "nice little wine" reserved for the occasion.

③
BISTROS

④ CHANEL NO. 5

The legendary Chanel No. 5 has remained among the world's ten bestselling perfumes ever since its creation in 1921, no doubt at the suggestion of Grand Duke Dmitri Pavlovich of Russia, Coco Chanel's lover. He introduced the fashion icon to Ernest Beaux, perfumer to the Russian court and a pioneer convinced that the "future of perfume lies in the hands of chemists." At the time, popular perfumes were made with natural essences that faded quickly and were too easy to identify. Ernest Beaux wanted to create an enduring and inimitable potion. He was the first to use synthetic chemicals derived from hydrocarbons discovered at the turn of the twentieth century, which he mixed with rare essences like Damascus rose, ylang-ylang from the Comoros, and Mysore sandalwood. When he presented his different samples in numbered vials, Gabrielle Chanel chose vial number five as her favorite. Out of superstition, she kept this number for the name of her first perfume—which she launched on May 5. Her lover designed a refined bottle inspired by the vodka flasks carried by the Russian Imperial Guard. Though the relationship between the handsome Dmitri and Coco Chanel eventually evaporated, the phenomenal success of No. 5 has never waned. Marilyn Monroe famously slept in nothing but Chanel No. 5, but for French people of a certain generation the perfume evokes memories of a mother or grandmother dabbing her neck with the vial's stopper before going out. Or the unforgettable scent of an elevator heavy with perfume from the beautiful upstairs neighbor, just like Proust's *madeleine*?

chanel.com

TOUR DE FRANCE

This famed bicycle race showcasing the best of France's landscapes gained its legendary status a little over a century ago. Initially organized by a sports magazine to drum up support among early fans of cycling, the first Tour de France began on July 1, 1903, outside the café Le Réveil Matin in the village of Montgeron, near Paris. The six-stage route connected Paris, Lyon, Marseille, Bordeaux, Toulouse, and Nantes, before looping back to the capital. Sales of newspapers that covered the event broke historical records. The Tour de France took on a political dimension in 1911 when its stage in Alsace-Lorraine, a region annexed by the German Empire in 1871, provided an occasion for the population to demonstrate their French patriotism, which did not sit well with the Kaiser. Early fans of the Tour were avid in their support, but still relatively rare; they applauded the French values of liberty, equality, and fraternity displayed by the courageous cyclists, those "aristocrats of muscle" who struggled along on the "little queen," as the bicycle was affectionately called. Starting in the 1950s, working-class fans settled in to watch the stages on television and, in 1960, President Charles de Gaulle himself attended a stage of the Tour. In 1975, President Valéry Giscard d'Estaing launched the tradition of presenting the winner with a yellow jersey on the Champs-Élysées. Today, the Tour is famous outside France, with athletes from around the world participating—and some of them even win! Even French people who couldn't care less about cycling have a basic understanding of the Tour, gleaned from summers spent with a grandfather who followed it closely.

ADOPT A CYCLIST FROM THE ROGER FOUNDRY

Long before video games were invented, French children played Tour de France with miniature Roger cyclists and marbles: after creating a circuit in the dirt or sand, they would race each other on it by flicking a marble and placing the figurine where it landed. Manufactured using the original 1930s molds, these figurines, crafted in ZAMAK (a lead-free alloy), are still hand-painted and continue to captivate collectors around the world.

fonderieroger.fr

Once forbidden by the nobility to play this quintessentially French game, commoners finally regained the right to heft a set of boules when feudal privilege was abolished on the fateful night of August 4, 1789. Long before that, the Romans had introduced an earlier version of *pétanque* to the Gauls that became so popular the clergy tried to forbid it, fearing it would interfere with religious practice. Clearly, they failed, because *pétanque* has been the most popular leisure activity in France since the nineteenth century. Family photos were once staged on the boules strip, and whole villages play against each other (the first competitions and tournaments date back to 1894). In fact, it's not uncommon for players to come to blows. The beloved *pétanque* (from the French *pieds tanqués*, "immobile feet"), as it is known today, was created in 1907 in Provence for a player riddled with arthritis. It gave rise to a whole mythology that exudes the essence of the South of France and the aniseed aroma of a glass of Pernod. In recent years, this "sport," traditionally the pastime of happy retirees, got a makeover: in summer, groups of young hipsters wearing "Riviera moccasins" (a chic imitation of the scrappy slip-ons favored by old-school players), love to "try for a tile" or "cap it."

STAY ON THE BALL WITH OBUT

The official supplier to the most prestigious *pétanque* tournaments, Obut has been making steel boules in the Loire region since 1955. Smooth, ribbed, steel, carbon, impact absorbing, soft, or half-soft: the company goes to great lengths to ensure their boules "tickle the jack." They even sell creams to pamper them and there's a museum in Provence where you can study up on the subject before your next match.

obut.com

⑥

PÉTANQUE

7

BERET

**HATS OFF TO
MAISON LAULHÈRE**

Founded in 1840, this brand has supplied the French army since World War II, as well as the armed forces of countries around the world. Still manufactured in Oloron-Sainte-Marie from merino wool and trimmed with a leather braid from the Montagne Noire region (in central southern France), the traditional beret is distinguished by a *bouffette* (a small black, yellow, or red ribbon) fastened on the side.

laulhere-france.com

For many years, this wool hat, flat as a crêpe, was the hallmark of Bernese shepherds, schoolchildren, and elderly French men, before becoming a symbol of revolutionaries and military personnel. Then, following World War I, women cast off their corsets and frills, and began wearing pants, as well as more functional men's clothing and accessories. The beret, varying in size, color, and degree of decorative embellishment, began to appear in haute couture fashion shows and atop movie stars like Arletty, Marlene Dietrich, Greta Garbo, and Lauren Bacall. In 1938, seventeen-year-old debutante Michèle Morgan gave it a shot of glamor when she received one of the most famous kisses in French cinema from Jean Gabin under a streetlamp in *Port of Shadows*. Tommy gun in hand, beret firmly in place, Brigitte Bardot sang "Bonnie and Clyde" alongside Serge Gainsbourg. Today, the "Basque" beret—as Napoleon III called this curious hat worn by laborers working on his palace at Biarritz—graces the heads of Cara Delevingne, Rihanna, and Bella Hadid, always one step ahead of the trends. But you are unlikely to run into any Parisians wearing berets, except under the Arc de Triomphe on Armistice or Victory Day—and even then, they're likely to be pushing ninety.

Camembert—known familiarly as *claquos* or *calendos*—is legendary. This soft, bloomy-rind cheese related to brie and coulommiers is thought to have been first produced in Normandy in 1791 by Marie Harel, a farmer in the village of Camembert. Parisians discovered it in the nineteenth century, when the railroad was constructed to connect Paris with Lisieux and Caen: the Norman treasure could be spirited to the capital in a little under six hours, secure in its miniature wooden box. A victim of its own growing success, the manufacture of Camembert was industrialized in the twentieth century; production often took place outside of Normandy and the resulting cheeses were but pale imitations. Small producers fought to defend their fattier, tastier Camembert, made in Normandy using raw, unpasteurized milk from local cows. A dry camembert is a dishonor to any cheese plate, and finding a perfect "runny" specimen remains a high-stakes challenge in most French households. It is considered very inappropriate to comment on its possible odor or to make a fuss if it is a little overripe. Only pregnant women fearing listeriosis get a pass—and even that is cutting it close.

OPEN A BOX OF
CAMEMBERT AT
FROMAGES DE STÉPHANIE

This unique version is made with 100 percent organic Norman milk.

Le Champ Laudier,
61170 Saint-Léger-
sur-Sarthe
+33 (0)2 33 28 09 98

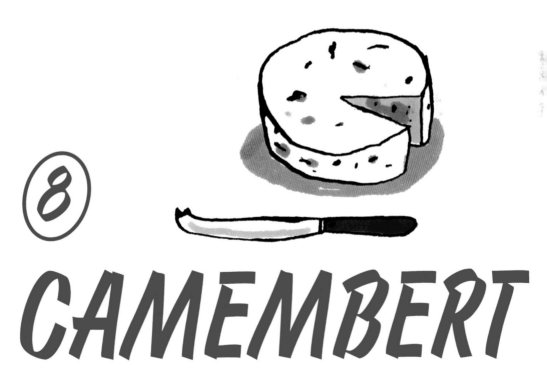

⑧

CAMEMBERT

For ages, Parisian waiters have gotten a bad rap from the rest of the world. Unpleasant, sullen (sourpuss soup is often on the menu), monosyllabic, incapable of speaking English, feigning not to have seen a customer if they've just decided to set the tables for lunch—all this, and worse. But is it true? In part, yes. But you have to understand French waiters. Descended from a long line of haughty types draped in white aprons, they think highly of their job. That's why they don't appreciate being addressed with a loud "Garçon!" accompanied by a snapping of fingers. They aren't arrogant, they're sensitive—and yes, there's a difference. That's also why they'll nonchalantly continue cleaning the counter while clients wave frantically for the bill: the waiter determines how to manage his time—he has some self-respect after all. If they occasionally correct the pronunciation of "croak misyhur" when a tourist is trying to order a *croque monsieur* sandwich, they don't do it out of mockery, but rather to be helpful. Once you've understood that and relax—and carefully avoid engaging in any kind of power dynamic—everything will be fine.

⑨

CANTAN-KEROUS WAITERS

CHAMPAGNE

Napoleon Bonaparte declared: "I can't live without champagne: when victorious, I deserve it, when defeated, I need it." Champagne maven Lila Bollinger agreed and famously quipped: "I only drink champagne when I'm happy, and when I'm sad.... Other than that, I never touch it. Unless I'm thirsty."

It took nearly two hundred years of scientific discoveries to create the "bubbly" that the French always find a reason to drink. In the mid-seventeenth century, residents of the Champagne region first attracted attention with a white wine they had pressed from black grapes: it was as clear and sparkling as crystal. Bubbles were considered a defect at the time and winemakers tried to get rid of them—it wasn't until the early eighteenth century that they realized the enormous marketing opportunity they had before them. It took more experimentation to arrive at the right amount of sugar and yeast for the perfect degree of bubbly. Cork stoppers, a more resistant glass bottle, and the discovery of the *muselet*—the wire cage around the cork that prevents gas from escaping—reduced the risk of bottles exploding, which until then had been common. In 1860, the creation of a *brut* version with less sugar made it acceptable to indulge in champagne at any hour (well, almost), in contrast to the original, which was typically paired with dessert. Champagne has been the honored guest at parties ever since. The French crack a bottle to celebrate just about anything, but also to drown out heartache and various other setbacks. They'll cast a knowing look and announce that they're "getting out the bubbles." Though no doubt a reprehensible practice, children are allowed to take a sip from their parents' glass before crying out "It prickles!"—another pre-dinner ritual. However, the traditional champagne glass (the shallow-bowled coupe) is not at all appropriate; neither is the champagne flute. Cellar masters prefer a tulip-shaped glass that few people actually use in real life.

POP THE CORK AT VIRGINIE T.

Descended from a long line of Champagne families, Virginie Taittinger started her own family-run brand in 2008. Sold exclusively online and delivered within 48 hours, her champagne has won over the most discerning of connoisseurs. Her conference-tasting events and VIP club provide opportunities to learn more about this essential subject in the company of other enthusiasts.

champagnevirginiet. com

WHAT YOU NEED TO KNOW ...

Why do the French complain all the time?

And why wouldn't they?

Why does France have so many bar-room political pundits?

Because after three glasses of wine, you couldn't have a clearer picture of the country's problems.

Why do the French talk about food while they're eating?

Read the chapter on Foodies!

Why do the French greet each other with cheek kisses?

Because they are highly tactile. Remember those touchy-feely moments between Trump and Macron?

Why do the French always cross the street on a red light?

There's no way they're taking orders from a little glowing man—even if he *can* change from red to green.

Why is everything closed on Sunday?

Because between Mass, Sunday dinner, and fishing, there's not much time left for shopping.

Why does everyone think the French eat frogs' legs, even though no one really does?

If they don't, it's only because, after eating three dozen snails smothered in garlic butter, no one is very hungry anymore.

Why do the French always say "no," only to say "yes" later?

Because they are contradictory by nature: think of Charles de Gaulle, who said no to Marshal Pétain, the English, the Americans, *and* the Russians. But probably changed his mind later.

Why do the French still smoke when everyone knows smoking kills?

Because life is more beautiful when viewed through a veil of smoke. And they like to live dangerously!

Why do the French let children drink?

Because one is never too young to start training as a sommelier. And a French gentleman must be able to hold his drink.

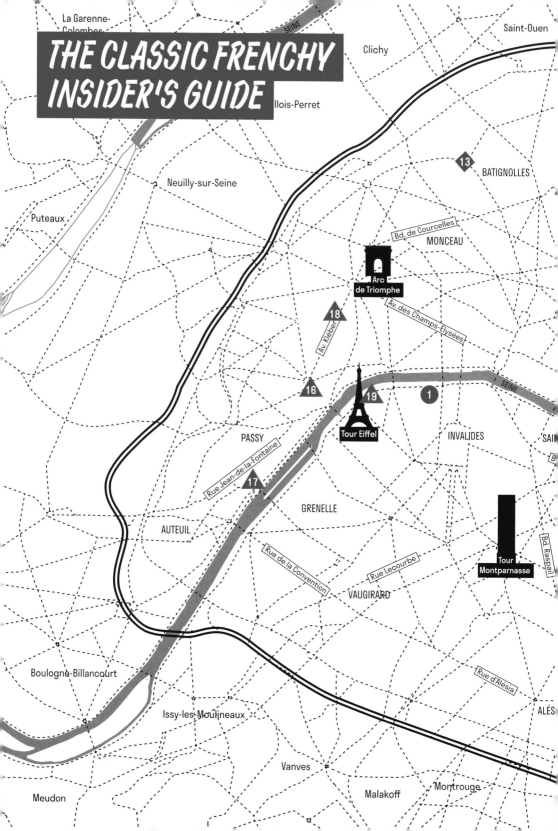

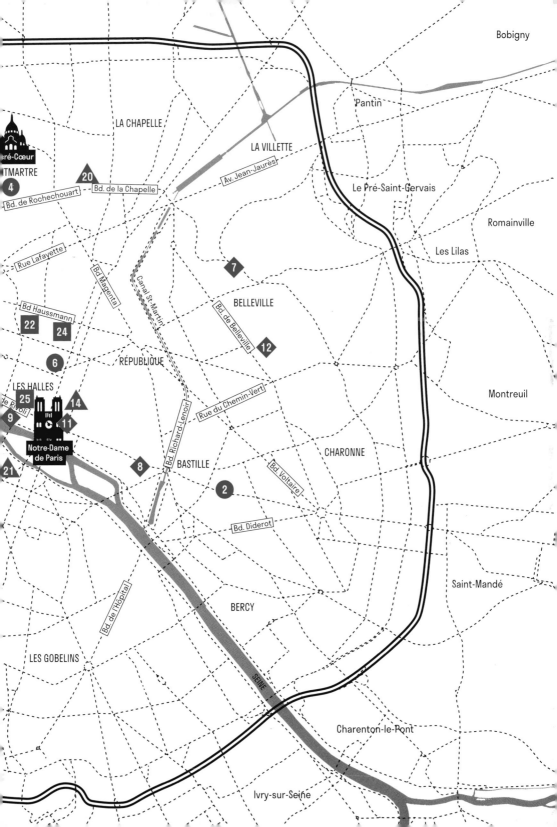

SURVIVAL GUIDE FOR TOURISTS ...
OR THE PRACTICAL PARISIAN

WHAT SETS GOOD BREAD APART?

The American historian Steven Kaplan, an accomplished Francophile and world-renowned specialist on the history of bread, leads an ongoing battle against industrial standardization, which he sees as a real tragedy for the baguette. According to him, good bread meets six criteria: appearance, crust, crumb, consistency, odor, and taste. Strong aromas ranging from hazelnut to caramel nestle in the crust, which must be golden brown and lightly caramelized. The crumb should be spongy and plump, with well-formed and slightly colored holes of uneven size. Above all, good bread goes "crunch"!

THE BEST BAKERIES

1 LE MOULIN DE LA VIERGE
64, rue Saint-Dominique, Paris VIIe

2 LA BADINE DE MARTINE
74, rue Crozatier, Paris XIIe

3 BOULANGERIE MAISON M'SEDDI
Voted best baguette in Paris in 2019; this annual distinction gives the winning bakery the privilege of being the official supplier to the French president for one year.
215, boulevard Raspail, 75014 Paris

4 PAIN PAIN, BOULANGERIE MAUVIEUX
88, rue des Martyrs, Paris XVIIIe

5 AU LEVAIN D'ANTAN
6, rue des Abbesses, Paris XVIIIe

6 BO & MIE
18, rue de Turbigo, Paris IIe
boetmie.com

BONA FIDE BISTROS, WHERE YOU CAN EAT TO YOUR HEART'S CONTENT

7 LE CADORET
1, rue Pradier, Paris XIXe
+33 (0)1 53 21 92 13

8 VINS DES PYRÉNÉES
25, rue Beautreillis, Paris IVe
+33 (0)1 42 72 64 94

9 LA POULE AU POT
9, rue Vauvilliers, Paris Ier
+33 (0)1 42 36 32 96

10 CHEZ GEORGES
1, rue du Mail, Paris IIe
+33 (0)1 42 60 07 11

11 BENOIT
20, rue Saint-Martin, Paris IVe
+33 (0)1 58 00 22 05

12 LES CANAILLES MÉNILMONTANT
15, rue des Panoyaux, Paris XXe
+33 (0)1 43 58 45 45

13 LE BOUILLON PIGALLE
22, boulevard de Clichy, Paris XVIIIe
+33 (0)1 42 59 69 31

Get some perspective on the city at the following lofty viewpoints.

▲14 LE GEORGES
Located on the top floor of the Centre Georges Pompidou, this cult restaurant comes with a postcard-worthy panorama.
Place Georges Pompidou, Paris IVᵉ
+33 (0)1 44 78 47 99
restaurantgeorgesparis.com

▲15 LE TERRASS' HOTEL
Have a quiet dinner or sip a cocktail on the luxuriant 180-degree terrace.
12-14, rue Joseph-de-Maistre, Paris XVIIIᵉ
+33 (0)1 46 06 72 85
terrass-hotel.com

▲16 LE CAFÉ DE L'HOMME
Located directly opposite the Eiffel Tower in the Palais de Chaillot, this 1930s architectural masterpiece was created for the 1937 World's Fair. Get your own private viewing!
17, place du Trocadéro et du 11-Novembre, Paris XVIᵉ
+33 (0)1 44 05 30 15
cafedelhomme.com

▲17 RADIOEAT
This trendy upstairs cafeteria, where journalists and musicians from Radio France come to lunch, has an uninterrupted view of the Left Bank. It's even better at night.
Maison de la Radio
116, avenue du Président Kennedy, Paris XVIᵉ
+33 (0)1 47 20 00 29
maisondelaradio.fr/page/restaurant-bar

▲18 L'OISEAU BLANC
On sunny days, The Peninsula Paris's rooftop restaurant and bar, located on the sixth floor, offers one of the best views of the capital.
19, avenue Kléber, Paris XVIᵉ
+33 (0)1 58 12 67 30
paris.peninsula.com

▲19 LES OMBRES
Have a cocktail and dinner on the roof of the Musée du Quai Branly, nose-to-nose with the Eiffel Tower.
27, quai Branly, Paris VIIᵉ
33 (0)1 47 53 68 00
lesombres-restaurant.com

▲20 LA BRASSERIE BARBÈS
Admire the neighborhood's very Parisian Métro and zinc roofing from the rooftop bar, drink in hand.
2, boulevard Barbès, Paris XVIIIᵉ
+33 (0)1 85 15 22 30
brasseriebarbes.com

▲21 43 UP ON THE ROOF
This place, on the ninth floor of the Holiday Inn Paris-Notre Dame, offers the most spectacular rooftop view of the city. May–September, 5–10:30 p.m. in good weather. No reservations.
4, rue Danton, Paris VIᵉ
+33 (0)1 81 69 00 68
ing.com/holidayinn/hotels/us/en/paris/parnd/hoteldetail/dining#

THE BEST ADDRESSES FOR THE AUTHENTIC PARISIAN TOUCH

22 APPARTEMENT SÉZANE
Morgane Sézalory's brand Sézane is wildly popular in France, with devotees flocking to her New York offshoot. You'll find her unique take on fashion and lifestyle beautifully arranged here, as though you'd just turned up at a designer's house.
1, rue Saint-Fiacre, Paris IIᵉ
sezane.com

L'APPARTEMENT FRANÇAIS
From kitchen to closet, by way of the living room and study, you'll find everything to build a Made-in-France lifestyle artfully arranged in a 2,100-square-foot (200 m²) space.
A recurrent and nomadic pop-up; check for updates:
lappartementfrancais.fr

23 GAB & JO
This shrine to the glory of French design is a touch patriotic. It offers a motley selection of products made exclusively in France, like the wooden "Map of France" puzzle or the "Cocorico" T-shirt, which make perfect souvenirs. Be on the lookout: you may see Napoleon or Marie Antoinette pop by for an impromptu photoshoot.
28, rue Jacob, Paris VIᵉ
09 84 53 58 43
gabjo.fr

24 PARIS ACCORDÉON

You don't have to be world champion accordion player Yvette Horner to fall for the charms of Paris's last remaining accordion specialty shop. Fans of all kinds of squeeze box will leave happy. The shop is a wonderland dedicated to the *bal-musette* style of music; it also houses a school and an orchestra that performs regularly.

36, rue de la Lune, Paris IIe
+33 (0)1 43 22 13 48
parisaccordeon.com

25 L'EXCEPTION

This concept store brings together the crème de la crème of French designers under a modern chic aesthetic. Whether established or just starting out, if they have talent, they've probably caught the sophisticated eye of Régis Pennel, a graduate from one of the top French engineering schools, who has successfully reinvented himself as a fashion designer.

24, rue Berger, Paris Ier
+33 (0)1 40 39 92 34
lexception.com

HOW TO ADOPT AN EIFFEL TOWER

Yes, you can take home your very own tower! Say "oui" to any number of styles:

Beautifully drawn ... on the "Ça c'est Paris!" tableware collection by **MAISON GIEN**.
gien.com

Gleaming ... from the "Paris Printemps" dish towels by **MAISON MOUTET** or the "Souvenir de Paris Acier" dish towels by JACQUARD FRANÇAIS.
tissage-moutet.com
le-jacquard-francais.fr

Majestic ... on the superb "La Tour Eiffel" posters by **SIMON BAILLY** or on notebooks by **MAISON IMAGES D'ÉPINAL**, with covers inspired by late-nineteenth-century illustrations of the Eiffel Tower.
simon-bailly.com
imagesdepinal.com

Illuminated ... on delicate porcelain votive holders by BERNARDAUD.
bernardaud.com

Flamboyant ... in a limited-edition art print by YELLOWKORNER.
yellowkorner.com

Radiant ... and enclosed in a bedside lamp by the creator of **LA TÊTE DANS LE BOCAL**.
en.smallable.com/brands/la-tete-dans-le-bocal

Shining brightly ... on a table-top lamp by COUDERT.
luminaires-coudert.fr

IS THERE ANOTHER WAY TO VISIT PARIS?

Traipsing single file from one monument to the next behind a flag-waving guide isn't everyone's idea of a good time in Paris. There are much more entertaining ways to discover the city, while still learning something from a knowledgeable and enthusiastic guide. Here are a few ideas for getting off the beaten path with your kids that don't include them sighing with boredom every five minutes.

DO THE PARIS SHOPPING TOUR

Do you want to experience fashionable Paris? Or perhaps take your time without husband and children in tow? Maybe you'd like to meet a young designer, check out the hippest new spots in the capital, or spend several hours in the shoes of a true Parisian? Diane Lepicard organizes several experiences in Paris, the fashion capital of the world. Just take your pick (a custom option for families is available, too).
parisshoppingtour.com

VISIT MONUMENTS FROM ANOTHER ANGLE WITH "QUI VEUT PISTER?"

Go on a treasure hunt with friends and family and have fun discovering the city. Set off on a playful investigation of Paris's cultural heritage and little-known corners. Budding Detective Maigrets will love this, as will anyone who gets bored on longwinded tours. Choose from mysteries in Montmartre (available in English), or, for French speakers, crimes in Saint-Germain or murders at Notre Dame. Then get sleuthing!
quiveutpisterparis.com

DEVOUR PARIS WITH "LA ROUTE DES GOURMETS"

Carole Métayer initiates visitors into France's best-kept food secrets through tasting workshops, unusual meals in Paris, and visits to small food shops. From the history of cooking to chocolate to Champagne wines, there's something to satisfy everyone's hunger for knowledge.
laroutedesgourmets.fr

ENJOY THE ULTIMATE—BUT ENDEARING—PARIS CLICHÉ

Step away from the crowds to embrace your role as a dazzled tourist and see Paris from the relative comfort of a Citroën 2CV—the iconic, metal-bodied economy car introduced in the 1940s to replace the horses and carriages used by French farmers. Several themed itineraries are available—driven by a beret-topped driver, of course!
4roues-sous-1parapluie.com

THE CLASSIC FRENCHY ONLINE

Shop like the French and avoid any faux pas.

A PIECE OF CHIC

This is the place to find quality crafted silk motoring scarves made in Lyon. Tootle back in time to the glory days of legendary race car driver Henri Pescarolo, who reigned over the famed 24 Hours of Le Mans.
a-piece-of-chic.com

NO/ONE PARIS

Created in 2013, this brand shot to fame following a collaboration with the legendary but now-defunct Colette concept store. Its organic cotton T-shirts, sweatshirts, and accessories, stamped with tongue-in-cheek monikers like "Paname" (a nickname for Paris that dates back to World War I) and "Belleville Hills," draw inspiration from streetwear. From bomber jackets to beanies, you'll find everything you need for a hip Parisian look.
no-oneparis.com

LE SLIP FRANÇAIS

This company invented underwear that smells good! (For up to thirty washings, so they say). For those who are proud to be French right down to their underpants, Le Slip Français has playful underwear, as well as swimsuits, slippers, and pajamas, all of them made in France.
leslipfrancais.fr

LANDMADE

From a woodpile tarp to a lamp in homage to the moped, plus a thousand other more ordinary household objects, Landmade has a French-made treasure for every moment of your day.
landmade.fr

MAGASIN GRAND TRAIN

Here you'll find all the old-fashioned charm of French railroads in one place—minus the pesky delays and ticket inspectors. Glimpse another era in vintage photographs of the Orsay Station, locomotives from the 1950s, the emotional partings of early-twentieth-century travelers, alongside beautiful reproductions of advertisements from the early days of train travel, notebooks, and mugs.
magasingrandtrain.sncf.com

FILS DE BUTTE

Inspired by French workwear, this men's fashion brand plays with working-class dress codes to create 100 percent made-in-France clothes for hipster thirty-somethings. The button-up "Lantier" jacket, for example, is an homage to Emile Zola's character Jacques Lantier, a train mechanic. Women who want to play at *Jules et Jim* will also appreciate the selection.
filsdebutte-paris.com

CAVIAR DE FRANCE

The first Russian émigrés, fleeing the revolution of February 1917, taught the secrets of caviar production to fishermen in the Gironde region of southwest France. French caviar has since made a name for itself—you can even sample it right off the back of your thumb, like a real Cossack.
caviardefrance.com

THE ARISTO CHICS

ARE YOU

A LITTLE, VERY, INTENSELY, MADLY, OR NOT AT ALL...*

ARISTO CHIC?

* Our daisy-petal mantra "he loves me, he loves me not" seems so flatly black-and-white compared to this French version, which perfectly highlights their nuanced approach to love.

QUIZ

● I've never confused corduroy and velvet. ● I make the gardener laugh with my ideas about sustainable agriculture. ● I'll pay for the new roof with one of our ancestral portraits. ● "Life without a refrigerator" sounds tempting (my children might disagree).
● My kids call my mother "Grandmother" (never "Grandma"). ● My onion soup is legendary. ● I know how to pronounce Broglie, Trémoille, and Montrachet.
● I don't have a TV and still haven't bought a smartphone. ● Three-, four-, five-, or six-day beards? I can't bear them. ● I'm strongly in favor of school uniforms. ● What could be more chic than a slightly threadbare cashmere sweater? ● I think Andy Warhol was a bit much.

→You checked 7 to 12 statements. You are a die-hard Aristo Chic. Confirm your connection by reading the rest of this chapter.

→You checked 3 to 6 statements. You're almost a part of the family. Strengthen the bond by picking up a few pointers in this chapter.

→You checked 2 or fewer statements. There is absolutely nothing Aristo Chic about you. If that bothers you, read on to get to know them better!

BACKSTORY

"What will we gain from destroying the aristocracy of nobles if it is replaced by the aristocracy of wealth?"

—Marat

The Aristo Chics invented waste reduction before "Zero Waste" was a thing, piling everyone into the Citroën 2CV long before car sharing came along, swapped châteaux in the days before Airbnb, and were upcycling before Repair Cafés were invented. And they never once bragged about it!

Even the storming of the Bastille failed to revolutionize life for this founding arm of French style. Proud of ancestors who lost part of their fortune, sometimes their châteaux, and occasionally their heads in tumultuous eighteenth-century France, Aristo Chics are the natural ancestors to modern-day proponents of making do with less. Their family trees are full of courageous warriors who had the great privilege to spill their blood defending the kingdom, and they love giving their children hard-to-spell names like Adélaïde, Menehould, and Thaïs for girls, and Aymeric, Adhémar, or Enguerrand for the boys, in memory of a great-great-great-great-great-uncle who fought bravely for France back in '43 (1143, that is).

Aristo Chics exchange, share, and recycle everything; they practically invented the clothing swap and carpooling out of economic necessity. They only buy things made to last: year in and year out, the same shetland sweater can be seen warming the shoulders of generations of children, to end its days, if it's still in one piece, on the floor, as the Labrador dog's blanket. Penniless but ever elegant, they frown upon frenzied spending and are impervious to temporary, useless, and costly fads. Aristo Chics don't get to choose between a new it-bag and a new roof for the family château; and besides, Grandmother's Kelly is still in mint condition.

These enemies of waste have always practiced communal life, welcoming to their family home (often a *hôtel particulier*, or townhouse) the mother-in-law who can't stand to live alone anymore; the handsome, broke nephew on his way to the priesthood; or the far-flung cousin who has come all the way to Paris for prep school. Convinced that the real "French Revolution" was to give power to those with money, they exhibit an ironic indifference toward fortunes that are easily won and too conspicuously spent.

Despite being perfectly integrated into the French Republic, they remain very sensitive to notions of rank. Never confuse Ancien Régime aristocracy with the more recent First Empire nobility, revived by Napoleon I in the early nineteenth century. The former can ferret out fake antiques without even trying, and are not impressed by family names with the so-called aristocratic particle *de* ("Hokum!" remarked the eighteenth-century memoirist Saint-Simon) that, contrary to popular belief, is not actually a mark of blue blood.

POETIC ICONS

Louise de Vilmorin: aka "Marilyn Malraux," she was the lover of the writer and Gaullist dignitary André Malraux. She's the archetype of a seductive, spirited, educated woman.

Antoine de Saint-Exupéry: The fame of his humanist hero the Little Prince gave way to rampant merchandising (and gained a cult following among French parents).

DESIGNER ICON

Jean-Charles de Castelbajac: An eccentric artist and a talented dabbler in everything from mixed media to fashion design. His highbrow-pop-arty style has always been popular internationally. Parisians love to hunt down the angels he draws in chalk on the capital's walls.

Fencing and shooting are no longer essential elements of their education, so they concentrate on manners, chivalry, and culture as a means of distinguishing themselves—despite the risk of appearing eccentric in the eyes of those—and they are many—unaware that one never says "bon appétit" before a meal or "enchanté" (delighted) when meeting someone for the first time.

From the cradle—a creaking piece of furniture also passed down from generation to generation—Aristo Chic children are instilled with a taste for respectable pastimes. Reading, rounds of hide-and-seek with cousins in the park, board games, or playing dress-up with treasures discovered in trunks in the attic will always trump video games.

Aristo Chics love what sets them apart from the ordinary *hoi polloi*. They happen to be among those rare French people who dare to wear brightly colored clothes and hats on occasions other than marriages. They also have a knack for transforming clothes from the last decade into original, stylish pieces.

The fashion world loves this family and sometimes catches them off guard by borrowing some iconic piece that the Aristo Chics have been wearing for decades. They were stunned to learn that rubber boots, so practical for hunting, stole the runaway at a Saint Laurent show.

The return of Do-It-Yourself decor, presented in magazines as the pinnacle of cool modernity, elicits a chuckle. The Aristo Chics have known for ages that dime-a-dozen fabrics from Montmartre's Marché Saint-Pierre add a lovely modern touch to any eighteenth-century headboard.

Finally, every family has an uncle or an aunt who can repair the refrigerator or the old Citröen 2CV. Mechanical skill is often accompanied by an impressive knowledge of framing, plumbing, and painting. After all, Louis XVI was crazy about interior design!

ELEGANT ICONS

Mme de Pompadour: A favorite of the king and the ancestor of today's influencers. Everyone copied her châteaux, her clothes, her porcelain—all without a soupçon of social media.

Loulou de la Falaise: Inspiration, muse, and friend to Yves Saint Laurent. They shared many good times, vacations in Morocco, and all-night parties at 7 (the most famous gay nightclub in Paris).

HIP ICONS

Étienne de Crécy: In the footsteps of Maurice Chevalier, Yves Montand, Charles Aznavour, Serge Gainsbourg, Françoise Hardy, and Daft Punk, the newest French singer making waves abroad is one of the founders of the famous French Touch house music movement. *Hurrah!*

CODE OF CONDUCT

A few Aristo Chic tribal rituals explained for outsiders who want to fit right in ...

The thank-you letter

The lady of the house always appreciates a little witty handwritten letter (known in French as a *lettre de château*) thanking her for hosting you at the get-together. Whether you're a regular, a relation, or a first-time guest, it is considered polite to praise her home, the beauty of the region, and your hostess's culinary talents. Lazily shooting off a text message, on the other hand? Never.

Formal modes of address

This strange French custom persists among certain social classes. Things are simple in English: you address other people as "you" whether they're a prince or a peasant. In France, *tu* is used between friends from kindergarten through college, those you play sports with, Facebook "friends," colleagues at start-ups, modern parents and children, lovers, cops and hoodlums.... But you never use *tu* with your bank manager, the president, your accountant, and certainly not when meeting your future in-laws! What is more, in certain polite-society families, children still use the more formal *vous* to address their parents, who use *vous* between themselves (but not necessarily in private—that's what adds spice!). Similar to "Sir" and "Ma'am," it is a sign of respect and esteem, if a little old-fashioned.

The homemade gift

Marmalade, estate honey, an embroidered glasses case, hand-painted porcelain, a knitted scarf: DIY gifts are always appreciated among Aristo Chics—and valued far more than any manufactured bauble.

I'D RATHER DIE THAN ...

Send
New Year's wishes by
text message

Visit Saint-Tropez
in August

Own a teacup
dog (Labradors
forever!)

Give up my monogrammed
bedlinen

Stock
mauve,
scented
toilet
paper

Host
a dinner
for
thirteen

Miss
the convent
school reunion
dinner

Drink champagne
from a plastic glass

Use the crosswalk

Leave
the light on
when I exit
a room

Drive an SUV, especially
a matt black one, especially
in the city

THE ARISTO CHIC:
A CONVERSATION KING

H ow it is possible to converse so brightly around such drab dishes? The Aristo Chic table is often a disconcerting experience for the uninitiated. It's possible to find oneself invited to lunch in a château where Louis XIII once spent the night, poking at a slice of stringy roast on an emblazoned porcelain plate. You'll be riveted, of course, by the garden that was designed by Louis XIV's gardener Le Nôtre (it looks just like Versailles) but, good lord, the food is awful! Perhaps the reason for this mysterious incongruity lies in the fact that Aristo Chics never adjusted to cooking for themselves once the servants hightailed it out. Yet, extraordinary stoicism is expected from diners: everyone praises the cook warmly, and she graciously accepts these entirely undeserved compliments. You would be mistaken to think that Aristo Chics, especially in rural regions, give any importance to the quality of their cooking; what really matters is quality conversation. Theirs is a profusion of brilliant little anecdotes that demonstrate an ironic disdain for trivial domestic incidents. The brazen art of recounting the smallest irritating mishap as though it were an epic saga is their supreme form of elegance; it's almost all that remains of their lordly arrogance. (If you want to fit in, try turning an episode involving a broken-down moped into a heroic account of derring-do.)

People who actually complain about such mundanities of life—a flat tire or a runaway dog—make them break out in hives. They consider the current compulsion to carry on endlessly about *bouffe* (food) or *pinard* (wine) at the dinner table to be incredibly vulgar, vexing even. (This is just as well, since there isn't much to say about their meals.) And spirited conversation should never be allowed to ruin table manners. From the age of seven to seventy-seven, Artisto Chics meticulously fold their lettuce leaves eight times with a piece of bread while witty remarks fly around the table. This exercise in culinary origami is crucial—it demonstrates that one is "in": no one in this family ever, ever cuts their lettuce. And make sure to eat it with your mouth shut tight, without making a sound. Got it?

"FRENCH WIT" ICON

Jean d'Ormesson: Ever cheerful, cultivated, and gentlemanly, this writer and journalist was the archetype of the French gentleman, down to his perennially impeccable necktie.

SUPERMODEL ICONS

Inès de La Fressange and Caroline de Maigret: Beautiful, zesty brunettes with a sense of humor, they have taught the rest of the world how to be Parisian chic.

ARISTO CHIC "MUST HAVES"

Find your own touch of nobility in this selection approved by the most exacting of the French families.

① CANDLES

While the French lower classes were lighting their homes with stinky yellow tallow, the nobility and the clergy were using costly white beeswax candles. They already feared counterfeits: there was no way they would buy something diluted with old wax or, heaven forbid, potato. Starting in the nineteenth century, successive scientific discoveries led to the manufacture of entirely synthetic candles.

THE ICONIC BRAND: TRUDON
The Manufacture Royale de Cire (Royal Wax Manufacture) withstood several regime changes to emerge as Trudon, and illuminated the best houses in the monarchy and then the Empire. The founder was even given a noble title by Louis XVI. Maison Trudon was revived in 2006, and supplied candles for Sofia Coppola's film *Marie Antoinette*. Back in style again, the company continues a baroque tradition that does not shy away from embellishment. Minimalists need not apply.

trudon.com

♥ WE LOVE …
the candle bust of Marie Antoinette—a charming tribute to the French queen who lost her head on October 16, 1793. Aristo Chic tastes, laced with a touch of humor, tend toward the perfume "Revolution," with notes of cedar and patchouli, and the lily-of-the-valley-scented "Prolétaire" candle.

② TOILE DE JOUY LINEN

THE ICONIC BRAND: PIERRE FREY

For three generations, this company has been creating and manufacturing magnificent cloth, including Toiles de Jouy reproduced according to period documents. The founder—Pierre Frey—began his career at the age of seventeen, with a hat maker, then went to work for Charles Burger, the renowned nineteenth-century upholstery manufacturer, where he worked his way up from the bottom. In 1935, he founded his own company. A relentless worker, he held every possible position, by turns designer, shop keeper, and salesman, even delivering to his clients by bike. His reputation quickly spread outside of France, and in the 1950s he created exclusive models for Elsa Schiaparelli and the decorator and art collector Carlos de Beistegui. In 1969, his son Patrick expanded the company's range to include tableware, cushions, tablecloths, and scarves. Today, Pierre Frey continues to innovate and collaborate with well-known designers like India Mahdavi.

pierrefrey.com

Ladies at the court of Versailles were so crazy about this airy, colorfully printed cotton imported from India that Louis XIV, in order to protect the Lyon silk industry, had to ban it—but he was powerless to prevent the development of a black market for the terribly fashionable cloth known in French as "indiennes." In 1759, the ban was finally lifted, and many factories started printing on cotton. A young German man, Christophe-Philippe Oberkampf, created one of the most famous royal factories in Jouy-en-Josas. The magnificent floral and geometric designs were reserved for clothing, while the light, bucolic prints, many of them painted by Jean-Baptiste Huet, and initially intended for furniture, would forever after be known as "Toile de Jouy."

WE LOVE …
the "Paul and Virginia" motif, inspired by a classic book by Bernardin de Saint-Pierre and based on a popular design by Huet.

③ SIGNET RING

Engraved signet rings have been used since Antiquity as symbols of authority, but also as seals at a time when only the privileged classes knew how to read and write. In the Middle Ages, knights carved their coat of arms into clunky helmets and armor in order to identify themselves on the battlefield and to avoid killing allies. These same coats of arms appeared engraved in signet rings that, over time, became a simple marker of social and cultural belonging among the nobility. Traditionally in France, the eldest member of the family wears it on the left ring finger. If he wears it with the motif facing out (*en baisemain*), it means he is single. If, however, the motif is facing in (*en bagarre*), keep walking!

THE ICONIC BRAND: ARTHUS-BERTRAND
Founded in 1803 (although it wasn't called Arthus-Bertrand back then), and specialized in making flags, embroidered emblems, and military insignia, this company was the official supplier to Napoleon Bonaparte's First Empire, who brought the company wealth and fame by establishing the Legion of Honor and constantly going to war. Matching Napoleon's victories with its own series of successes, it survived the fall of the emperor. In 1925, after more than a century of decorating distinguished men, Arthus-Bertrand turned to their children with a collection of baptismal medals, then to their wives, with a line of jewelry. Known for expertise and quality craftsmanship, Arthus-Bertrand calls upon artists like Jean-Charles de Castelbajac and Hilton McConnico to enrich its collections.

arthusbertrand.com

WE LOVE …
the "Love" and "Emblème" signet rings, engraved with calligraphy inspired by the talented Nicolas Ouchenir, to be worn either *en baisemain* or *en bagarre*.

④ PERFUME

People rarely bathed at Versailles during Louis XIV's reign, convinced that water carried diseases like bubonic plague. But linens were changed several times and a day, and people doused themselves in perfume. Fragrant sachets tucked under armpits, in the folds of clothes, and in wigs, and scented gloves and fans were all used to hide bad odors. "To be clean is to smell nice!" As bathrooms and bathtubs came into use, the fragrances became more discreet. The first perfume makers opened in Paris in 1774. Marie Antoinette, whose supplier escaped the guillotine and went on to serve Napoleon, started the "floral" trend: rose, lily, violet, and carnation. Chemistry and industrialization later made perfume accessible to everyone, and Paris eventually became the world fragrance capital.

THE ICONIC BRAND: GUERLAIN

Pierre Guerlain was twenty years old when he opened a boutique in 1828 on the ground floor of the Hôtel Meurice on rue du Rivoli in Paris. He established the foundations of modern perfumery with his scented soaps, lipstick, beauty creams, and blush. Empress Elisabeth of Austria—the legendary Sissi—loved the Crème de Fraise (Strawberry Cream), which protected her complexion. Eau de Cologne Impériale, commissioned by Empress Eugénie, wife of Napoleon III, remains one of the company's classics. Pierre embodied French elegance and refinement and eventually became the official perfumer to the European royal courts. In 1889, his son Aimé launched Jicky, the first modern perfume, a combination of natural essences and synthetic ingredients. Shalimar was developed in 1921, and Vol de Nuit ("Night Flight") appeared in 1933, in homage to aviator and *The Little Prince* author Antoine de Saint-Exupéry, a family friend. The timeless classics Chamade, Jardins de Bagatelle, L'Homme Idéal, and many others followed.

guerlain.com

♥ WE LOVE …
the golden bee bottle, a symbol of the Second Empire: gilded, monogrammed, and elegant enough to last you a lifetime.

⑤ RUBBER BOOTS

The conquistadors' discovery of *caoutchouc* (borrowed from a Quechua word meaning "weeping tree") revolutionized the world. The Mayans used the supple and elastic sap from the rubber trees to make common objects and bouncy balls that leapt skyward. Unfortunately, this wonderful waterproof material hardens upon contact with air, melts in the sun, and becomes totally useless after months of sea transport.

Since the eighteenth century, Europeans have tried to master the material: the English used it for erasers, while the Montgolfier brothers mixed it with varnish to protect the silk on their first "flying globe" hot-air balloon.

In the following century, it took several discoveries and innovations to make rubber the essential material we know it as today: the Scottish chemist Macintosh invented a process for waterproofing fabrics, developing in the process the famous water-resistant raincoats and the first rubber condoms. Goodyear was able to make it resistant to changes in temperature, paving the way for Dunlop to invent the car tire. Used prolifically ever since, commercially and in daily life, its only flaw is that it is difficult to recycle.

THE ICONIC BRAND: AIGLE

In 1850, the American Hiram Hutchinson had the amazing idea of using rubber to make waterproof shoes for workers and farmers. He moved his family from the United States to Montargis in the Loiret region of France, to open his first factory, called Aigle (eagle) after the symbol of his native country. His idea was a success and before long, Aigle was being worn across France, by anyone who walked or worked in the mud. Aigle has since become fashionable, racking up collaborations with designers, including one with fashion brand Vicomte A (another Aristo Chic favorite) and with Ines de la Fressange.

aigle.com

WE LOVE …
the black Truite waders. You just can't get any more fashionable.

⑥ THE SILK SCARF

Jean-Baptiste Colbert, minister of finances under Louis XIV, established regulations for the Grande Fabrique de Soie (Great Silk Factory) in Lyon, and freed the French from lusting after Italian products. Sumptuous cloth was manufactured for various royal homes, including Versailles, then for all the foreign courts. Lyon became the largest industrial city in France. But with the French Revolution came new ideas, and luxurious silk fell out of fashion; people preferred the simplicity of cotton, linen, chiffon, and gauze. Later, Napoleon's abundant orders of silk intended for renovations in imperial residences—like Fontainebleau or the Tuileries, which had been destroyed by the Revolution—did much to revive the silk industry. New designs were created just for him, giving rise to the neoclassical Empire style. Orders came in from around the world, and aristocratic silk, which captivated the victorious nineteenth-century bourgeoisie, made a total comeback.

THE ICONIC BRAND: HERMÈS

The first square silk scarf appeared in 1937, one hundred years after Pierre Hermès, a former apprentice saddler from Pont-Audemer in Normandy, traveled to Paris to make his fortune and created Maison Hermès. Hermès's initial mission was to make horseback riding equipment, but the founder's grandsons quickly realized that the rise of the automobile obliged them to evolve. In 1880, located on rue du Faubourg-Saint-Honoré, they began making luggage, and their expert craftsmanship captivated elegant globe-trotters—including horse riders. Other pieces soon followed, including the iconic silk square. Over the last several decades, the Hermès square, along with the Birkin and Kelly bags, has become a classic piece, a collector's item passed from mother to daughter. Every thirty minutes, a Hermès scarf is sold somewhere in the world.

hermes.com

WE LOVE ...
everything! It's hard to choose from the dizzying array of silks.

THE GOURMET ARISTO CHIC

Reading about the latest trends from the comfort of their ancient armchairs, Aristo Chics would be tickled to discover that they're living a Zero Waste lifestyle without even trying. And to think that American chefs like Dan Barber organize workshops—using fried skate-wing cartilage and vegetable peel fries—to educate hipsters! Hubert and Madeleine would find this immensely amusing were they to catch wind of it in their fiefdom in the boondocks of southwest France. There are none of these affectations in their own home. A duck carcass? Into the pot it goes, along with Tarbais beans, vegetables, and herbs. Any remaining scraps of meat quickly dissolve into a delicious broth. This is known as *garbure*, a classic of southwestern French comfort food and Sunday night dinners. What becomes of fallen or overripe fruit in the centuries-old orchard? Clafoutis and stewed fruit for children who have rarely laid eyes on a commercially made cookie. Bread, a highly symbolic food, is also the subject of a particular obsession in this family: among Aristo Chics, bread is never eaten fresh, because whatever's leftover has to be finished first. This healthy loathing for waste ("don't throw away food") may bring them admirably closer to country life, but it's a real pain for those who appreciate a fresh baguette. But the creativity that comes with recycling toast or hardened bits of breads readily makes up for this very petty bourgeois frustration.

THE ARISTO CHIC SWEET TOOTH

Aristo Chics may be frugal, but they have their weaknesses. They have a royal disdain for rose-petal macarons and peppermint-lemongrass chocolate from Pierre Hermé and Patrick Roger—"gimmicks!" they cry—and prefer their own respectable suppliers. Their sweet tooth is likely inherited: dessert was long reserved for the nobility. They adore plump regional macarons from Saint-Jean-de-Luz (created for the marriage of the Infanta of Spain and Louis XIV in 1660) or Poitiers, made according to a simple, historic recipe using almond flour. They also like candies with a story, and keep a little tin on hand for the road trips that living in a country house inevitably entails: Négus from Nevers, created in 1900 in honor of the Ethiopian emperor's visit to the World's Fair in Paris, with their fiendish combination of hard caramel wrapped around soft caramel; jam-filled Froufrou (made since 1885); poppy-flavored Coquelicot de Nemours; or colorful retro hard candies from Bagnères-de-Bigorre. Grandchildren in the back of the antique Volvo are allowed a candy if they've behaved themselves at Sunday Mass.

THREE DEVILISHLY GOOD WAYS ARISTO CHICS REUSE STALE BREAD

PAIN PERDU (FRENCH TOAST)
Called "French toast" outside of France, *pain perdu* ("lost bread") is the best way to give leftover bread a delicious and crispy afterlife.

Ingredients
→ ½ cup milk → 2 large eggs → 1 tablespoon brown sugar → 1 vanilla bean → ground cinnamon → 4 slices stale bread → butter, for cooking

Method
❶ Beat milk, eggs, and brown sugar together in a shallow dish. Scrape the seeds from the vanilla bean into the mixture, along with a few pinches of cinnamon, if desired. ❷ Soak bread in mixture. ❸ When bread is moist, grill in a pan with a bit of butter until golden. ❹ Covertly eat as many slices as possible before telling the kids it's snack time.

GOLD-MEDAL CROUTONS
Nothing tops soups and salads better than homemade croutons, without the funky additives found in their commercial counterparts.

Ingredients
→ stale bread → olive oil
→ herbs (thyme, savory, etc.)

Method
❶ Cut stale bread into large cubes; a mix of different kinds of bread is fine. ❷ Soak bread in mixture. ❸ When bread is moist, grill in a pan with a bit of butter until golden. ❹ Covertly eat as many slices as possible before telling the kids it's snack time.

CHICKEN WITH BREAD STUFFING
Don't know what to do with that rock-hard leftover baguette? Turn it into an unforgettable dish.

Ingredients
→ 1 stale baguette → 1 whole chicken
→ garlic → thyme

Method
❶ Insert the baguette into the chicken's cavity with unpeeled garlic and thyme. ❷ Roast the chicken at 400°F (200°C) for 1 hour 20 minutes or until cooked through, letting the juices soak into the bread. ❸ Enjoy, without thinking about calories.

SWEET WEBSITES

TOP MACARONS
Maison Adam → *maisonadam.fr*
Rannou Métivier → *rannou-metivier.com*

THE BEST OF THE REST
Maison Fossier: The famous pink Reims cookie (biscuit rose de Reims) was invented by this official supplier to the king in 1775. Flavored with vanilla and colored with cochineal, the recipe has remained the same since 1690. Order them online along with savory versions, which are perfect with a glass of champagne. This famous little cookie makes a good base for raspberry trifle.
→ *fossier.fr*

TOP-DRAWER CANDY
Servant Chocolatier → *chocolaterie-servant.com*
Mazet → *mazetconfiseur.com*

Maison La Varenne: When a historian meets a former Pierre Hermé employee, many candies, fruit jellies, and little cakes ensue, all with eighteenth-century inspiration. Tasty time travel, indeed.
→ *maisonlavarenne.com*

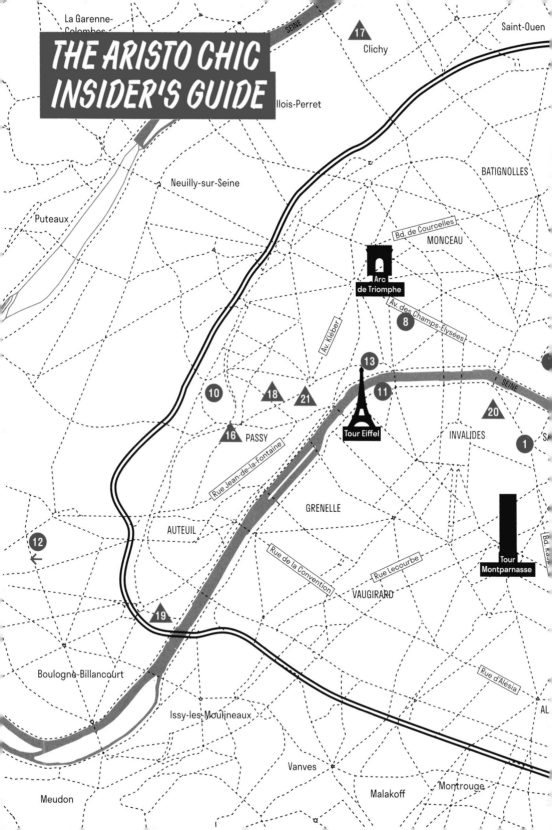

THE ARISTO CHIC INSIDER'S GUIDE

THE ARISTO CHIC IN PARIS

In the eighteenth century, Aristo Chics and bankers began building *grand hôtels particuliers* or townhouses with vast gardens on what was known as the Faubourg Saint-Germain. The neighborhood evolved during the nineteenth century as Paris underwent an urban transformation spearheaded by Baron Haussmann (he ordered the construction of Boulevard Saint-German and destroyed a few homes in the process), but it remains one of the historic fiefdoms of the Aristo Chic tribe. Between 1890 and 1910, this exclusive golden triangle, defined by rue de Lille, rue de Constantine, rue de Babylone, and rue Bonaparte, was home to the most prestigious social class of the period. Undine Spragg, the ruthless social climber in Edith Wharton's novel *The Custom of the Country*, decided to worm her way into this world by ensnaring the Marquis de Chelles. Of the two hundred *hôtels particuliers* of yesteryear, only fifty or so remain, most of which have been turned into ministry offices or embassies. Parisians love to stroll around the area, keeping an eye out for an open porte cochere entrance in hopes of glimpsing a regal façade or garden.

THE ULTIMATE ARISTO CHIC LANDMARK?

1 L'HÔTEL DE GALLIFFET, built in the late eighteenth century, is now home to the Italian Cultural Center and is occasionally open to visitors. Constructed on the eve of the French Revolution, it was confiscated and became the residence of the wily statesman and diplomat Talleyrand, who hosted Napoleon and other notables there.
50, rue de Varenne, Paris VIIᵉ
+33 (0)1 44 39 49 39

OUT AND ABOUT WITH THE ARISTO CHICS

Aristo Chics don't necessarily have the means to live near the Palais Bourbon (originally the country house of the Duchess of Bourbon and now seat of the French National Assembly). But they know exactly where in the capital to find their signature cocktail of everything chic, simple, and eccentric. Naturally, they prefer places steeped in history that have neither lost their charm nor sag under the weight of a bygone past. Here's where they like to wander:

BE A VAGABOND AROUND THE PALAIS ROYAL

Radiating the magnificence of the seventeenth century, this is the Paris of playwright Molière and composer Lully. The Japanese who settled in the area in the 1980s perfectly captured that poetic spirit.

2 RUE SAINT-AUGUSTIN
→ AT NO. 18: The Oriza L. Legrand perfume shop is a charming reconstruction of a fragrance house created during the reign of Louis XV and wildly popular around 1900. Today, the store creates lovely reinterpretations of old-fashioned scents from the archives. Violette du Czar, Gentry Jockey Club, and Marions-Nous exude true Parisian sophistication.

3 RUE DE LOUVOIS
→ AT NO. 8: The Humaine Comédie, formerly a bookstore, has become an elegant Japanese hairsalon that opens out onto a ravishing square with a burbling fountain covered in finely wrought figurines.

4 RUE CHABANAIS
→ AT NO. 11: At Tomo, two young pastry chefs make hybrid *dorayaki*—a tiny Japanese pancake—called a "Paris-Tokyo" in a tip of the toque to the traditional Paris-Brest puff pastry filled with hazelnut–almond praline cream.
→ AT NO. 14: The beautiful Louiselio, clad in a potter's smock à la Camille Claudel, has been making ceramics here for decades.

5 RUE VILLEDO
→ AT NO. 5: Kunitoraya 2, a refined *udon* establishment in an untouched bistro interior from 1900.
→ ALSO AT NO. 5: Télescope, serving the best filter coffee in Paris.

6 RUE DE RICHELIEU
→ AT NO. 47: In her cheese shop, Madame Hisada uses sake to age venerable regional cheeses.
→ AT NO. 58: The National Library's exceptional Labrouste room features spectacularly renovated cupolas.

7 RUE SAINT-ROCH
→ AT NO. 18: Brigitte Tanaka stocks the most Granny Chic antiquities in Paris, all refined and eccentric.
→ AT NO. 23: Located at the end of a courtyard, the Antonine Catzéflis Gallery stocks sophisticated art selected by a Parisian with eclectic tastes that go against the conformist grain.

8 COME AND ADMIRE THE HÔTEL DE LA PAÏVA, the sumptuous home of one of the most famous Second Empire *horizontales* (i.e., courtesans), Thérèse Lachman, alias the Marquise de Païva. This courtesan had a fondness for diamonds and completely ruined numerous Aristo Chic paramours. Her dramatic bed (on view at the Musée des Arts Décoratifs) inspired Emile Zola's novel *Nana*, about a fictional nineteenth-century prostitute.
25, avenue des Champs-Elysées, Paris VIIIᵉ
Guided and private tours:
paris-capitale-historique.fr

9 SHED A TEAR AT THE HÔTEL DE SOUBISE, one of the most sumptuous palaces in the Marais and now part of the national archives, where you can read the last letter Marie Antoinette wrote before ascending the scaffold. The sumptuous gilded rococo woodwork and emblazoned moldings are a sight to behold.
Every first Saturday of the month from 2:30 p.m to 4 p.m.
60, rue des Francs-Bourgeois, Paris IIIᵉ
+33 (0)1 40 27 60 29
archives-nationales.culture.gouv.fr/web/guest/hotels-de-soubise-et-de-rohan

10 CONTEMPLATE THE MYSTERY OF MONET'S *WATER LILIES* in the beautiful room reserved for them at the Marmottan Monet museum, which is mysteriously devoid of tourists. Shhhh...
2, rue Louis-Boilly, Paris XVIᵉ
marmottan.fr

11 INDULGE IN NAUGHTY TREATS AT DEUX ABEILLES, the legendary tea room popular with mostly female members of high society, from neighborhood Aristo Chics to the editors of *Vogue France*. The chestnut cake and lemon and ginger tea alone are worth the trip.
189, rue de l'Université, Paris VIIᵉ
+33 (0)1 45 55 64 04

12 SEE THE WORLD AT THE ALBERT KAHN MUSEUM, in the themed gardens and magnificent collection of photographs that belonged to this visionary banker. His ambitious Archives of the Planet is the world's largest autochrome collection, containing 72,000 plates amassed between 1909 and 1931 by photographers Kahn recruited to travel the world recording everyday life.
14, rue du Port, 92100 Boulogne-Billancourt
albert-kahn.hauts-de-seine.fr

13 KILL THREE BIRDS WITH ONE STONE: Visit the Palais Galliera, the famed fashion museum managed by the city of Paris, whose collections are unparalleled in Europe and where the temporary collections are always impeccable; on Wednesday and Saturday mornings, visit the very popular Avenue du Président-Wilson market, opposite the Musée d'Art Moderne de la Ville de Paris. Seeing all that glorious produce can work up an appetite, so settle into a table at Les Marches, a bistro steeped in postcard-Paris spirit. Pike quenelles, leek vinaigrette, andouillette, baba au rhum, and smiling waitstaff are rare commodities in Paris, so reservations are recommended.
palaisgalliera.paris.fr
mam.paris.fr
lesmarches-restaurant.com

ARISTO CHIC CONFIDENTIAL

THE TONIEST SPOTS WHERE YOU CAN ...

14 **LUNCH IN MONASTIC CALM:** Grab a table at the Collège des Bernardins, in the renovated thirteenth-century nave. Meals are prepared by Table de Cana, a caterer that specializes in good food and job placements for those who need it most. Good deeds and good food, what more could you ask for?
Monday to Friday, Saturday upon reservation.
20, rue de Poissy, Paris V^e
+33 (0)1 53 10 74 43
collegedesbernardins.fr

15 **PRETEND YOU'RE AT HOGWART'S:** Visit the quirky François Tillequin museum, where centuries-old vials and jars recount the history of pharmaceuticals. Botanical collections from master apothecaries of the Enlightenment and exotic spoils brought back by nineteenth-century explorers haunt the museum's spectacular shelves—relics from various World's Fairs held in Paris. Here you'll learn that Coca-Cola was in fact a Corsican discovery, and that the patent was acquired in 1892. Visits must be arranged with a guide, by appointment; entry is free.
4, avenue de l'Observatoire, 75006 Paris
+33 (0)1 53 73 98 04
fondation.parisdescartes.fr/musee-francois-tillequin-matiere-medicale/

TIGHTEN YOUR BELT WHILE LETTING LOOSE:
Browse the racks at the Espace NGR, a private sale venue popular with ladies-in-the-know from Passy, a moneyed neighborhood in the sixteenth arrondissement. You'll find a gold mine of unbeatable deals on end-of-season items from lovely French ready-to-wear and design brands.
16 40 bis, rue de Boulainvilliers, Paris XVI^e
17 Espace NGR l'Annexe (10,700 sq. ft./1 km² dedicated to decoration):
6 bis, rue Petit, 92110 Clichy
ngr.fr

18 **LIVE LIKE A DUCHESS IN A *HÔTEL PARTICULIER*** (even if only for the weekend): Book a room at the Windsor Home hotel. The eight rooms in this ravishing Parisian home are deliberately old-fashioned. The bust of Louis XIV, Toile de Jouy, and chandeliers dripping with crystal pendants exude an air of an ancestral château.
3, rue Vital, Paris XVI^e
windsorhomeparis.fr

19 **UNEARTH FRENCH-QUALITY VINTAGE:** Sharpen your elbows at Joli Closet, an exclusive consignment store. From the Chanel 2.55 to the Hermès Kelly, every cult Parisian handbag is on hand. And if the leather is slightly worn, all the better—brand new is *so* nouveau riche.
41 bis, rue Claude-Terrasse, Paris XVI^e
jolicloset.com

20 **BURY YOUR NOSE IN THE FLOWERS:** The bouquets at Harvest Fleuriste, a delightful little space nestled on rue de Bourgogne, offer a moment of pure Proustian poetry. Have flowers sent in advance if you are invited to a dinner party (never take them with you, to avoid burdening the mistress of the house, who has other things to do). You can also pick out a unique blown-glass vase. The space doubles as a photo gallery.
Harvest Atelier-Boutique
29, rue de Bourgogne, Paris VII^e
harvest-fleuriste.com

21 **PAMPER YOURSELF:** The herbalist Lila Sobanski at l'Herboristerie is the real deal; this trained pharmacist is a plant-remedy convert. Come for the tea, packaged-up with old-fashioned charm, and for wise advice whenever you catch a cold in a chilly Parisian breeze.
71, avenue Paul-Doumer, Paris XVI^e
herbosobanski.fr

THE ARISTO CHIC ONLINE

Get Aristo Chic from the comfort of your couch
with these select websites.

MAISON GUIBERT
This luxury saddler has been outfitting exacting, fashionable horsewomen since 1999. After failing to find horse-riding equipment he liked, Pierre Guibert entered the trade himself, and with great success, as demonstrated by his saddles in vegetable-tanned leather, made-to-measure calfskin riding boots, and sublime gloves. He has even managed to seduce the British—hardly novices when it comes to equestrian sports.
guibert.fr

BRUN DE VIAN-TIRAN
This family operation, and the oldest blanket manufacturer in France, has been making wool blankets and throws in Merino d'Arles for eight generations. The carding process gives the fibers exceptional warmth and softness, which comes in handy in a big drafty house—or anywhere else, for that matter.
brundeviantiran.com

MADEMOISELLE SAINT GERMAIN
How does a facial cream made with the queen of Hungary's water or a cucumber ointment sound? This recently created Versailles-based company has two passions: botany and reviving traditional French cosmetic heritage (updated for modern consumers, of course). The ingredients in their unguents come from the King's Vegetable Garden on the Château de Versailles estate.
mademoisellesaintgermain.com

LE LOIR EN PAPILLON
Mickael François Loir has made masculine elegance a way of life. A fierce opponent of the pre-tied bowtie and an admirer of Oscar Wilde (a kindred fan of cufflinks), he is fascinated by the insects from which he draws inspiration for his designs. His website carries elegant accessories that embellish any outfit with a bit of dandy refinement. Everything is, of course, handmade in Paris. Now, you just have to learn to tie a bowtie.
leloirenpapillon.com

CABANON
Supplying the very best of camping gear made in France. This is the place to find a tent signed by the worker who sewed it by hand, ideal for housing a herd of scouts on an outing. If you don't have a château, the tepee is always a hit with the commoners.
cabanon.com

THE ARISTO CHICS ON VACATION

HEAD SOUTHWEST TO … GERS!

For Aristo Chics, this is the "other South of France": in other words, the real one, the rural, authentic southwest France, and the flip side of the French Riviera (which they find artificial and trashy). They are entitled to their opinion, and there's no question that the Gers region (situated in the heart of Gascony, the home of d'Artagnan of *The Three Musketeers* fame) is indeed worthy of devotion. Without a single château or remarkable landscape in sight, the houses nestled in these gentle hills and medieval villages, are, refreshingly, not all vacation homes. Aristo Chics spend the summer with family in their self-restored sprawling homes, content to roam the backroads. They like to complain that there are too many people in August, which is completely false: an exquisite peace reigns over the region. In Gers, no one frets over duck breast fillet or foie gras being affronts to animal rights. Here, that could cause a diplomatic incident.

TOUR LECTOURE
This village is worth a visit for its little Romanesque cathedral, streets overlooking the countryside, and the foie gras with sliced melon at the Hôtel de Bastard. The legendary Café des Sports is a real melting pot of locals, chic American tourists, hikers, and farmers discussing business over duck confit and a bottle of the local Madiran wine. *hotel-de-bastard.com*

DIG IN AT AUCH
The restaurant terrace at the Hôtel de France is the ideal place to observe passersby and taste the famed white Tarbais beans. Another sublime cathedral—gothic this time—is just steps away. *hoteldefrance-auch.com*

START HAPPY HOUR AT DAWN
The markets at Eauze (Thursday morning), Mirande (Monday morning), and Aire-sur-l'Adour (Saturday morning) are wonderfully preserved marvels of rural French life. Wander between tantalizing stalls of sausages and Tomme des Pyrénées before—like a true local—you allow yourself a bracing "morning tipple."

STAY LIKE A LOCAL, EAT LIKE A PRINCE
The rooms and catering at Descoubet farm provide the ultimate Gers experience. You may wish to fast for several days before your arrival. *ferme-descoubet.com*

HIKE OFF THE CALORIES
Use the hiking-specific guidebook *Le Gers à pied* to make the most of Gers's peaceful natural environment and cultural heritage. The book exists only in French—it is très French to speak only one language, after all—but the maps are easy for anyone to decipher. Pick up a copy in local bookstores or order online at *boutique.ffrandonnee.fr*

HAVE A CHURCH ALL TO YOURSELF
In the village of Mazères, make an appointment with Claude for a private visit of the twelfth-century fortified church on the banks of the Adour; he's an enthusiast who lives across the street and has a key to the church. Reservations: +33 (0)5 62 96 39 09

THE
VINTAGE
BOURGEOIS

ARE YOU

A LITTLE,

VERY,

INTENSELY,

MADLY,

OR NOT AT ALL...

VINTAGE BOURGEOIS?

Check the statements that most apply to you.

● "Never complain, never explain" is my motto. ● I love wearing pastel capris in summer. ● Mopping my plate with a piece of bread is a no-no. ● Self-control is an essential social skill (see above). ● I never wear white bathing suits. ● No cell phones for kids under sixteen. ● The nuclear family is sacrosanct. ● Pope Francis's anti-banking encyclical letter was a triumph! ● Lemon-scented finger wipes after oysters? Unthinkable. ● Red lingerie is vulgar. ● I cover my mouth when I yawn. ● Serve cold cuts straight from the package? Out of the question.

→You checked 7 to 12 statements. Whether you know it or not, you're a true Vintage Bourgeois. Read on to find out why.

→You checked 3 to 6 statements. You're nearly part of the (extended) family. Score some brownie points by devouring this chapter.

→You checked 2 or fewer statements. It seems you're neither Bourgeois, nor Vintage! All is not lost—just follow our advice.

BACKSTORY

The Vintage Bourgeois are the guardians of such expressions as "Bonjour, Madame" (Hello, ma'am), "Merci, Mademoiselle" (Thank you, miss), "Pardon, jeune homme" (Pardon me, young man), and "Je vous prie de m'excuser, chère amie" (Please excuse me, dear friend). Politeness costs nothing, after all.

Unrivaled since ascending to power in the nineteenth century, the Vintage Bourgeois (VBs for short) form the bedrock of French high society. Well educated, with good jobs, good manners, good neighborhoods, and good orthodontists, they embody classic national values, approved by generations of bourgeois before them. Like Proust's heroine Madame Verdurin, who topped off her bucket list by marrying a prince in *In Search of Lost Time*, they all dream of being part of the Aristo Chic family—minus the leaky roof, of course.

Rarely impressed—more likely irked—by bling and flashiness, they appreciate discretion, temperance, and close-knit circles. They're not likely to flaunt on Instagram their latest family vacation spent skiing in Val d'Isère or beachcombing in Brittany. Neither would they trade in their little Breton sailboat to water ski off Mauritius. Instead, they prefer traveling with close friends to places as yet untouched by mass tourism. They'll gladly clamber up mountain paths in the Southern Alps off-season for a cheese-tasting with the surly shepherd who made it. They also enjoy more spiritually minded journeys, and relish the chance to step back and reflect upon the whirlwind of our consumer era. Accompanying the sick on a pilgrimage to Lourdes is a favorite option. A soupçon of volunteer service is *de rigueur*; anything less suggests a distastefully selfish nature.

The Vintage Bourgeois may be free thinkers, but they prefer it if their children didn't range *too* freely. They monitor adolescent friendships via a series of evening events called *rallyes*, which operate a bit like a private club and provide a venue for social equals to get to know one another (membership starts in primary school). Regrettably, not even tuxedos and taffeta dresses can prevent certain, perhaps inevitable, excesses, dreaded by the mothers who host these affairs. Breathe a sigh of relief: stories about that time Blandine or Charles narrowly escaped falling into an alcoholic coma will never leave the confines of their elite polo club. Phew!

Vintage Bourgeois children are brought up with manners that seem old-fashioned to most: they're the first to give up their seats on public transport to elderly women while others pretend to be absorbed in a riveting game of Candy Crush. Their respectful "Bonjour, Monsieur" when getting into a taxi often takes the driver by surprise. They are taught to not interrupt adults, to clean their room, to wash their hands before dinner,

HUMOROUS ICONS

Valérie Lemercier and Bertrand Burgalat: The first is a comedian with a fine line in satire, while the second performs refined pop, clad in a suit fit for a provincial preacher; both navigate bourgeois conventions with brio.

TRADITIONALIST ICON

Alain Finkielkraut: This controversial philosopher and intellectual tirelessly champions the notion that "Things were better before" and advocates for the preservation of the French language. He never bows to political correctness.

The great actors Jean Rochefort (*Ridicule*), Philippe Noiret (*Cinema Paradiso*), and Jean-Pierre Marielle (*The Da Vinci Code*)— these irreverent, elegant, and cultivated figures from the 1960s and 1970s represent the France that existed before the rise of the Internet. It was a time when having a memorable voice was more important than physical appearance— or online presence.

and to make do with water instead of soda (which will only ruin their teeth). When mixing with the VBs, you'd do well to stay on your best behavior!

The VBs "take breakfast," they "lunch," and they "dine," but they never, ever simply "eat." "Only animals *eat*," is the usual response should a child forget this crucial linguistic rule. Meals are important, and are shared sitting down, at the table, among family or friends. Foraging around in the fridge for a random snack is not an approved method of sustenance, but rather a sign that the family unit is dissolving into a crude and selfish state of "every man for himself." "This is not a hotel!" is a favorite VB reproach, flung at teenagers who have the impudence to take breakfast at 2 p.m.

VB moms carefully monitor their children's academic performance. High standards are expected: they'd better be good at math, the jewel in the crown of any French education. They must also be bilingual—a rarity in France—and are regularly packed off to boarding school in England or entrusted to foreign babysitters—modern versions of the old-fashioned *jeune fille au pair*, who teach them Chinese or Japanese under the guise of after-school games. Such fun! In fact, education is the only area spared from this family's legendary frugality. After earning their diplomas (with honors, of course), it goes without saying that gaining entry to one of the prestigious Parisian schools is far preferable to an ordinary university. For VB parents, a child's successful education is a badge of honor. Then they can humblebrag at socialite dinners about Laure or Alban's new job at Louis Vuitton.

The French like to make fun of this tribe's reputation for resistance to change. However, much to everyone's amazement, they've actually produced a few well-known "revolutionaries," including Brigitte Bardot, Françoise Sagan, and Yves Saint Laurent. An impressive disregard for convention has been known to break through their well-heeled demeanor. Therein lies the paradox of the Vintage Bourgeois: there's fire burning under that icy carapace!

THE VINTAGE BOURGEOIS

CODE OF CONDUCT

A few clues to help you decrypt the Vintage Bourgeois lifestyle that may, at times, leave you scratching your head.

"PM" (pour memoire, or reminder)

This rather useful custom consists of sending a message the evening before a dinner party—text messages are tolerated, if not exactly encouraged—reminding guests of an invitation received several weeks earlier. Boring but necessary details (parking, door code, etc.) are included. Now there's no getting out of it.

"EV" (en ville, or "in the city," written on an envelope)

These mysterious initials are written on the bottom-right corner of a letter when you leave it directly in the recipient's mailbox or with a neighbor. No stamp is needed—just stamina, good walking shoes, and a certain amount of leisure time.

"PAM" (pas avant le mariage, or "not before marriage")

This frustrating diktat still drives some couples to marry very young. Their hastiness may also imply that a "JMJ" (*Journée Mondiale de la Jeunesse*) baby is on the way, no doubt conceived PAC (*Pas Avec Capote*, or "without a condom") during the annual get-together for Catholic youth.

I'D RATHER DIE THAN ...

Skip Christmas Mass

Lick my knife

End up with the Q in Scrabble ...

Leave dog poop behind, even in a deserted street

... or worse, lose at bridge!

Jump the metro turnstile

Let someone snatch my copy of *Figaro* magazine off the doorstep

Wear too much Guerlain Terracotta perfume

Name the newest arrival "Kevin" or "Neymar"

Fail to sell out of sponge cake at the school bake sale

Wear tennis socks with a pair of Church's

Turn the heat on before December 15

THE VINTAGE BOURGEOIS: A FASHION ICON

LITERARY ICONS

Roger Martin du Gard:
The magnum opus
of this Nobel-Prize-
winning author, *The
Thibaults*, a masterful
saga depicting the
French bourgeoisie
from 1922 to 1940,
can be found on every
VB family's bookshelf.

The Countess of Ségur:
Her stories of naughty
and nice little girls
have made her the
star of well-educated
nurseries since 1860.

POSTWAR ICONS

Claude Sautet and
Claude Chabrol:
No one knew better
than these cult
filmmakers how to
capture the postwar
period known as
Les Trente Glorieuses
and its bourgeoisie.
Stéphane Audran,
Claude Chabrol's wife,
perfectly embodied
the role of wife of
a famous 1970s
eccentric, both
onscreen and in
real life.

Did Saint Laurent break with convention by creating a distinctive, iconic wardrobe for bourgeois women just because he found them unbearably dull? It's tempting to think so! Saint Laurent borrowed from the masculine wardrobe for his womenswear, following Coco Chanel's lead (on her quest to refine women's clothing, she nabbed the idea for her famous little tweed jacket from her lover the Duke of Westminster). In 1966, YSL dropped a fashion bomb: Le Smoking, a tuxedo suit for women, caused an immediate sensation. Women couldn't wait to snatch it up, despite the law forbidding them to wear pants—and a good thing they did, since the law wasn't repealed until 2012(!). Reissued and reinterpreted to death, the YSL tuxedo suit was immortalized in 1975 by Helmut Newton in a photo full of sapphic undertones for *Vogue France*. The newly emancipated bourgeoise, with impeccable hair and understated makeup, also liked to play it cool in little trapeze-cut schoolgirl dresses, sober, military-inspired jackets, and seemingly prudish silk ascot blouses. Luis Buñuel's film *Belle de Jour* (1967) subverted the archetype of the VB ice maiden even further. Sporting a now legendary black schoolgirl dress with white collar and cuffs (designed, naturally, by YSL), the main character, a modern Madame Bovary, played by Catherine Deneuve, goes looking for thrills by becoming a prostitute. Thus a fantasy was born, and the image of Catherine Deneuve's face and blond hair has haunted the collective imagination of the French bourgeois ever since.

Even today, the timeless Vintage Bourgeois look continues to inspire creators. Fashion designers Guillaume Henry and Christophe Lemaire regularly borrow from the VB wardrobe, seemingly conventional but simmering with ambiguity, and houses including Maison Margiela and Louis Vuitton have been known to raid Madame's closet for ruffles, blazers, and impeccable A-line suits. After all, knowing the good places to shop is

a family tradition (among the boys, too), so you can trust their expertise and talent for giving a twist to any classic dress code. Kim Kardashian can't hold a candle to the Vintage Bourgeois, because, as the connoisseurs know, nothing is sexier than a VB woman in a camel trench coat and pencil skirt. Right, Madame Carine Roitfeld?

THE VB "FORGET ME NOT" LABEL PAR EXCELLENCE

Created in 2015, the Vanessa Seward fashion label reconnects with the time-honored values of the sexy bourgeois woman, striking a balance between suggestiveness and restraint, a line too subtle for the Modern Bourgeois (you'll meet her in the following chapter), who insists on wearing short dresses and slim jeans. The entire 1970s Paris Right Bank wardrobe—silk necktie blouses, elegant knee-length dresses in printed silk, pencil skirts, and high-heeled sandals—gets a modern twist with updated cuts and materials. The eponymous, very smartly dressed founder, who has also supplied designs for Azzaro and A.P.C., has always championed this discreet but torrid version of ultra-femininity. The mid-rise "Alabama," a flattering straight-leg jean, is already a cult favorite among thirty-somethings in Paris.
vanessaseward.com

VINTAGE BOURGEOIS "MUST HAVES"

What's the fastest way to put down roots?
Channel your inner VB with these well-heeled
accessories.

① GLOVES

The ornamental glove comes straight
out of the ninth century, when it formed
part of a bishop's vestments, like the
miter or the cross. Eventually, it became
a heavily ornamented accessory favored
by the aristocracy—Anne of Austria was
said to have owned a staggering 347
pairs—and a man would throw his glove
in the face of his rival when a young
lady offered hers to a suitor. During
the mid- to late nineteenth century,
French society women never ventured
out with bare heads or hands, and right
up until the 1960s ladies never went
anywhere without their gloves, except
perhaps to visit friends. The cigarette
posed a thorny problem: gloves on
or off? Today, it is still common to
run into cantankerous old ladies
who refuse to take public transport
without their leather gloves. And who
can blame them?

THE ICONIC BRAND: CAUSSE
Maison Causse, founded in 1892
in Millau, the original home of the
lambskin glove, prospered until the
revolutionary summer of 1968, when
people began to demand the overthrow
of bourgeois accessories. Acquired by
Chanel, the company was revived in the
1990s, as the French luxury industry
boomed. Still based in Aveyron, it
supplies chic Parisian ladies as well
as international stars: Sharon Stone,
Madonna, and Karl Lagerfeld are all
loyal fans.

causse-gantier.fr

♥ WE LOVE …
the "Victoria," a magnificent women's
glove in glazed lambskin. Choose the
midnight blue if you're aiming for a classic,
pared-down look, although more exotic colors
are available.

② SCENTED SOAP

Soap has had a turbulent history in France. Popular in the Middle Ages, when (contrary to popular belief) people enjoyed a good scrub down in the nearest river, its role was usurped by perfume during the Renaissance. The rise of bourgeois values in the nineteenth century, when cleanliness and hygiene became supposed indicators of good character, contributed to a booming soap industry. Its capital, Marseille, is home to dozens of soap factories and just as many brands. Chemistry and globalization may have changed many things, but a true VB still prefers refined bath soap in pleasantly outdated fragrances like violet and vetiver.

THE ICONIC BRAND: ROGER & GALLET

Created in 1862 by two astute brothers-in-law, the Roger & Gallet company quickly earned a reputation throughout the royal courts of Europe for its Jean-Marie Farina Eau de Cologne. Made with natural distilled essences, it was popular as a perfume, but also as an antiseptic in the days before bathrooms (a quick rubdown with a cologne-soaked sponge à la Pepé le Pew and you were good to go!). Napoleon III was crazy about it and had a special vial made that he could slip into his boot. The company's round soaps were an early hit: perfumed all the way through, they retained their fragrance right up to the very last lather. The elegant marketing—and that legendary pleated tissue-paper packaging—is wholesome enough to captivate the sternest VBs (and others, too). Pharmacies in chic neighborhoods always have some in stock.

roger-gallet.com

♥ WE LOVE ...
the Jean-Marie Farina soap, obviously. Its notes of Mediterranean citrus make it the most iconic of the company's fragrances.

③ FLORAL EARTHENWARE

The forty-five-piece white, flowered dinner set is the guest of honor at every bourgeois table. Often less fragile and easier to work with than porcelain, and more affordable as a result, earthenware debuted under Louis XIV. From the nineteenth century to the 1930s, it earned pride of place at respectable tables. Though it fell into disuse following the onslaught of Nordic and minimalist design, millennials have revived it, reassured by its "granny chic" effect.

THE ICONIC BRAND: GIEN

Gien was founded in 1821 by an Englishman in the eponymous city on the banks of the Loire, where the raw materials and forests for making and firing earthenware were available. The Faïencerie de Gien, the largest earthenware manufactory in Europe, ruled in VB dining rooms until 1914. Gien also created the iconic Paris subway tiles in 1930. After a period of difficulty, the company, classified as a "Living Heritage" brand by the French government, bounced back around 2014 by collaborating with a number of artists and fashion designers. The "Rouen Fleuri" (in blue or red) and "Tulipes Noires" (Black Tulips) designs remain unequaled classics.

gien.com

♥ WE LOVE …
the little "assiettes canapés" (hors d'oeuvres plates) with personalized initials—a small consolation for those unable to afford the hand-painted designs prized by wealthier collectors.

④ THE NECKTIE

Louis XIV gave his seal of approval to the scarves worn so elegantly by the Croatian hussars recruited by his father. In fact, the French word for tie, *cravate*, derives from the word for Croatian, *croate*. A taste for a lace-embellished version spread throughout aristocratic Europe. Later taken up by eighteenth-century dandies and then the affluent classes of the following century, the necktie represents just the sort of understated formal attire the VBs adore. During an after-work dinner with friends, men still ask the lady of house permission to untie this symbol of good manners. So retro!

THE ICONIC BRAND: CHARVET

Opening in 1838, this historic Parisian shirtmaker practically invented the men's fashion boutique. Its famed shirts clothed Baudelaire, Manet, and even George Sand, who also shopped here for her lover Alfred de Musset. All the crowned heads of Europe and French politicians are regulars here, and Charvet's printed silk ties are legendary. Marcel Proust would spend hours choosing just the right shade of pink, and painters like Raoul Dufy contributed to the more flamboyant styles. Though the designs have mellowed in recent years, they remain a Father's Day gift appreciated by the upper crust, with silk knot cufflinks a nice choice for more modest budgets.

28, place Vendôme, Paris 1er

♥ WE LOVE ...
the neckties available in thousands of styles. To visit the boutique (there's no online store—heavens no!) is to dive into a bygone world of classic elegance.

⑤ THE MOCCASIN

The French discovered the hide shoes known as *mekezen* worn by indigenous tribes when they founded New France in North America in the seventeenth century. The Norwegians and English still disagree over who invented the modern version. Be that as it may, the moccasin achieved celebrity status in the 1920s when Georges Bass, a hunter in Maine, introduced his version. Popular with Ivy League students, it soon captivated Europe as well. Considered a sports shoe, it is never worn with a dress suit. You have been warned!

THE ICONIC BRAND: J. M. WESTON

Founded in 1891 in Limoges, this French luxury shoe company, official supplier to the French Republican Guard and Gendarmerie, is reputed for its Goodyear welted soles, imported from the United States. After the Liberation of France, the brand's founder created a moccasin intended to rival staid derby and brogue shoes. He had a huge hit on his hands: his moccasin was an absolute must-have throughout the 1960s. Barefoot in his "Mocs," Alain Delon oozed charm in the 1960 film *Purple Noon*. Weston's 180 moccasin—renamed the "Janson-de-Sailly," in homage to the high school in Paris's upscale sixteenth arrondissement frequented by Weston's most loyal clients—became a sine qua non: whether flirting or dancing, posh fashion victims never left the house without them. The French president François Mitterrand had over thirty pairs. It's safe to say that moccasins are more than a fashion statement—they're a VB legend.

jmweston.com

WE LOVE ...
The unisex Moc in ocean blue or turmeric yellow.

⑥ THE POLO SHIRT

Until the 1920s, tennis players battled it out in the same white, long-sleeved, thick cotton shirts worn by polo players. In addition to being uncomfortable and impractical, they were extremely hot. This inspired a lighter, short-sleeved version in cotton piqué that eventually conquered the world. Appearing preppy on tidy middle schoolers and threadbare on their regatta-loving grandfathers, intentionally sexy on high-school girls with swinging blond pony tails and perfectly starched on their tan forty-something mothers, the polo shirt is the preferred casual wear item of the traditional French bourgeoisie. Dress-down Fridays just wouldn't be the same without it. Of course, it goes without saying that the collar should never be turned up, even if certain tacky bad boys occasionally give it a try.

THE ICONIC BRAND: LACOSTE

The Lacoste shirt was popularized in 1927 by René Lacoste, one of the "Four Musketeers," a group of French tennis players who dominated the game in the 1920s and 1930s. The shirt was unique in that its jersey neckline protected players from the sun. In 1933, after retiring from the game, René teamed up with André Gillier, a leader in the French hosiery industry (and the grandfather of the founder of fashion brand Zadig & Voltaire); together they launched what was to become the beloved polo shirt. In the 1950s, this multi-generational piece was made available in a variety of colors, but kept its famous crocodile logo, inspired by René's nickname, "the Crocodile," from when he was a tough-skinned champion.

lacoste.com

WE LOVE …
the L.12.12 polo, in navy blue, of course.

THE GOURMET VINTAGE BOURGEOIS

Despite repeated attacks by that hybrid monstrosity called brunch, Sunday lunch remains a defining moment of the VB week. It reunites the household, electronic devices switched off, wrists resting politely on the table. The roast chicken, introduced under Louis XVIII and successor to King Henry IV's beloved *poule au pot* (stewed chicken), is no longer the holy grail. However—since this may be the only time students get a square meal each week—the menu features meat: perhaps a side of beef, a leg of lamb or, less commonly, roast beef (which fell out of fashion in the 1970s, along with the electric knife). Vegetarian VBs are few and far between.

Except when invitations come from nonagenarian grandparents wedded to the sacrosanct 12:30 p.m. rendezvous *à table*, the start time has become much more flexible: accommodation must be made for the *djeuns* (teenagers) who went to bed late, and for the younger siblings returning muddy and famished from the morning's scout outing. So everyone sits down to lunch late, casually dressed but well groomed. On the way back from a run, one of the parents will have purchased a warm *tradition* baguette and a Sunday dessert—likely something with puff pastry and cream. The best classic pastries, from the *religieuse* to the Paris-Brest, not to mention the *baba au rhum*, have been revived and reinvented by an enthusiastic new generation of pastry makers, so there's no excuse not to indulge.

But even more important than the menu is the chance for everyone to debrief on the events of their week: an annoying exercise for the youngest, but a precious lesson in perfecting their ability to avoid speaking with a mouthful of food—a vital skill in well-to-do circles.

THE VINTAGE BOURGEOIS HACHIS PARMENTIER (SHEPHERD'S PIE) RECIPE

Serves 4
Ingredients
→ 1 carrot
→ 1 celery stick
→ 1 onion
→ 1–2 tbsp olive oil
→ 2¼ lb. (1 kg) ground beef
→ a few sprigs of thyme
→ 2–3 bay leaves
→ salt and pepper, to taste
→ 2¼ lb. (1 kg) potatoes
→ 1 stick (100 g) butter
→ ½ cup (100 ml) heavy cream
→ dried breadcrumbs

Method
❶ Sauté the finely diced vegetables in olive oil until soft. Add the meat and herbs; stir until brown. Simmer on low for at least six hours until the meat absorbs nearly all the liquid.
❷ Preheat oven to 350° F (180° C).
❸ Boil the potatoes until tender. Mash with butter and cream.
❹ Remove the bay leaves and transfer the beef to an ovenproof dish. Top with mashed potatoes and bake for about 15 minutes. Sprinkle breadcrumbs on top for added crunch and bake another 5 minutes.
❺ Serve hearty helpings, and enjoy (just try to keep the noise down as you gobble it up!).

THE BEST SUNDAY TREATS IN PARIS

THE PARIS-BREST BY JACQUES GENIN

This tire-shaped pastry was created to celebrate the Paris–Brest bicycle race (everything is an excuse for a feast in France). A self-taught pastry chef and high-flying chocolate maker, Jacques Genin revisits the classics, adding his own special touches. His *pâtes de fruits* (fruit jellies) in flavors like black currant, rhubarb, blood orange, and the more adventurous beet, pepper, fennel, and cucumber, are simply mouthwatering.
27, rue de Varenne, Paris VII^e
133, rue de Turenne, Paris III^e
(chocolate only)
jacquesgenin.fr

THE SAINT HONORÉ BY ARNAUD LARHER

Invented in 1847 by Maison Chiboust, a pastry maker located on—you guessed it—rue Saint-Honoré in Paris, the Saint Honoré is one of the great classics of French pastry tradition. It is often referred to as a "Saint Ho" (pronounced "Sainto") by VBs. This version, created by a pastry chef who gained "Master Craftsman" status in 2007, is famous throughout Paris.
53, rue Caulaincourt, Paris XVIII^e
arnaudlarher.com

THE *BABA AU RHUM* AT UN AMOUR DE BABA

Legend has it that the King of Poland, Stanislas Leszczynski, father-in-law to Louis XV, found his *kougelhopf* too dry and so doused it in wine. But it was in 1835 that this indulgent dessert went down in a shower of rum, thanks to pâtissier Nicolas Stohrer. Un Amour de Baba serves nothing but this cake, reinterpreted in a thousand different ways with a globetrotting list of ingredients, including Martinique rum, Irish coffee, mascarpone, and hibiscus. Who could resist such tasty temptation?
179, rue du Faubourg-Saint-Honoré, Paris VIII^e
unamourdebaba.fr

Cyril Lignac's *baba au rhum* is also a bestseller, famous for its billowy Bourbon-vanilla whipped cream.
2, rue de Chaillot, Paris XVI^e
gourmand-croquant.com

THE *MILLE-FEUILLE* AT KL PÂTISSERIE

Supposedly invented in the seventeenth century by François Pierre de La Varenne and perfected by pioneer of French haute cuisine Antonin Carême, the *mille-feuille* owes its name to its many folds of flaky pastry layered over vanilla pastry cream. Kevin Lacote (Monsieur KL himself) assembles his version at the very last minute in order to keep the barely sweetened cream fresh and airy. The pastry shop is also a tea room, and Wednesdays are reserved for churros. You've been warned!
78, avenue de Villiers, Paris XVII^e
klpatisserie.com

"COLLECTOR CAKES" FROM FOU DE PÂTISSERIE

Julie Mathieu and Muriel Tallandier, founders of the pastry fanzine *Fou de Pâtisserie*, decided to give their readers a treat by curating a selection of Paris's best cakes all in one shop. You'll find bestsellers by renowned pastry chefs like Jacques Genin, Philippe Conticini, Hugues Pouget, Christophe Adam, Jonathan Blot, Cyril Lignac, Yann Brys, Pierre Hermé, and Gilles Marchal. Now here's a concept store for your sweet tooth!
45, rue Montorgueil, Paris II^e
36, rue des Martyrs, Paris IX^e

THE *RELIGIEUSE* PASTRY BY STOHRER

The oldest pastry shop in Paris was founded in 1725 by a Polish pastry maker who followed Marie Leszczynska, the young wife of Louis XV and daughter of the King of Poland, to Paris. The shop still retains its striking interiors and aura of a bygone era. Its *religieuse*, generous enough to serve ten, is a cult classic at family reunions. The four-serving *puits d'amour* is another paradigm of pâtisserie that just happens to be perfect for sharing. Between two. If absolutely necessary.
51, rue Montorgueil, Paris II^e
stohrer.fr

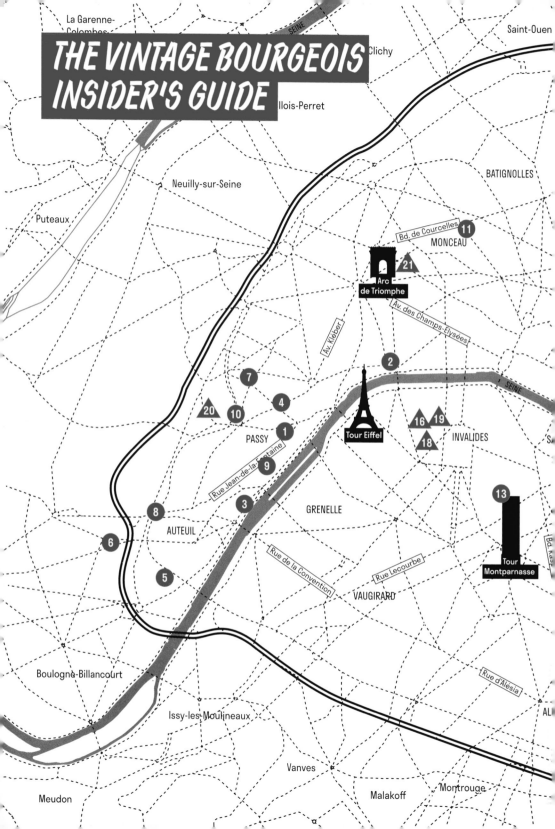

THE VINTAGE BOURGEOIS
INSIDER'S GUIDE

THE VINTAGE BOURGEOIS IN PARIS

During the nineteenth century, deeming the northern part of the sixteenth arrondissement too nouveau riche and overrun with tourists (especially following the construction of the Eiffel Tower), the VBs began to settle down in the older villages of Auteuil and Passy. They weren't the first to do so: what was once a quiet, bucolic corner of countryside on the outskirts of Paris was already so sought-after in the seventeenth century that Molière, and later Balzac, had settled there to escape the hubbub of the capital. The forests, vineyards, and farms have all since disappeared, but a few private hamlets and villas surrounded by trees still remain, hidden from prying eyes. The neighborhood is rich in museums and charming old-fashioned homes but generally criticized by Parisians as being dull and uptight. That's sometimes true. And often false. Proof? The Grande Épicerie de Paris Rive Gauche, a shrine to the purest form of food snobbery, set up shop there in November 2017, ushering in a new kind of neighborhood pride. The area is now fashionable, and even described as "cool," to the great astonishment of the Vintage Bourgeois, who pretend not to notice but are nonetheless flattered by the designation.

THE PERFECT VINTAGE BOURGEOIS LANDMARK?

① BALZAC'S HOUSE, which offers a glimpse of what this neighborhood was like in the nineteenth century. When badgered by his creditors, Balzac would escape by a secret door in the back of the garden that still surrounds this unusual little museum.
47, rue Raynouard, Paris XVIᵉ
maisondebalzac.paris.fr

OUT AND ABOUT WITH THE VINTAGE BOURGEOIS

The Vintage Bourgeois know the sixteenth like the back of their hand. Occasionally, and with caution, they have even been known to venture beyond its borders.

IN THE SIXTEENTH ARRONDISSEMENT

② GET YOUR "DENEUVE" ON at the Musée Yves Saint Laurent Paris, established in the former Saint Laurent fashion house. This institution, located on historic ground, celebrates the designer who catapulted the bourgeois woman to the status of international legend.
5, avenue Marceau, Paris XVIᵉ

PRACTICE YOUR TABLE MANNERS at a number of tradinomic restaurants where the design is relaxed, the table set *à la française*, and the food just right, based on a selection of carefully sourced products. The Comice and La Causerie, whose retro-sounding names belie genuine modernity, are worth a detour.

③ → Comice
31, avenue de Versailles, Paris XVIᵉ
+33 (0)1 42 15 55 70
comice. paris

④ → La Causerie
31, rue Vital, Paris XVIᵉ
+33 (0)1 45 20 33 00
lacauserie.fr

LOOK UP AS YOU WANDER among the area's majestic caryatid columns, Hector Guimard's art nouveau fancies, Mallet-Stevens's deco experiments, the bold lines of modernist Auguste Perret, mysterious private alleyways, and several architectural gems from the 1960s, like the Maison de la Radio. Arrange a themed tour with a guide; you'll be glad you did.
lecercleguimard.fr
paris-promeneurs.com
unjourdeplusaparis.com
maisondelaradio.fr

LOOK FOR THE NEW PARISIAN BROOKLYN in Village Boileau, on the south side of the sixteenth, the new post-hipster spot, according to the experts. The Holiday Café and clothing store of the same name draw fashion magazine editors from across the city. A chic secondhand clothing shop and a quality grocer have joined the precursors. Other visitors will appreciate the vast art deco spaces like the Molitor hotel, quirky working-class housing blocks, and the melancholy charm of this area generally, where few tourists venture.

5 → Le Holiday Café
192, avenue de Versailles, Paris XVI^e
+33 (0)1 42 24 90 21
holiday-magazine.com

→ Le Village Boileau
You'll find lots of information about the village at franckdurand.com, under the "Plus" section.

6 → Hôtel Molitor Paris
This former art deco swimming pool has become a luxury hotel and spa—there's yoga, too!
10, avenue de la Porte-Molitor, Paris XVI^e
mltr.fr

SPY ON THE INVADER at the l'Hôtel Brach, a hotspot concocted by Philippe Starck in a former mail sorting center, which manages to attract elegant tourists to this sleepy residential neighborhood. Live out an ultimate fantasy by getting yourself invited up to the rooftop.

7 → 1–7, rue Jean Richepin, Paris XVI^e
+33 (0)1 44 30 10 00
brachparis.fr

RISE ABOVE IT ALL by drinking with the gilded youth on the rooftop of the very "jungalow" Auteuil Brasserie. Or get down with eclectic musicians at the Belair, the third-floor bar at the Maison de la Radio, complete with a small dance floor and a spectacular view of the Front-de-Seine neighborhood. YSL would have approved.

8 → Auteuil Brasserie
78, rue d'Auteuil, Paris XVI^e
auteuil-brasserie.com

9 → Le Belair
Open until 2 a.m. following performances at the Maison de la Radio.
116, avenue du Président-Kennedy, Paris XVI^e, *maisondelaradio.fr*

10 TALK OVER TEA ON THE CHAUSSÉE DE LA MUETTE, devouring the best puff pastries in Paris at Yamazaki, a long-established Japanese pastry shop, or while admiring the ballet of fur-clad beauties at the Rotonde de la Muette. This

brasserie boasts spectacular interior design, revisited by the renowned design duo Roman and Williams, who oversee the Ace Hotels and The Standard in New York.

→ Yamazaki
6, chaussée de la Muette, Paris XVI^e

→ Rotonde de la Muette
12, chaussée de la Muette, Paris XVI^e
+33 (0)1 45 24 45 45
en.rotondemuette. paris

BEYOND THE SIXTEENTH (IF YOU DARE)

11 EXPLORE VANISHED SPLENDOR IN THE MONCEAU NEIGHBORHOOD, favorite with the nineteenth-century Jewish bourgeoisie. The Musée Nissim de Camondo, a marvelous 1911 *hôtel particulier* inspired by the Petit Trianon in Versailles, houses the eighteenth-century collections of Moïse de Camondo, whose family was slaughtered in the concentration camps. The moving interiors exude an admiration for France and are filled with photographs of Nissim, the adored son, who was killed in World War I.
63, rue de Monceau, Paris VIII^e
lesartsdecoratifs.fr

12 PILLAGE FRENCH ABBEY TREASURES in the best place to find monastic craftsmanship in Paris. Look for the tipple the monks love to concoct when they're not saying their daily prayers. And the range of "power food," inspired by the work of Hildegarde de Bingen, tenth-century Benedictine nun, saint, and philosopher, is simply divine!
23, rue des Petits-Champs, Paris 1^{er}
comptoir-des-abbayes.fr

13 KICK BACK IN A PARK known only to local residents: the Catherine-Labouré garden, which looks much as it did in the seventeenth century, when it was an orchard and vegetable patch. You can picnic and sunbathe to your heart's desire on the vast lawns—a rare privilege in Paris. Open daily 8 a.m. to 9 p.m. in summer. Free entry.
29, rue de Babylone, Paris VII^e
equipement.paris.fr/jardin-catherine-laboure-2465

14 GET YOUR MAGNESIUM FIX at the oldest chocolate factory in Paris, À la Mère de Famille, where you'll also find marshmallows, candied chestnuts, caramels, and other irresistible candies. The historic boutique, unchanged since the early nineteenth century, exudes Belle Époque charm.
35, rue du Faubourg-Montmartre, Paris IX^e
lameredefamille.com

VINTAGE BOURGEOIS CONFIDENTIAL

THE BEST CHIC SPOTS IN WHICH TO ...

15 **GET YOUR BEATITUDE SLEEP:** This Parisian convent is a far more fashionable—and economical—option than some Scandi-chic Airbnb apartment. For a modest tithe, the Maison Rédemptoriste, a calm and welcoming establishment, has lovely rooms and studios to rent for two guests.
170, boulevard du Montparnasse, Paris XIVe
paris.catholique.fr/Hebergements-courts-sejours-et.html

16 **MEND YOUR WAYS, "SEW" EASILY:** Mercerie Madelaine, an institution in the chic seventh arrondissement, is run by a dedicated sewing enthusiast. Fans of embroidery, knitting, sewing, and other DIY projects will find everything they need, including ribbon, lace, designer buttons, sublime wools, and super-trendy sequined iron-on patches, as spectacular as they are inexpensive.
14, rue Cler, Paris VIIe

17 **INDULGE YOUR SWEET TOOTH:** Gérard Mulot, a decadent pastry shop near Place Saint-Sulpice, draws crowds of regular customers who line up to buy lovely brioches, sinfully good Florentine cakes, and one of the best strawberry cream cakes in Paris.
76, rue de Seine, Paris VIe

18 **GO PIE-EYED:** Indulge your cravings for wonderful pâté en croûte at Lastre Sans Apostrophe. This restaurant's version of the bourgeois classic, slices of meat pâté surrounded by puff pastry (which even has its own French and world championships), resembles an abstract painting. They've given vintage charcuterie a tempting makeover.
188, rue de Grenelle, Paris VIIe

19 **STAY COOL:** The beautiful fans made by Duvelleroy, founded in 1827, were brandished by all the crowned heads of Europe (Empress Eugénie and Queen Victoria were loyal customers). The brand has been revived by two enterprising young women and keeps the front rows of Paris Fashion Week refreshed, as well as modern young ladies sweltering in the heat of the Paris metro.
17, rue Amélie, Paris VIIe

20 **KID AROUND:** Watch the Guignol puppet show in the Jardin du Ranelagh, the best show in Paris and a favorite for generations. Don't forget to take a ride on the nineteenth-century wooden carrousel. The Jardin du Ranelagh, which was opened to the public in 1860, includes a family-friendly walkway that leads to the Bois de Boulogne.
1, avenue Prudhon, Paris XVIe

21 **PRETEND YOU'RE A NINETEENTH-CENTURY COLLECTOR:** In Baron Salomon de Rothschild's sumptuous cabinet of curiosities, you'll fine jade, porcelain, weapons, miniatures, and sculpture. Established prior to 1860 and later moved to the Monceau neighborhood by his widow, it is open by appointment only, providing a wonderful opportunity to discover a luxurious home decorated in cordoba leather, stained glass, and tapestry.
11, rue Berryer, Paris VIIIe
Reservations: +33 (0)1 71 93 75 55
hotelsalomonderothschild.com

THE VINTAGE BOURGEOIS ONLINE

The best online stores for brushing up on the classics from the comfort of your own home.

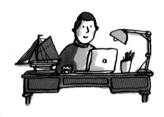

DELPHINE DELAFON
The iconic 1970s bucket bag is back and available in an infinite number of colors, customized in the workshop according to your wishes. Delphine Delafon launched her brand when she made the bag of her dreams. Her collection has since grown, and the original style is now in good company. *delphinedelafon.com*

CHATELLES
François du Chastel took a chance on the slipper—a functional flat that steps in somewhere between the classic moccasin and the slightly boring ballerina—and created his first pair to win over his sweetheart. She loved the slippers so much that she ran off with them. Unperturbed, the former banker became a slipper designer. Panther, patent, monochrome, or sequined, and infinitely customizable, Chastel's Chatelles seduce ladies both naughty and nice. *mychatelles.com*

GUÊPES & PAPILLONS
Remember the old saying about brushing your hair one hundred strokes a day to strengthen it and make it shine? Empress Sissi of Austria reportedly owed her incredible locks to this daily ritual, which has since become a thing of the past. This new "vintage" store stocks the same kind of horn and boar-bristle brushes that Her Imperial Highness used, along with all the hair accessories a chic lady could ever wish for. Everything is handmade, and you can ask to have your initials or a message engraved on the handle. *guepesetpapillons.fr*

MAISON F
How can you achieve the sensual allure of a VB style icon? Easy! Jazz up your blouse with an ascot. This designer tie maker stocks over eighty styles of bowties, neckties, and ascots to drape around your neck. *maisonf.com*

THE VINTAGE BOURGEOIS ON VACATION

HEAD STRAIGHT TO ... BRITTANY!

The Breton coast remains the summer fiefdom of the VBs. Healthy, sport-filled vacations in a bracing climate are their idea of a perfect time, even if they are touchy about the reality of the region's rainfall. The rest of France snickers at the average water temperature, but the VB pays no mind to their sarcasm, plunging in with a rapturous, "It's soooo warm!" when the water reaches a nippy 65°F (18°C). The VBs like to refer to their little slice of coast (with names usually ending in "ec" or "ech") as the "French Maldives." The comparison is not unwarranted, at least as far as the color of the water is concerned, and the sublime peace to be found at certain

beaches. A one-piece bathing suit for women and terrycloth robes to wrap up the little ones, blue from a prolonged dip, are essential. Swimming in a neoprene wetsuit is considered wimpy, however. To perfect your Brittany experience and warm up after a wonderful walk on a windy coastal path, headland, or plunging cliffs, you must:

SAVOR AWARD-WINNING FRENCH CRÊPES

Since nabbing the French National Crêperie Federation's Gold Medal in 2017, the family-run crêpe restaurant Mad'moiselle Breizh has become a cult destination. The classic buckwheat *complète* (ham, cheese, egg) is a winner, and the "Breizh Burger" with foie gras draws the hardiest of galette fans.
Reservations essential.
5, rue Charles-de-Gaulle, 29630 Plougasnou
+33 (0)2 98 79 92 25

MAKE A SPLASH

At the Grand Hôtel des Bains, a superb, renowned seaside establishment, you can enjoy the covered heated saltwater pool and observe the French bourgeois on vacation from behind your sunglasses (or umbrella). The pool is a definite selling point when you consider how bracing the ocean is.
15, rue de l'Église, 29241 Locquirec
+33 (0)2 98 67 41 02
grand-hotel-des-bains.com

LINGER ON THE WAY HOME

On your way back from the beautiful beaches at Dourveil and Kersidan, stop for an apéro and a few oysters or langoustines bursting with freshness at Laurent Publier, known for the quality of their raw produce. The view over the Aven is free, but it would be worth paying a supplement.
16, chemin des Vieux-Fours, Kerdruc, 29920 Névez
+33 (0)2 98 06 62 60

HAVE A BEER DOCKSIDE
(a popular local sport)
After visiting Névez, a Breton-speaking community located slightly inland, pull up a chair on the terrace outside La Châtaigneraie, just above Port-Manech with its row of tiny beach cabins. Order a pint of Sant Erwann made with seven grains—in Brittany, of course.
16, rue de la Plage, 29920 Névez
+33 (0)2 98 06 64 15

SMELL LIKE A SIREN

Initiates come to Lostmarc'h, the "ocean apothecary," for their rose, lavender, or verbena body creams made with pure water drawn from the Gulf Stream and locally harvested, active natural marine ingredients.
8, rue Sainte-Marguerite, 35400 Saint-Malo
+33 (0)2 99 40 62 50

CONTEMPLATE THE SEA FROM ON HIGH

The six television-free rooms in the Petit Hôtel du Large are the only ones on the Côte Sauvage to have a direct view of the ocean. Far from the crowds of vacationing tourists, the restaurant serves a rustic-refined maritime cuisine that alone is a worth a detour.
11, quai Saint-Ivy, 56510 Saint-Pierre-Quiberon
+33 (0)2 97 30 91 61
lepetithoteldugrandlarge.fr

FISH FOR A DISH

The classic Breton souvenir is a white earthenware bowl with blue handles, emblazoned with a name— Eugène, Germaine, etc.—on its side. This ceramic studio, which has created a buzz in French design magazines, also offers a range of funky bottles and plates decorated with colorful fish.
Atelier Valérie Le Roux
4, rue Duguay-Trouin, 29900 Concarneau
+33 (0)2 98 50 82 13

TAKE A BREAK FROM ALL THE OLD STUFF
(charming though it is)
Each summer, this foundation for contemporary art, established in a former Capuchin convent, hosts a large exhibit by a visiting iconic artist. Swapping shopping carts for culture, the foundation is the brainchild of the grandchildren of a national supermarket chain's founder.
Fonds Hélène et Édouard Leclerc pour la culture
Rue de la Fontaine-Blanche, 29800 Landerneau
+33 (0)2 29 62 47 78
fonds-culturel-leclerc.fr

THE
MODERN
BOURGEOIS

ARE YOU

A LITTLE,

VERY,

INTENSELY,

MADLY

OR NOT AT ALL ...

MODERN BOURGEOIS?

QUIZ

Check the statements that most apply to you.

● I'm in dire need of a "digital detox." Far away.
● My mother looks nonplussed when I mention my favorite barista. ● I only buy Chilean mineral water.
● I know each style of Isabel Marant's boots by name. ● My sitting room has more greenery than the Jardin des Plantes. ● Cap Ferret is way cooler than the Hamptons. ● My husband's underwear is all "Made in France." ● The name of my youngest child is tattooed behind my ear. ● I sponsored the planting of a truffle oak. ● I acquired all of my grandmother's vintage stoneware pots.
● If I indulge in a mojito, I do so mindfully.
● I have a crush on my surf instructor.

→You checked 7 to 12 statements. You are a Modern Bourgeois, whether you realize it or not! There are sure to be a few things you still need to know about your family, so read on.

→You checked 3 to 6 statements. Are the Modern Bourgeois still a mystery to you? Get to know them better, they're definitely worth it.

→You checked 2 or fewer statements. Not very Modern Bourgeois at all? Don't panic! You're about to discover the pleasant and particular habits of this tribe, along with their favorite hangouts.

BACKSTORY

"It is easier for a good worker to become a good bourgeois than for a good bourgeois to become a good worker."

—Georges Wolinski

We have the Modern Bourgeois to thank for the drastic increase in rents in eastern Paris, Basque Espelette pepper sprinkled on everything, superstar pastry chefs, and outrageously expensive feather-trimmed cashmere sweaters.

ZE FRENCH DO IT BETTER

Cousins of the Vintage Bourgeois, the Modern Bourgeois—or "MoBos" for short—pretend not to know their stuffy relations and prefer a more laid-back lifestyle, though the schism is more cultural than material. In abandoning the VBs' close-knit community, the MoBos have discovered a wider world and incorporated practices into their lifestyle that their traditional kin would find highly exotic. The appearance of the now ubiquitous Italian *burrata* cheese in French households, for example, was their doing. This open-mindedness, however, does not stop them from adhering to other, equally important conventions.

This "Colette generation," brought up on the now-defunct but legendary concept store and others that followed, is always a little ahead of the curve, chasing the latest trend just before the previous one goes too mainstream. MoBos have a particular fondness for what is known as "premium French": fashion labels that may not be completely luxury-level but are completely expensive—and completely interchangeable. To add a personal touch to their style, MoBos sprinkle just the right amount of hand-picked second-hand finds throughout their wardrobes—creating a kind of "effortless chic" that the rest of the world envies. Indeed, they're often fashion influencers: in the last ten years, they've managed to trigger a mass embrace of single-thread cashmere sweaters stamped with skulls or cannabis leaves, white Stan Smith sneakers, 120-euro solid-color T-shirts, foie-gras sushi, truffle chips, and the Louis Vuitton City Guides. Despite this insatiable appetite for novelty, they have not abandoned the basics: like many of their compatriots, they will still fight valiantly for the *tradition* baguette to be added to UNESCO's Intangible Cultural Heritage list.

Unlike their Vintage Bourgeois counterparts, the Modern Bourgeois have no reservations about entering unconventional occupations. Women are known to abandon lucrative jobs in PR to take up interior decorating or open a high-end deli or juice bar in a chic neighborhood. As for the men, if they were given the chance to choose any career they wanted, they would ideally do something involving made-to-measure masculine footwear or collectible vintage timepieces. The youngest members of the tribe willingly put years of business school to use working for humanitarian causes, returning to mom and dad's house to party in the summer. This idealism arises from the MoBos' desire to give their children a relaxed education. Hoping to spare their

UNTOUCHABLE ICONS

The MoBo pantheon encompasses singer Serge Gainsbourg, actress Jane Birkin, director Jacques Doillon, and their kin singer/actress Charlotte Gainsbourg and singer/artist Lou Doillon, as well as actress Sophie Marceau and singer/ actress Vanessa Paradis. The MoBos grew up with them, after all. Honorary members like pop stars Étienne Daho and Benjamin Biolay receive the same generous approval.

MUSICAL ICONS

Daft Punk: They quite simply saved the country's musical honor. "French rock is like English wine," teased John Lennon— but the whole world gets down to French electronic dance.

offspring the stress they endured, they favor alternative schooling founded on self-fulfillment, preferably the Montessori or Steiner institutions. Paradoxically, this sense of fulfillment includes ownership of costly high-tech objects from a very young age—the kind of lavish display that makes the Vintage Bourgeois shudder. To spare their spoiled children the hell of taking entrance exams for the top French schools, MoBos send them instead to the London School of Economics or Milan's Bocconi School of Economics, Management, and Law—after calling on the services of a "study abroad" coach to help ease the transition.

Judging the tony sixteenth arrondissement too dull, poor things, and Saint-Sulpice too expensive, this group has migrated toward formerly working-class neighborhoods. Though they fall short of fully integrating with their neighbors, at least they manage to cohabit the neighborhood; and that's not too shabby in a French society known for its inertia. Their choice of *quartier* gives them the frisson of slumming it while preserving the easy lifestyle they're used to. They like to remodel vast, aging apartments, old studios, and erstwhile industrial spaces with custom furniture and polished concrete, and to rub elbows with the young designers, new restaurants, and luxury brands that now occupy areas hitherto unexplored by the bourgeoisie. For this reason, the presence of MoBos is an irrefutable indicator of rising property values.

Early adopters of everything digital, MoBos are Instagram addicts who haven't quite given up Facebook, despite its takeover by eccentric childhood friends and cat videos. Ever since Sophie Calle's contemporary art exhibition at the Musée de la Chasse, MoBos have been posting snapshots of museum visits, evenings at the Paris Philharmonie concert hall, and their table at the Palais de Tokyo's annual gala. Saturday outings to the Fondation Louis Vuitton with little Eugène and Françoise (such grandiose nineteenth-century names!) are prized. Wednesday workshops at the Musée des Arts Décoratifs are full of children who, by age seven, can differentiate between Matisse and Picasso. The MoBos' favorite artists include Louise Bourgeois, Jean-Michel Basquiat, Damien Hirst, Pierre Soulages, and African photographers Malick Sidibé and Seydou Keïta. Naturally, catalogs from the latest exhibitions are prominently displayed on the coffee table.

SHARP-EYED ICON

Yasmina Reza: Although she points an ironic finger at MoBo idiosyncrasies, this author and playwright is a favorite among the more internationally minded of the family.

PARTY BOY ICON

Frédéric Beigbeder: This dilettante author of well-structured autobiographical novels is also known for his love of partying, illicit substances, and young women. MoBos look to him for clever turns of phrase.

CODE OF CONDUCT

Here are a few tips for decoding the most common MoBo expressions.

"On vous attend à 20h30."

"We'll be expecting you at 8:30 p.m."

Whatever you do, don't show up at 8:30! And don't show up five minutes earlier, either. If you follow these instructions to the letter, you're likely to irritate your host, who will be in the middle of getting dressed. Well-mannered guests arrive between 8:45 p.m. and 9:15 p.m. Turning up too late is also impolite—unless you sent advance notice "to start without us."

"On se fait un petit café?"

"Wanna grab a coffee ?"

For MoBos, the word *petit* (small) describes many things, none of which is remotely small: the *petit* drink is a strong cocktail, the *petit robe noire* (little black dress) was made by a chic designer, and the *petit marché* (small market) is rammed every week. In the same spirit, the *petit* coffee often implies a long conversation between friends at the café over at least three espressos.

"Surtout venez les mains vides."

"You don't need to bring anything."

Obviously, this friendly suggestion indicates quite the opposite. No MoBo heads out for dinner or a weekend away with friends empty-handed. Flowers—which should be delivered before or after a soirée, unless you want to annoy everyone—are no longer the standard. However, a small, chic decorative object, something from a fine-foods shop, or the book "that I loved, you'll see," are all increasingly popular types of dinner gift. Keep it reasonable to avoid any awkwardness.

I'D RATHER DIE THAN ...

Miss registering little Lucien at the public daycare

Admit to liking common white orchids

Confess to scouring the *My Little Paris* website for the latest hotspots

Miss the neighbors' annual courtyard barbecue

Buy anything other than Japanese milk bread

Be removed from the Vanessa Bruno private sale list

Be called a hipster

Give up my Depeche Mode vinyl collection

Admit to buying Nutella for the kids

Wear a helmet on a kick scooter

THE MODERN BOURGEOISE: AN ACE DECORATOR

The Modern Bourgeoise isn't a fan of inherited furniture—unless she was lucky enough to have parents who collected 1960s Scandinavian buffets, that is. (Coming into a collection of sleek vintage Ligne Roset furniture is also, alas, quite rare.) The MoBo will not fight her brothers and sisters for the walnut armoires and mahogany chests that line her parents' house. However, she has no qualms giving in to a single, all-consuming passion: contemporary design. She goes to great lengths to create a worthy, Instagramable backdrop for the family home, and she has several famous role models to look up to. In 1972, Claude Pompidou, the wife of the then French president, replaced the antiquated pieces in the Elysée Palace with creations by the modern French designer Pierre Paulint. More recently, Brigitte Macron drastically revamped her husband Emmanuel's office with armchairs by Patrick Jouin, which she deemed more "fitting" for a young president than the opulent furniture that belonged to the state. Though MoBos don't necessarily have the financial means to acquire creations by the Bouroullec brothers—two Breton superstars whose Vegetal chair is the MoBos' bucket-list piece—they glean more modest inspiration from lifestyle publications and websites. The magazine *Milk Decoration* and The Socialite Family website are two pillars of contemporary casual French chic. Within their pages, beautiful thirty- and forty-somethings from various creative fields (few industry executives make the cut) appear in apartments that all seem curiously alike. Several months ago, the fashion was all disheveled plants, sheepskins flung across rattan armchairs, and mismatched chairs congregated around a marble table. Now it's all teal velvet, figurative wallpaper, and Flemish urns overflowing with wildflowers. Who knows what tomorrow holds? This uniformity

of style doesn't bother the MoBo one bit; in fact, she finds it reassuring. She likes nothing more than to adhere to the aesthetic standards of her tribe, which gives her a deep sense of belonging. After painting the walls taupe and then dark grey, the MoBos all bought the same blue by designer Sarah Lavoine for their next round of decorating.

In the 1980s, MoBos bought metal and glass April vases by Tsé & Tsé. In the 1990s, they invested in Philippe Starck's Romeo Moon lamp and then, a little later, in his Louis Ghost chairs. Around the year 2000, they fell in love with sprawling linen couches by Caravane. In 2014, they stocked up on expensive filament bulbs (now dangling from the ceiling of every neighborhood bistro). Today, MoBos track down unique ceramics in boutiques in the tenth arrondissement or from Norman potters discovered by *Elle Déco* magazine. They are undoubtedly very pretty, but despite the "uniqueness" of each piece they always end up cradling the same *Begonia maculata*. There's plenty of work cut out for the next Roland Barthes, dissecting the new myths that make up contemporary life!

MODERN BOURGEOIS DESIGN TIPS

This trailblazer has an innate talent for mixing older pieces— she's not crazy, she did keep a few family souvenirs—with contemporary objects sourced (unlikely as it may seem) from the local supermarket. The Monoprix chain of mid-level grocery and general stores has been known to collaborate with contemporary designers and is a treasure trove for finding India Mahdavi designs at a reasonable price. The best examples look amazing combined with your favorite Le Corbusier calf-hide chair or piece of industrial furniture bought for a bargain at the huge Clignancourt flea market in the north of Paris. As soon as a designer collaboration is announced, a tour of the largest stores is a must. The online store AM.PM., on the other hand—a great barometer of up-to-date chic—is the official supplier of MoBo vacation home decor.

THE "IT" DESIGN WEBSITES

ateliersingulier.com: Exclusively French handmade and slow-made products.

bensimon.com: A selection of homeware curated by sneaker designer Serge Bensimon, for the Home Autour du Monde concept store.

caravane.fr: The headquarters of the "gypset" (i.e., gypsy jetset) and all things ethnic chic.

india-mahdavi.com: The designer who reintroduced color and cheer into interior design.

mariongraux.com: The MoBos' preferred ceramicist and a great example of someone who dropped everything to become a chic potter.

milkdecoration.com: The design bible!

monoprix.fr and AM.PM. on *laredoute.fr*: Two inexpensive treasure troves of homeware inspiration.

sarahlavoine.com: The final word in modern design elegance.

sentou.fr: Niche contemporary design.

thesocialitefamily.com: It doesn't get any more fashionable than this essential online reference.

MODERN BOURGEOIS "MUST HAVES"

The MoBos' unique style might show more international influence than that of the previous two families, but their codes and suppliers are decidedly French—and likely Parisian.

① DESIGNER SNEAKERS

Weary of white Adidas Stan Smiths—the flagship design created by the German shoe brand in 1964 for French tennis player Robert Haillet—MoBos have turned their attention to more niche designers (who also happen to be more expensive). Sneakers first appeared in the nineteenth century and were intended specifically for sports. In the 1970s, Hip-Hop took them out of the stadiums and the basketball courts and onto the street. Run-DMC dedicated a legendary 1982 song to sneakers, "My Adidas," which led to an incredible contract with the brand. In the 1990s, Nike sparked a limited-edition trend with the unbelievable success of their Air Jordans. But it would take several decades, and many rap videos, for sneakers to make their way into high fashion and onto the runway.

THE ICONIC BRAND: PIERRE HARDY

Pierre Hardy became a sneaker designer by accident. After studying graphic arts, he taught art until a friend suggested he join the prestigious Dior fashion house, where he was hired to manage licensing. He founded his sneaker brand in 1999, and his architectural and geometric creations were immediately successful.

pierrehardy.com

♥ WE LOVE ...
the wonderful Colorama sneaker, introduced in 2008. This colorful, unisex high-top has been rereleased several times and is now a collector's item. The Trek Comet and the Slider are also popular.

② STONEWASHED LINEN

Linen has a very long history. It originated in Ancient Egypt, and, later, under the Roman Empire, Caesar was highly impressed by the finely woven linen worn in Northern Europe. Linen cultivation and weaving, along with a series of inventions that enabled more efficient production, contributed to the prosperity of northern France, which for centuries was the world's largest linen producer. Since then, cotton and synthetic fibers have mostly replaced linen in clothing. After a long dry spell, MoBos took to the fabric for household linens, restoring it to its former glory in middle-class homes across the nation. The slightly worn tablecloth or bedspread in "stonewashed linen" has become a standard of contemporary design. Soft colors like faded blue, pale rust, dull gray, and dusty rose are enchanting, and linen doesn't have to be ironed, making it perfectly suited to the effortless, but very polished, ambiance so fashionable among MoBos.

THE ICONIC BRAND: SUMMER CAMP

Despite a name that evokes summers spent on a lake in Maine, this brand is 100 percent Lille. Founded in 2011 by an enthusiastic young couple, the Lefebvres, the company revived the family tradition of cultivating and weaving linen locally, but adapted it to new cool and crumpled standards. It's far less expensive than popular Parisian labels, and far softer than fast-fashion brands. The e-shop and two brick-and-mortar stores are the best-kept secrets of MoBos in the know.

summercamp-home.com

WE LOVE ...
the bedspread in teal, the MoBo color
of choice for at least the next decade.

③ THE SELVEDGE JEAN

"I have only one regret: that I didn't invent blue jeans," Saint Laurent supposedly said. The blue jean, created by Levi Strauss for gold miners from a heavy *bleu de Gênes* twill, became synonymous with 1950s bad boys. Marlon Brando, James Dean, and Elvis shimmied in jeans usually reserved for working—as opposed to working the room—and became icons for a generation of young people breaking with established conventions. American denim production couldn't keep up with demand, so factories began investing in modern machinery. They got rid of old weaving looms and sold most of them to Japanese factories. But the new jeans were supple, soft, and less resistant—they just weren't the same. Throughout the 1980s, purists hunted down selvedge 501s from the United States, made in tightly woven fabric and recognizable thanks to the red trim visible on the inside leg seams. Young people adored them, and the French brought back as many as they could from New York, smuggling them under the noses of zealous customs officials. A legend was born!

WE LOVE ...
the Petit Standard, the brand's first design. The cut has changed little over the years, and it's worn by women and men alike. Now that it's a classic, A.P.C. buys back the jeans once they're good and faded, customizing them and ... putting them back on sale.

THE ICONIC BRAND: A.P.C.

The A.P.C. selvedge jean was created almost by accident. In 1987, Jean Touitou, the future founder of the brand, went to Barcelona. The airline lost his luggage, so he went looking for a pair of jeans and a few clothes. What he found depressed him. It was impossible to source a pair of jeans that wasn't stonewashed or baggy. There he was, dreaming of Steve McQueen, and all he could find were jeans worthy of a boy band. He described this misadventure to a friend, who offered him a roll of Japanese denim woven on one of the old American machines. And that's how A.P.C. got its start, working with the Kaihara Denim company, which still makes selvedge denim developed specially for the brand. A.P.C. officially launched in 1987 with a pair of straight, selvedge denim men's jeans, totally at odds with the fashion of the day.

apc.fr

④ THE SLOGAN T-SHIRT

The T-shirt with a message, designed to convey a rock 'n' roll attitude, a love of nature, feminist convictions, or an altruistic streak, has become a classic. It's a way to bare your soul without risking anything more dangerous than a fashion misstep. In recent years, MoBos have sported an abundance of Elvis images, defiant "We Should All Be Feminists" logos (thank you, Dior), and miles of banners proclaiming the words "Happy" and "Hello Sunshine." The latest trend is toward French nostalgia, as evidenced by Yiddish Mamma's "Merci Simone" T-shirt (in honor of French lawmaker Simone Veil), and Patine Paris's "La Boum, la Boum, la Boum," which is regularly out of stock. This reference to a 1980s cult French teen party movie starring Sophie Marceau continues to unite generations.

THE ICONIC BRAND: ZADIG & VOLTAIRE
This French success story, launched in 1977 by Thierry Gillier and known initially for its casual, rock 'n' roll cashmere sweaters, leaves no MoBo unmoved. Whether you like it (in this case, just call it "Zadig") or find it a little too recognizable (the eternal MoBo dilemma!), the brand has become a byword in rebel cool.

zadig-et-voltaire.com

WE LOVE …
the long-sleeve Henley T-shirts in superb cotton, unanimously praised for their softness. Aficionados of both genders collect them. The messages change each year, but the comfort factor is a reliable constant.

⑤ THE LUXURY SOUND SYSTEM

MoBos have always loved listening to music on the latest equipment; whether it's classic French *chanson* or the latest indie band, "sound" means a lot to them, no matter what decade they're in. Luckily, they have the means and taste to invest in state-of-the-art technological paraphernalia, which has replaced the grand piano as a signifier of musical refinement. Already over-equipped with their stylish mini smartphone speakers that offer surround sound on the go, the MoBos went looking for a new playground and found it in an object that is as beautiful as a conceptual sculpture.

THE ICONIC BRAND: DEVIALET

This French start-up was created in 2007 by three friends who named it after the eighteenth-century engineer Guillaume Vialet, a friend of Diderot and contributor to the famous Enlightenment *Encyclopedia*. Simply put, the company aims to provide the best sound quality in the world. Its speakers are easy to use thanks to their white and silver UFO-like design and offer a "unique emotional experience." Whether that's true or not, the clever, ultra-technological positioning and design appeal to the wealthiest MoBos (prices start at 2,950 euros, or over $3,300/£2,650, per speaker), who were responsible for the company's early success. Its signature product, the Phantom, is now on sale in Apple Stores.

devialet.com

♥ WE LOVE …
the gold-plated Gold Phantom. Though too pricey for most of us, it's on display at Paris's Palais Garnier opera house, for which it was created. Visitors can appreciate its acoustic qualities in a dedicated room, and lucky buyers are treated to live-streamed performances.

⑥ THE GLAMOROUS BATHING SUIT

It was sunny that July day in 1946 at the Molitor swimming pool in the sixteenth, but none of the models approached by automotive engineer Louis Réard wanted to appear on the runway in the navel-revealing bathing suit he'd designed. It took an exotic dancer to step up to the challenge and bare her midriff. Réard named his two-piece suit the "Bikini," after the small atoll where the Americans were carrying out nuclear tests. Long banned from beaches, it was popularized in 1953 by a young Brigitte Bardot at the Cannes Film Festival. The tanned and liberated have loved it ever since.

THE ICONIC BRAND: ERES

Created in 1968 in Paris, before the city had fully recovered from the upheaval of student protests, Eres sensed that change was in the air: the musical *Hair* had caused a scandal on Broadway; the first pop-music festival was held, on the Isle of Wight in England; women discovered miniskirts and tights; and cabaret singer Maurice Chevalier doffed his boater and bade farewell to the stage. Stiff bathing suits with uncomfortable wiring were a thing of the past. In their stead, Eres developed an elastic fabric that hugged curves and made for marvelous cuts that glorified the body. Plus, their suits were available all year long. They were an immediate success, and became even more popular in 1971 when assorted tops and bottoms were sold separately, enabling customers to fine-tune their choices. MoBos are experts in Eres suits, and can pinpoint the styles they spot on the beach to within a year.

eresparis.com

♥ WE LOVE …
the bandeau bikini top with U-shaped bar, the brand's signature style. The pleating and clever structure enhance small chests and support larger ones comfortably.

THE GOURMET MODERN BOURGEOIS

Playing amateur bartender and shaking cocktails for friends is definitely in the MoBos' playful and curious spirit. And since they are a bit snobby, they also like nothing more than showcasing obscure, long-forgotten vintage spirits in their creations (Picon, Floc de Gascogne, Lillet, Byrrh, and Chartreuse are their favorites). Should they decide to whip up something more traditional, they prefer to use vodka made in France (like Citadelle) or gin distilled in Paris (like Lord Barbès)—products that have flourished in recent years along with the mixology trend that's sweeping the capital.

The Aperol Spritz is just too clichéd for the hip Modern Bourgeois, who prefers Suze, a liqueur made from yellow gentian whose bitterness—especially when diluted with a dash of blackcurrant liqueur—was a great hit with the great-grandparents.

THE MODERN BOURGEOIS SUZE COCKTAIL RECIPE

For one
Ingredients
→ ½ oz (15 ml) peach syrup
→ 1 oz (30 ml) Suze
→ ½ oz (15 ml) gin
→ ice cubes
→ sparkling water or tonic
→ rosemary

Method
❶ Pour the peach syrup, Suze, and gin into a large brandy or whiskey glass.
❷ Twirl the glass three times and fill to top with ice cubes.
❸ Add sparkling water or tonic to taste.
❹ Finish with a sprig of rosemary.
❺ Sip while uttering little cries of ecstasy.

A TRIO OF HANGOUTS
FOR THE NEW COCKTAIL SOCIETY

CRAVAN: A charming little art-nouveau establishment with historical cachet, it is home to one of the sexiest bartenders in the French capital; he happens to be insanely talented, too. Sip a Trocadéro (at the very least!) while nibbling on all manner of simple, sophisticated morsels. The bar's namesake, boxer and poet Arthur Cravan, was Oscar Wilde's nephew.
17, rue Jean de La Fontaine, Paris XVIᵉ

COMBAT: A pretty green boudoir bar, this is the fief for two glamorous tribes with unbridled inventiveness. The mocktails don't disappoint.
68, rue de Belleville, Paris XIXᵉ

BALAGAN: At this bar in one of the hottest restaurants in Paris, we dance between—or on—the tables: sexy atmosphere, gorgeous young things, and a lovely menu.
9, rue d'Alger, Paris Iᵉʳ

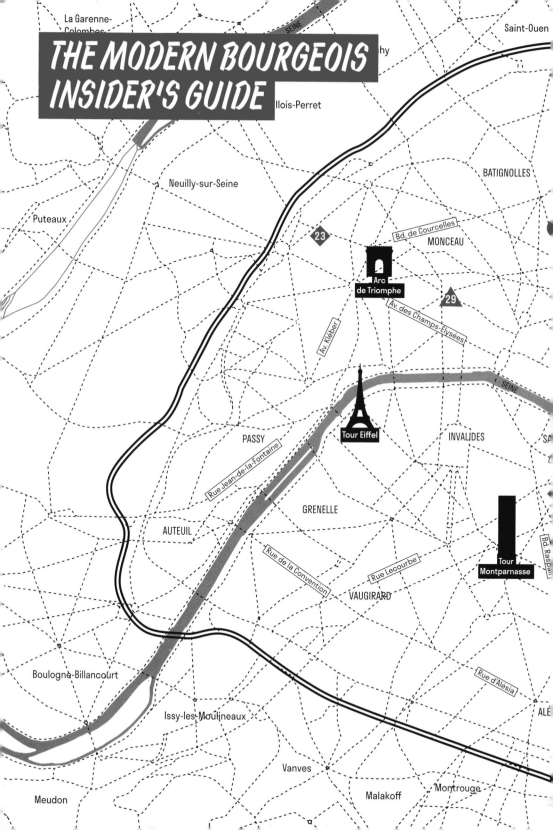

THE MODERN BOURGEOIS INSIDER'S GUIDE

La Garenne-Colombes

SEINE

Saint-Ouen

hy

Ilois-Perret

BATIGNOLLES

Neuilly-sur-Seine

Puteaux

23

Bd. de Courcelles

MONCEAU

Arc de Triomphe

29

Av. des Champs-Elysées

Av. Kléber

SEINE

Tour Eiffel

INVALIDES

SA

PASSY

Rue Jean-de-la-Fontaine

GRENELLE

Tour Montparnasse

Bd. Raspail

AUTEUIL

Rue Lecourbe

Rue de la Convention

VAUGIRARD

Boulogne-Billancourt

Rue d'Alésia

ALÉ

Issy-les-Moulineaux

Vanves

Montrouge

Meudon

Malakoff

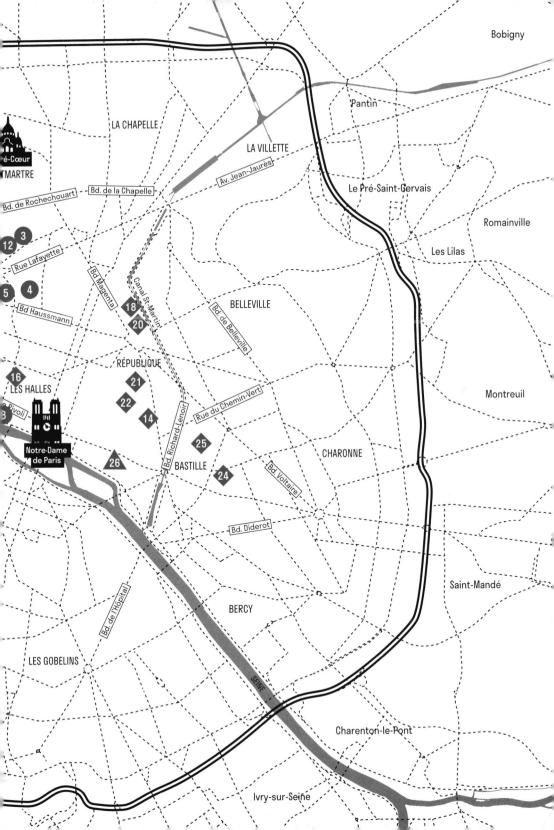

THE MODERN BOURGEOIS IN PARIS

The migration of the Modern Bourgeois into working-class neighborhoods began in the 1980s, with the conquest of northeastern Paris. Photo studios, advertising agencies, and publicists were the first to turn marvelous craft workshops into photogenic lofts. But a new generation of MoBos has recently settled into a calm and picturesque section of the ninth arrondissement, dragging strollers and shopping bags with them. They've avoided the areas around the Opéra Garnier, Grands Boulevards, and Chaussée d'Antin, deemed too noisy; instead, they've fallen for the charm of Avenue Trudaine and Nouvelle-Athènes, a tiny pocket of the Saint-Georges neighborhood just south of Montmartre. Nouvelle-Athènes had its moment of glory in the nineteenth century. Before it was overtaken by Montparnasse in the 1920s, this little paradise, built on the site of a former orchard, was home to a motley band of artists, prostitutes, and rich bourgeois, who occupied studios, beautiful houses, and opulent apartment blocks. The neighborhood pulses with theaters, cabarets, and concert halls. Despite filling up with families, it has retained its original fun-loving spirit. Even back in 1787, the Rue des Martyrs had some twenty-five inns and music halls for the forty-eight houses on the block. Faithful to tradition, clubs and bars such as the Bus Palladium, Lautrec, Nouvelle Eve, and Carmen still welcome night owls with open arms.

THE PERFECT MOBO LANDMARK?

1 **THE MUSÉE DE LA VIE ROMANTIQUE**, a *hôtel particulier* surrounded by a small park. This house, where the Dutch-born Romantic painter Ary Scheffer lived, is typical of the nineteenth-century Bourbon Restoration period. Stroll around the garden dreaming of Chopin playing the piano for his lover George Sand, to whom the permanent collection of this ravishing place is dedicated, and have a bite to eat in the tree-shaded tea room run by the Rose Bakery.
Hôtel Scheffer-Renan
16, rue Chaptal, Paris IX\ :sup:`e`
museevieromantique.paris.fr

OUT AND ABOUT WITH THE MODERN BOURGEOIS

The ninth arrondissement, long notorious for its women of dubious character, hides grand architectural treasures, romantic walks, and many happening new spots. It's the most recent area to have been taken over by the MoBo crowd.

2 **STROLL ALONG AVENUE FROCHOT**, a marvelous nineteenth-century cul-de-sac, now private, that was home to many artistic types, including Django Reinhardt, Toulouse-Lautrec, and Jean Renoir. The neo-gothic house at No. 1 is supposed to be haunted after a housemaid was murdered there. Flatter a resident as they key in the entrance code and you might just get to look around for yourself.

3 **GO IN HOT PURSUIT OF CITÉ NAPOLÉON**, one of the few remaining examples of the working-class housing blocks initiated by Napoleon III in Paris and intended to house employees from the gasworks on the Rue Condorcet.

4 **SLIP INTO CITÉ BERGÈRE**, a peaceful neo-classical street and a registered historic monument, where the porcelain-making Weil family, from which Marcel Proust's mother hailed, lived for many years.

5 AMBLE ALONG PASSAGE JOUFFROY, built in 1847, which connects the Grands Boulevards with the rue de la Grange-Batelière. It is the longest covered arcade in Paris. Guided tours are available at:
unjourdeplusaparis.com
parisontheway.fr

6 LET LOOSE AT LE CARMEN, a bar and nightclub open from 6 p.m. to 6 a.m., located in a *hôtel particulier* that once belonged to the Romantic-era composer Georges Bizet. There are over forty flavors of home-infused gin on the menu.
34, rue Duperré, Paris IX^e
le-carmen.fr

7 UP THE STAKES AT THE DROUOT AUCTION HOUSE, where it is always fun to discover what's on view. Bid on something that takes your fancy by winking discreetly at the auctioneer.
drouot.com

8 CULTIVATE YOUR KIDS AT THE MUSÉE EN HERBE, which holds workshops and art exhibitions for small children aged five to twelve. Parents are treated to an Art'Péro (museum entrance plus aperitif): the French always find a good reason to drink, don't they?
23, rue de l'Arbre-Sec, Paris 1^er
+33 (0)1 40 67 97 66
museeenherbe.com

SHOP AND SNACK IN SOPI (SOUTH PIGALLE)

9 RUE CONDORCET
→ AT NO. 45, Mamiche: regulars at this hipster *boulangerie* have a weakness for the *ficelle*, a soft breadstick with salted butter and chocolate (to die for).
mamiche.fr

→ AT NO. 57, Rétro Chic: The young man who runs this wonderful little boutique is strict about where he sources his vintage womenswear, which is often stamped Saint Laurent Rive Gauche or Emmanuelle Khan.
Call +33 (0)6 17 93 03 64 for further information.

→ AT NO. 65, Philippe Model Maison: This aesthete is well known to Parisians. His boutique-cum-cabinet of curiosities contains the best of contemporary French ceramics—stoneware from Compiègne and Besançon, and red clay from Nantes. Unique cups and pitchers line the shelves.
philippemodelmaison.com

10 RUE FROCHOT
→ AT NO. 9, Le Pigalle: This chic but nevertheless "neighborhood" establishment hosts a beau-monde crowd for breakfast or drinks in a setting that oozes old-time Paris.
lepigalle.paris

11 RUE HENRY-MONNIER
→ AT NO. 28, Buvette: This Franco-American *gastrothèque* serves small, creative plates and interesting wines in the soft glow reflected by its molded silver ceiling. The weekend brunch is very popular.
ilovebuvette.com

→ AT NO. 30, Debeaulieu: The star florist to Paris's creative set has an enchanting boutique where little-known flowers brush petals with French beauties. Taking home a few sky-blue dried delphiniums is an absolute must.
debeaulieu-paris.com

→ ALSO AT NO. 30, Headless St Denis: Unearth second-hand clothes customized by a humble and talented designer for super reasonable prices. The vintage jewelry is also hard to resist.
Call +33 (0)6 68 86 23 00 for more details.

12 RUE VICTOR-MASSÉ
→ AT NO. 3, Vestiaire Général: Located on the most rock 'n' roll street in Paris—it's lined with stores selling guitars and amps—this menswear shop focuses on French expertise. Snap up the iconic denim work jackets by Fils de Butte.
vestiaire-general.com

→ AT NO. 30, L'Entrée des Artistes: Behind its intriguing façade, this former hostess bar has sinfully good cocktails. Now an elegant restaurant, it also hosts jazz and swing dancing on weekends.
lentreedesartistespigalle.com

SHOPPING: COLETTE AND ITS NATURAL HEIRS

The most famous concept store in the world—Colette—was French. It invented the genre, then closed its doors in late 2017, after twenty years devoted to fashion, to impossible-to-find mineral waters, to unearthing new talent, and to design. Known for initiating improbable but triumphant collaborations, upsetting the rules of the traditional boutique, mixing genres, and sometimes offending with its unique brand of elitism, Colette paved the way for hip nonchalance, and its success launched careers.

A SELECTION OF WHERE YOU CAN FIND CONSOLATION NOW THAT COLETTE IS GONE

13 NOUS
Created by two former Colette staffers, Nous carries the torch of the original Paris hotspot. It offers an enterprising mix of pioneering names, emerging brands, and exclusive collaborations with artists that change often enough to keep things interesting.
48, rue Cambon, Paris 1er

14 MERCI
This MoBo shrine offers a selection of homeware and interior design that "gives meaning to everyday actions." That's some claim—but why not put it to the test yourself? Design, fashion, and food are all available in one sleek space.
111, boulevard Beaumarchais, Paris IIIe
merci-merci.com

SEPT CINQ
Let the two smiling founders of this concept store, dedicated exclusively to young Parisian creators, guide you through their chic and constantly evolving selection.
15 Sept Cinq – Pigalle (shop and studio)
54, rue Notre-Dame-de-Lorette, Paris IXe
16 Sept Cinq – Châtelet (shop and tea room)
26, rue Berger, Paris 1er
Brunch reservation recommended:
+33 (0)9 83 00 44 01
sept-cinq.com

17 LE 107 RIVOLI
Designer Mathilde Bretillot has done a marvelous job of showcasing rare objects from around the world in her boutique housed within the Musée des Arts Décoratifs. The lovely selection is chosen according to whichever exhibition is currently on view, and it's so well curated, you may forget to visit the museum itself.
107, rue de Rivoli, Paris 1er

CENTRE COMMERCIAL
At last, a place where you can shop with a clear conscience! The boutique carries products by quality-focused brands, all ethically and sustainably made.
18 2, rue de Marseille, Paris Xe
19 9, rue Madame, Paris VIe
For kids:
20 22, rue Yves-Toudic, Paris Xe
centrecommercial.cc

21 EMPREINTES
The first concept store dedicated to the arts is located in the heart of Paris's Haut Marais. Furniture, design objects, jewelry, and sculpture are available as unique works of art or in limited editions. Everything is lovingly created by French craftspeople (always a top selling point for MoBos), and designs range from everyday objects to statement pieces. When you've had enough beauty, settle in for a coffee and flip through the art book you just treated yourself to.
5, rue de Picardie, Paris IIIe
+33 (0)1 40 09 53 80
empreintes-paris.com

22 LA GARÇONNIÈRE
This elegant space dedicated entirely to fashionable masculine living stocks 120 brands for the boys. The modern dandy will feel right at home amid the knitted ties, Parisian-brewed beer, niche clothing selection, and beauty products for beards. There's even an in-house barber shop and café.
47, rue des Archives, Paris IIIe
+33 (0)9 73 68 14 47
la-garconniere.fr

23 LE BAZARISTAIN
Unusual and exclusive pieces sit alongside crafts from around the world and work by emerging designers in this modern Parisian souk.
10, rue Saint-Ferdinand, Paris XVIIe
lebazaristain.com

BOUTIQUE LES FLEURS
This charming shop is a treasure trove for small gifts. The sharp-eyed owner has put together an unbeatable selection of jewelry, decoration, stationery, bric-a-brac, dried flowers, and leather goods. A visit here also gives you the chance to stroll along rue Trousseau, which is home to other boutiques featuring small, under-the-radar designers.

24 Maison, brocante et petit mobilier
5, rue Trousseau, Paris XIe

25 Bijoux et accessoires
6, passage Josset, Paris XIe
boutiquelesfleurs.com

MODERN BOURGEOIS CONFIDENTIAL

THE MOBOS' MOST BOHEMIAN SPOTS IN WHICH TO ...

26 SIP IN SECRET: Slip into Bar 1905, a speakeasy nestled in a former wine cellar and accessed via a hidden staircase. Sip an "À Rebours" cocktail, created in homage to French author and art critic Joris-Karl Huysmans's novel *Against the Grain*. Belle-Époque tables and plush upholstered couches complete the picture. The second-floor terrace is one of the best-kept secrets in Paris: there are only eight seats.
Open Tuesday to Saturday from 6 p.m. to 2 a.m.
25, rue Beautreillis, Paris IVe

SHARE A PRIVATE DINNER: Book an evening at one of the "secret restaurants" that are de rigueur for exacting Parisians, where a select smattering of guests indulge in a menu created by a chef working his or her magic from home, in a loft space, or even in a former bakery.
fingle.fr and *archibaldgourmet.com*

27 DIVE INTO THE MYSTERIOUS UNIVERSE OF GUSTAVE MOREAU: He is the father of symbolism and the only painter to have transformed his home-cum-studio into a museum dedicated to himself during his own lifetime. A good friend of arch dandy Count Robert de Montesquieu, Moreau was the last word in late nineteenth-century elegance, admired by both Oscar Wilde and Marcel Proust. He rarely left his incredible studio, whose twisted staircase has become as famous as the dominating and denuded heroines he so loved to paint.
Musée National Gustave-Moreau
14, rue de La Rochefoucauld, Paris IXe
musee-moreau.fr

28 SLIDE BETWEEN THE SHEETS: Book a room at the Hôtel Particulier Montmartre, the smallest hotel in the capital. This little gem, tucked into a cul-de-sac off Avenue Junot, squeezes five dreamy suites into a charming nineteenth-century *hôtel particulier* surrounded by a vast garden.
23, avenue Junot, Pavillon D, Paris XVIIIe
hotel-particulier-montmartre.com

29 WEAR THE PANTS: Offer yourself an impeccable but affordable made-to-measure pair of pants from Philippine Janssens, heir to a family of luxury fabric merchants. Actresses, princesses, powerful women, and ordinary Parisians alike make appointments at this plush store to choose from among thirteen styles and a multitude of fabrics that most flatter their body shapes. Delivery, following a final fitting, in three weeks.
93, rue du Faubourg-Saint-Honoré, Paris VIIIe
philippinejanssens.com

THE MODERN BOURGEOIS ONLINE

Whether you live in Detroit or Poitiers, there's absolutely no excuse for depriving yourself of this tribe's best shopping addresses.

MAISON THOMAS

This lovely niche brand creates luxury goods without the matching price tag. Its elegant "Porte-Moi" saddlebags feature modern touches like neon-colored stitching and incredibly refined closures. They are made in a French workshop in the Val-de-Loire region that shares space with a legendary French fashion house whose name begins with H and ends with S (shhh, you didn't read it here).
maison-thomas.com.

NATIONAL STANDARD

In just a few years, this brand has become the king of Paris street style. National Standard started out in 2010 with just two sneaker designs; today it has over a dozen, which are all available in beautiful colors and materials. But François Chastang and Arnaud de Louvencourt have remained loyal to their original intentions: to make quality sneakers in understated, elegant styles that won't break the budget.
nationalstandard.fr

HEIMSTONE

Heimstone's Instagram account is a perfect online resource for tens of thousands in search of romantic fashion pieces with a hint of rock 'n' roll. This is where Alix Petit, ambassador for the brand she created in 2007, recounts her life. Always sneaker-clad, and often wearing a wool beanie, she presents exclusive print dresses, parkas, and coats in luscious colors, as well as wool sweaters (her passion) in pastels. On top of that, she does yoga, and is a mother.
heimstone.com

LOUIS-GABRIEL NOUCHI

A newcomer on the fashion scene, Nouchi has already garnered a reputation for his delightful collaborations with glove-maker Agnelle, online catalog La Redoute, and department store Galeries Lafayette. He recently launched his first collection for men, designed in loose, flowing fabrics that girlfriends will want to borrow.
louisgabrielnouchi.com

DE TOUJOURS

The most beautiful online collection of classic clothes, inspired by traditional attire, heritage sports, and time-honored occupations. From Camargue herdsmen's pants and mechanic's overalls to the indispensable fishermen's sweater, every one of these made-to-last pieces is carefully curated. The website and the Instagram account are full of inspiring photos that illustrate how to wear these cult pieces with style.
detoujours.com

ANNELISE MICHELSON

This designer has come far from a world where the small, cute, and undemanding reign supreme. Her imposing goth/punk/industrial jewelry is always super sophisticated and shakes up whatever style is currently trending. Rihanna and Bella Hadid, experts at finding new talent, are fans of her sculptural cuffs and "Carnivore" ear cuffs.
annelisemichelson.com

THE MODERN BOURGEOIS ON VACATION

HEAD STRAIGHT TO ... GUÉTHARY AND CAP FERRET!

These seaside spots are the alpha and omega of the MoBos' summer travel plans when they decide to stay in France. After Biarritz and Saint-Jean-de-Luz, Guéthary is the latest place to be on the Basque coast, which the French like to call their "little California." Cap Ferret, on the tip of a spit of land that separates Arcachon Bay from the Atlantic Ocean, has a reputation inversely proportional to its size: thirty-six square miles (over ninety square kilometers) of coveted territory bitterly contested by numerous celebrities.

Both Guéthary and Cap Ferret are adored by MoBos for their undisputed beauty (natural coastline and wild waves), their supposed surf culture (even if you don't surf, it's advisable to walk around in a wetsuit rolled down to the hips), and their festive, intergenerational lifestyle. MoBos are reassured by the number of celebrities that agree with their choice, even if they pretend to rail against the arrival of the showbiz world and admit that the weather isn't always perfect.

IN GUÉTHARY

Once you've dropped the kids off at surf school (or left them with the au pair in the evening), opportunities abound to socialize with your espadrille-wearing counterparts. At the very least, you should:

SIP THE LEGENDARY MOJITO OR A MIND-BLOWING CAIPIRINHA Enjoy a sundowner at Hétéroclito, facing the legendary surf spot of Parlementia, or at Ilunabar, nearby, where you can perch on the railings overlooking the uninterrupted seascape. Or why not try both, and stay for dinner (if you haven't already filled-up on too many tapas and *chipirons*, the local calamari)?

HÉTÉROCLITO
Chemin de la Plage, 64210 Guéthary
+33 (0)5 59 54 98 92

PARLEMENTIA
4, chemin du Port, 64210 Guéthary
+33 (0)5 59 24 33 59

ILUNABAR
50, promenade de la Plage, 64210 Guéthary
+33 (0)6 16 61 61 00

HAVE A COFFEE AT THE MADRID
Formerly mission control for local pelota tournaments, this space is now an HQ for cool denizens of the Basque coast.
563, avenue du Général de Gaulle,
64210 Guéthary
+33 (0)5 59 26 52 12

BREAKFAST AT THE C
Everything here is beautiful at the C on Cenitz Beach: the view, the interior design, the food, the waitstaff, the customers. You'll be hard-pressed to find a better example of Robinson Crusoe chic. Come evening, it has the best sunset view on the coast.
257, chemin de Cenitz, 64210 Guéthary
+33 (0)6 50 73 23 09

IN CAP FERRET (CALL IT "LE FERRET" IF YOU REALLY WANT TO FIT IN)

When the market wraps up and they've had an obligatory café and *cannelé* sponge cake at Lemoine, the Ferrets-Capiens (as they're known) head for a picnic on the Banc d'Arguin or Banc du Toulinguet beaches—spectacular stretches of undisturbed sand (well, they were before they arrived, anyway). In the evening, if you want to observe them invigorated, tanned, and shimmying around in brick-red pants, you can:

GET YOUR IODINE FIX
Fill up on oysters, along with a little pâté with Espelette pepper and a white Bordeaux at La Cabane du Mimbeau, one of the many open-air oyster cafés in the area.
28, avenue de la Conche,
33970 Lège-Cap-Ferret
+33 (0)5 56 60 61 67

DINE AT CHEZ HORTENSE
It's fine to criticize this local cult favorite a little, but it would be unreasonable not to show your face at some point. The mussels and fries are unforgettable.
26, avenue du Sémaphore,
33970 Lège-Cap-Ferret
+33 (0)5 56 60 62 56

NIBBLE TAPAS AT SUNSET
At Chez Pierrette, a new-Basque guinguette (a casual, outdoor festive eatery), with multicolored string lights, the food is good and the girls are sexy (and vice versa).
6, allée des Cupressus,
33950 Piraillan
+33 (0)6 67 92 60 11

CHECK OUT THE CONCERTS
The bar Le 44 is a friendly fusion tapas restaurant that attracts local characters, and where his 'n' her surfers hold court.
No reservations.
44, avenue du Sémaphore,
33970 Cap Ferret

CHANNEL YOUR INNER PIRATE
Sip flavored rums at the Tchanqué, a cute bar hidden among the foliage of the Maison du Bassin, a charming local hotel.
5, rue des Pionniers,
33970 Lège-Cap-Ferret
+33 (0)5 56 60 49 84

MAKE SOME WAVES
Amble over to Sail Fish, a local nightclub institution where youngsters boogie on down with their parents (who have the good sense to disappear quickly, although never quite soon enough, if you ask the kids).
Rue des Bernaches,
33970 Lège-Cap-Ferret
+33 (0)5 56 60 44 84

THE
INTELLEC-
TUALS

ARE YOU

A LITTLE,

VERY,

MADLY

INTENSELY,

OR NOT AT ALL ...

INTELLECTUAL?

QUIZ

Check the statements that most apply to you

 I'm a big fan of Robert Zimmerman's more famous alter ego. Grammar is non-negotiable. I still secretly listen to ABBA. I know there's more to Lévi-Strauss than jeans. I memorized every film starring Louise Brooks. For a long time I went to bed early. I organize my books by subject and author (and NEVER by color!). I arrive at all of my appointments on foot. I start my day with a softboiled egg and the newspaper—at Café Flore when I'm in Paris. I have elbow patches on my sweaters and jackets. Like Balzac, I'm addicted to filter coffee. I think that bookworms have a certain allure.

→You checked 7 to 12 statements. Yes, you're a hard-core Intellectual! You'll probably recognize yourself in the portrait that follows.

→You checked 3 to 6 statements. You're so close! Increase your IQ (Intellectual Quotient) by reading this chapter.

→You checked 2 or fewer statements. There's nothing Intellectual about you. But it's not too late to do something about it: light up a Gauloise and settle back with the following advice.

BACKSTORY

"Courage is aiming for the ideal and understanding the real." —Jean Jaurès

We have the Intellectuals to thank for many contributions to society: incisive critical thinking, for introducing the world to such lofty concepts as existentialism and structuralism, for safe-guarding corduroy pants, and for philosophical word-play over endless cups of coffee.

The French have a long and passionate love affair with their Intellectuals. After all, France is the land of Descartes, the father of modern philosophy. To question, to reason, and to doubt, all in the quest for truth, are some of the basic building blocks of French culture—and also contribute to a unique form of French arrogance.

The French love to debate, forever convinced that they're right—a sentiment inherited from the verbal jousting of role models stretching back to Voltaire and beyond. Émile Zola became the first truly mediatized figure in a long line of activist Intellectuals thanks to his famous open letter *J'accuse ...!*, published at the height of the Dreyfus Affair, a nineteenth-century political scandal involving serious miscarriage of justice and antisemitism. (Just imagine what he could have achieved if he'd had a Twitter account.)

For the French, the word *Intello* ("Intellectual") evokes a host of charismatic figures: Jean-Paul Sartre and Simone de Beauvoir changing the world over coffee at the Deux Magots café; Albert Camus in his Humphrey Bogart raincoat; André Malraux and his disheveled locks; Left Bank singers Juliette Gréco, Barbara, and Léo Ferré; Bernard-Henri Lévy, king of the bare-chested "new philosophers" of the 1970s; France Culture radio station; and the historically famed La Hune bookstore in Paris. Leading French newspapers regularly feed into this mythology, periodically republishing evocative photos, in black and white whenever possible. Do they continue to revisit this glorious past in order to distract readers from the absence of French thought in current international debate? A few photogenic descendants of the great minds of yesteryear—like the philosophers and essayists Raphaël Enthoven (the son of Jean-Paul Enthoven, publisher and journalist) and Raphaël Glucksmann (son of the philosopher André Glucksmann)—perpetuate this aura of cerebral glamour among well-read millennials. But this affection for Intellectuals is founded more on their appealing public image than on substance, and no doubt explains why the French forgive them for taking stances that have been known to lack good judgement: after all, French Intellectuals have supported just about every Communist dictatorship on earth, from Stalin to Pol Pot.

Two sub-tribes butt heads in this family: the Intellectuals on the left, well-meaning and well-liked—to put it succinctly— and the Intellectuals on the right, deemed more inflammatory

MONOGRAMMED ICON

BHL: Ordinary names lack sophistication. Go with a monogram, like the controversial, cosmopolitan philosopher Bernard-Henri Lévy.

SEMIOLOGIST ICON

Roland Barthes: This philosopher's essay collection on modern French culture, *Mythologies*, remains legendary. All Intellectuals interested in the world around them dream of writing the sequel.

THEATRICAL ICON

Olivier Py: Author and director of theater and opera, prolix and ubiquitous, he is unanimously liked by Intellectuals— which is quite a feat in France, where it's more common to be unanimously disliked. Director of the Théâtre National de l'Odéon, and then, since 2014, of the Avignon Festival, he has a desirable position—which helps.

and often accused of betraying the first group, who consider their adversaries vile reactionaries.

Obviously, not all Intellectuals are writers, publishers, journalists, theater directors, or literary critics. So what, in that case, do they have in common? The answer is their exaggerated esteem for culture and a solid grounding in the humanities. Illustrious high schools like the Louis-le-Grand and Henri IV receive their children, who are drilled and doped up on Latin and Greek, much like Communist athletes were fed with steroids. Their parents, who staunchly defend Republican egalitarianism for everyone else, will do just about anything to make sure their offspring get into these prestigious establishments. To the average French teenager, "Intellectual" is more an insult than a compliment; regardless, the senior-year high-school exam—the *bac*—and its legendary *philo* (philosophy) test are the subject of much media attention every June. Sometimes famous Intellectuals agree to take the exam again for fun, even at the risk of receiving a poor grade. The Intellectuals *love* to take tests!

The male Intellectual is a self-styled dandy and wears his hair skillfully disheveled, always just a bit longer than fashion dictates, with an artfully wrinkled, white button-up shirt and rarely polished lace-up shoes. You won't find many hooded sweatshirts on the second floor of Café Flore. The Intellectual woman, with her chic student look, is interested in seducing his mind. Paradoxically, the philosophizing object of her attention appears to have no qualms about marrying or having children with actresses or supermodels reputed for their sex appeal. It's all very aggravating.

Their choice of vacation also attests to this tribe's never-flagging intellectual curiosity. Lie around in the sun? Never! Intellectuals don't head to Saint Bart's, but rather to Avignon, Gordes, or one of the other cultural festivals, staged against a backdrop of ancient stones, that France is so good at. Are they snobs? Of course not! These cultural jaunts in no way prohibit them from appreciating an aperitif at the local bar while reading the regional paper, whose small-town stories are endlessly amusing. Children—spared a deluge of fashionable and useless toys, because nothing stimulates the imagination like a good book, or even boredom—sagely follow in tow, secretly lamenting the simple pleasures a Mickey Mouse beach club holds for the under-twelves. (They keep quiet, though: their parents would be *seriously disappointed* if they ever found out.)

THE INTELLECTUALS

CODE OF CONDUCT

Several important social rituals underscore this family's lifestyle, all worth critiquing.

Literary prizes

These awards punctuate the French publishing year and regularly give rise to dedicated articles, news slots, and Parisian dinner-party conversations. They are also a reliable source of Christmas gift ideas: you can't go wrong with a Goncourt or Femina Prize winner (surely?).

Love letters

Text messages and emails might have replaced handwritten correspondence, but sweet little words of love—and their intoxicating effects—are still very much in vogue. Intellectuals have read *Dangerous Liaisons*, and all those simmering letters must have left their mark. The writing and receiving of billets doux thus remains a hot topic of conversation, even after school age. The Instagram account @dear_amours_solitaires (and the original French version: @amours_solitaires), which collects the most beautiful, romantic text messages is vastly popular. Are the French in love with love? Certainly, if you consider the enormous commercial success of François Mitterrand's *Lettres à Anne* (Gallimard, 2016), a compilation of missives the French president sent daily between 1962 and 1995 to Anne Pingeot, his great illicit paramour.

Gallery openings

It's wise to be seen at these cosmopolitan events, especially if you belong to the happy few who regularly receive invitations. And the art? Plan on scheduling a second visit to appreciate it at your leisure, sans the selfies, snacks, and spirited commentary.

I'D RATHER DIE THAN ...

Admit to never having finished Proust's *In Search of Lost Time*

Admit to discovering Pierre et Gilles only recently

Buy books on the Internet

Swap my ancient rusty bike for a fixie

Stick Post-its in my first edition of *Waiting for Godot*

Be seen reading a horoscope in public

Miss the Nobel Prize for Literature

Miss an installment of the *New French Review*

Be caught watching *MasterChef*

Prance around in neon sneakers

Write in txt spk to friends (WTF?)

THE INTELLECTUAL: A MASTER OF SEDUCTION

French gallantry: it is an isolated phenomenon or a carefully constructed myth intended to delude women, as some feminists claim? Its association with the French began long before Louis XIV, but it was the young king who imposed a "code of conduct" toward women in his court. He required his courtiers to appear bareheaded before him but also greeted women by respectfully doffing his hat. He also allowed pregnant women to use a stool, or *tabouret*, in his presence, one of most coveted privileges at court. He was fond of the ladies and preferred them to be educated and spirited.

While women were hidden away in Spain and ignored in England, where clubs were for men only, French women were free to go where they pleased and to converse with men other than their husbands. This free-wheeling attitude brought with it frivolity, "flirting," and crude innuendo, which many foreigners found incomprehensible at the time. There is a fine line between gallantry and libertinism, one often crossed by the "chivalrous" gentleman who employs flattery and compliments to get what he wants, like the notorious womanizer Don Juan. Using honeyed words to seduce, charm, captivate, and intoxicate is an old trick especially dear to the French, and has enabled many an ugly man to win a lady's affection. Words have a way of setting hearts afire. Just ask any fan of white-hot sexting ...

A surprising number of French women have publicly confessed to finding the frankly homely-looking Michel Houellebecq irresistible. Sartre collected young mistresses, while the rakish Serge Gainsbourg—who came up with the brilliant lines *"La beauté cachée / Des laids des laids / Se voit sans / Délai délai"* (The hidden beauty / Of the ugly, of the ugly / Soon makes itself obvious)—sweet-talked Brigitte Bardot into his bed and Jane Birkin into his life. A slightly restless and tormented streak is also appreciated. The actor and singer Benjamin Biolay also belongs in this category, and he's only ever had dramatic love affairs with beautiful actresses. Obviously, suitors who

happen to be both intellectually engaging and dashing to look at find it even easier: look at the actors Sami Frey, Jean-Louis Trintignant, or Michel Piccoli in their heyday—vintage legends who are still popular among the denizens of Saint-Germain.

The good news, then, is that intelligence is still considered a powerful aphrodisiac in France, and those who have it enjoy an undeniable sex appeal. That being said, not all Intellectuals are created equal. The speaker who lacks panache, the boring pedant, and the overly earnest just won't cut it. The two cult titles of the Intellectual romantic canon describe bouts of nocturnal verbal jousting that are arousing, but that can also remain completely platonic. In *La Nuit et le Moment*—a play by the eighteenth-century writer Claude-Prosper Jolyot de Crébillon—the two characters of Clitandre and Cydalise bicker between the sheets. In Éric Rohmer's film *My Night at Maud's*, foreplay consists of endless commentary on a philosophical discourse by Pascal. After all, pleasure is first and foremost an intellectual pursuit. Right?

MORALIST MUSE

Filmmaker <u>Éric Rohmer</u>: Rohmer, who died in 2010, cultivated a brand of literary cinema that borrowed from seventeenth-century literature. His extremely well-constructed voice-over dialogs and monologs send Intellectuals into ecstasies. Others might consider him, well, *wordy*.

INTELLECTUAL "MUST HAVES"

Our list of well-reasoned essentials for fitting in with the smart set.

① THE SCARF OR WRAP

Nowadays Parisian Intellectuals like to brighten up their sober outfits with squares of printed colored fabric. Tie your scarf with nonchalance in Saint-Germain-des-Prés, confidence in the Marais, and casual elegance near the Panthéon. Whether it's made from cotton, linen, or wool with silk or cashmere, it may be one of the only items in the modern French wardrobe that isn't grey, blue, or black.

THE ICONIC BRAND ... ÉPICE
This brand of scarves, squares, and foulards was founded in Paris in 1999 by Bess Nielsen, a Danish woman who has become more French over the last thirty years than some natives will ever be. "Everything inspires me except fashion," says the designer. And it's easy to believe: her prints are so beautiful and varied they instantly whisk you off to faraway destinations. What a nice way to travel the world without leaving the Left Bank! The Frenchies love that idea.

epice.com

♥ WE LOVE ...
the elegant checked designs inspired by Masai motifs and produced in different colors each year.

② THE OVERSIZED TEAPOT

Chinese black tea was brought to Europe by the Dutch in 1606. The English took to it quickly, but so did aristocratic French "salons," which in fact inspired Perfidious Albion's four o'clock tea tradition. Tea was eventually replaced in France by coffee and hot chocolate, only to reappear in the late nineteenth century in an imitation of English chic. Writing, thinking, and studying for exams requires fuel, and tea has secured its role as trusted companion for those long, earnest afternoons. Every Intellectual has an oversized teapot stashed in their cupboard.

THE ICONIC BRAND: GUY DEGRENNE

Founded in 1948 by a visionary silversmith enthusiast and still popular on French wedding gift lists, this brand helped democratize "silverware" in France by introducing stainless-steel cutlery, supposedly using the steel from armored tanks abandoned after the 1944 Normandy landings. Postwar housewives loved how easy this material was to look after. Since then, the company has conquered the world, Intellectuals included, who love to have a Diptyque Feu de Bois scented candle burning in the background while they fill up on tea from a Salam teapot—a white porcelain model nestled inside a felt-lined stainless-steel cover, and one of Guy Degrenne's bestsellers since 1953. Do give yours a few dents, to prove you haven't just bought it!

degrenne.fr, diptyqueparis.com

WE LOVE ...
the new six-cup black porcelain design with a copper cover that keeps your brew hot twice as long as standard teapots.

③ THE CABINET OF CURIOSITIES

Louis XVI was a great fan of geography and ethnography, and loved the rare bibelots that explorers brought back from their travels (which he'd bankrolled, of course). Collecting exotic plants, insects, horns, stuffed animals, fossils, and stones from unknown lands excited enlightened minds, and amassing treasure troves of extraordinary pieces was quite the rage. No château or *hôtel particulier* was complete without its "cabinet of curiosities," greenhouse, or aviary. Joséphine de Beauharnais, the first wife of Napoleon I, even kept, in her park at the Château de la Petite Malmaison, ostriches and other lovely bird specimens that reminded her of her native Martinique.

THE ICONIC BRAND: DEYROLLE

Created in 1831 by the Deyrolle family, the store is now located in a former *hôtel particulier* on the rue du Bac and remains endearingly unique. Its stock of maps, books, botanic specimens, horns, and stuffed animals is endlessly fascinating. Acquired in 2001 by Louis-Albert de Broglie, the "gardener prince," it has dusted off its collections to launch contemporary collaborations with cutting-edge artists and fashion labels, while continuing to offer a world-famous selection of mounted insects and butterflies, animal taxidermy, and seashells.

deyrolle.com

♥ WE LOVE ...
the magnificent midnight-blue damselfly *Calopteryx splendens*, and the gold and green beetle *Carabidae coleoptera*, which would look stunning on a desk or worktable.

④ LITTLE COTTON UNDIES

Until the early nineteenth century, underpants were for men: high-society women went bare under their skirts. Only servants, who often found themselves bending over in public, were permitted to cover their derrieres. Modeled after the long, voluminous undergarments worn by little girls, the first divided underpants for women followed on from hooped skirts, which sometimes provided awkward intimate glimpses of those wearing them. Thus, modesty was born.

THE ICONIC BRAND: PETIT BATEAU

Pierre Valton, creator of a lingerie workshop that became Petit Bateau in 1920, invented modern underpants in 1918. Designed without the traditional long legs, made of cotton jersey rather than rough wool, and with an elastic waist instead of buttons, his innovation went on to win the Grand Prix at the 1937 World's Fair in Paris. Petit Bateau remains the favorite brand of Intellectuals and college girls in the bookish fifth arrondissement. The white crewneck T-shirt (size: sixteen years old) is a staple of the Parisian woman's wardrobe.

petit-bateau.fr

WE LOVE ...
the 1960 version of the hundred-year-old little white undies in a cotton piqué called "*à point cocotte.*" The French have made it an emblem of sexy innocence.

⑤ THE "BLANCHE"

Formerly known as the NRF (*Nouvelle Revue Française*/New French Review), this literary collection founded in 1911 is legendary in France. The authors it publishes collect literary prizes like other people collect stamps—there are 38 Nobel Prize winners in the bunch—and the catalog abounds with French heroes: Proust, Gide, Malraux, Camus, and Sartre are all on the roster. The simple design—a red title on a cream background—guarantees an elegant library. And a slim volume peeking out from the pocket of an overcoat puts the final touch on a certain brand of style.

THE ICONIC BRAND: GALLIMARD

The "Blanche" is a core collection of this publishing house, which has close ties with twentieth-century and contemporary French literature. Founded by Gaston Gallimard, it is now directed by his grandson, Antoine. Aspiring writers still dream of signing with Gallimard.

gallimard.fr

❤ WE LOVE ...
the notebooks, which borrow design details from the books in the collection. Between the covers, which play on the titles of famous works by Blaise Pascal or Michel Foucault, lie finely lined pages that just beg to be written on.

 # THE LUXEMBOURG GARDEN CHAIRS

Before they became a favorite spot for students cramming for exams, the wonderful Luxembourg Gardens were a hunting ground where young Louis XIII chased after wild boar. Until the French Revolution, philosophers went there to philosophize, and lovers exchanged confidences away from prying eyes. Napoleon I had play areas built for children, and then little carts pulled by adorable goats or donkeys appeared. In 1879, Charles Garnier built the wooden carrousel, whose horses have delighted generations of children. It's hard to get bored at the "Luco," as the gardens are known, because they have something for everyone: beekeeping classes, orchid-filled greenhouses, bandstands, tennis and basketball courts, teams playing *pétanque*, spots where chess grandmasters can plot their moves, bars, ponds with drifting miniature sailboats, and even an annual match of court (or "real") tennis. The laziest visitors lounge in the famous green chairs, which are now free to use (until 1974, attendants known as *chasières* would collect a rental fee).

THE ICONIC BRAND: FERMOB

In 1953, this nineteenth-century brand founded by a blacksmith began to specialize in the metal furniture that is now the pride of cafés and public gardens all over Paris. The folding bistro chair has been a bestseller for years, and the brand now offers a whole collection of outdoor furniture in bright colors.

fermob.com

WE LOVE …
the low-slung "Luxembourg" chair, ever-popular in public gardens but just as comfortable in private ones.

THE GOURMET INTELLECTUAL

Cerebral sustenance is all well and good, but it doesn't necessarily recharge the batteries of those who think (and therefore are). Intellectuals really appreciate quick dishes served in neighborhood bars—they've got better things to be doing, after all—like hot goat cheese salad or a platter of something that can be snacked on while in the midst of a heated debate. The *croque-monsieur* is a perennial favorite. In the 1990s, Intellectuals loved the *poilâne-jambon* (sourdough bread and ham) variation from the Cantal region, and now they like their *croque* made with Poujauran sandwich bread and truffle-infused salt, like the one served at Café Trama, or with savory pastry cream, available at pastry chef Sébastien Gaudard's shop. Intellectuals, of course, take notes while they eat, otherwise they'd be caught licking their fingers.

Their ability to go from café to café without eating anything hasn't escaped the notice of bistro owners who'd like to see the bill tally up to something with a bit more meat. This habit is a holdover from high school when the Intellectual stayed out for ages with friends at the local bistro, smoking like a firefighter. That hazy legend blew away forever in early 2008 when smoking was banned in bars and restaurants ... Nostalgia just isn't what it used to be!

Café Trama
83, rue du Cherche-Midi, Paris VIᵉ

Pâtisserie – Salon de thé des Tuileries,
Sébastien Gaudard
1, rue des Pyramides, Paris 1ᵉʳ

THE INTELLECTUAL'S WELSH RAREBIT RECIPE
(LIKE THE ONE AT CAFÉ FLORE)

This Welsh version of the *croque-monsieur* has somehow become a sought-after classic at the Flore, the legendary café in Saint-Germain-des-Prés adored by both tourists and locals alike. The place even awards its own literary prize. The Flore's rarebit makes for an ideal pre- or post-show snack.

Serves 2

Ingredients
→ Scant 2 cups (225 g) grated Cheddar
→ 4 tbsp (60 ml) beer
→ 1 tsp (5 ml) mustard
→ 4 slices of whole wheat sandwich or country-style bread

Method
❶ In a soup pan, melt the Cheddar into the beer and add mustard.
❷ Toast the bread.
❸ Place the bread in a roasting pan.
❹ Pour the melted Cheddar over the toast.
❺ Grill in the oven.
❻ Eat while it's still steaming—and don't worry if you burn your tongue (that's part of the fun!).

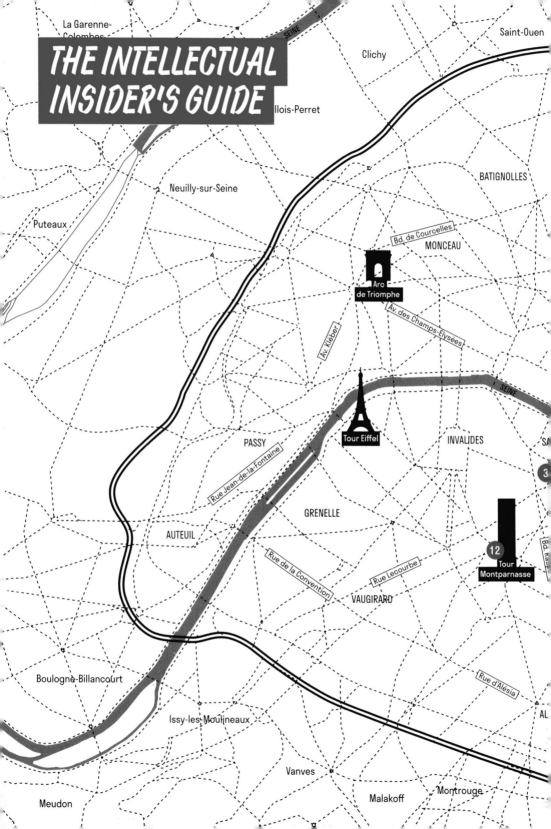

THE INTELLECTUAL INSIDER'S GUIDE

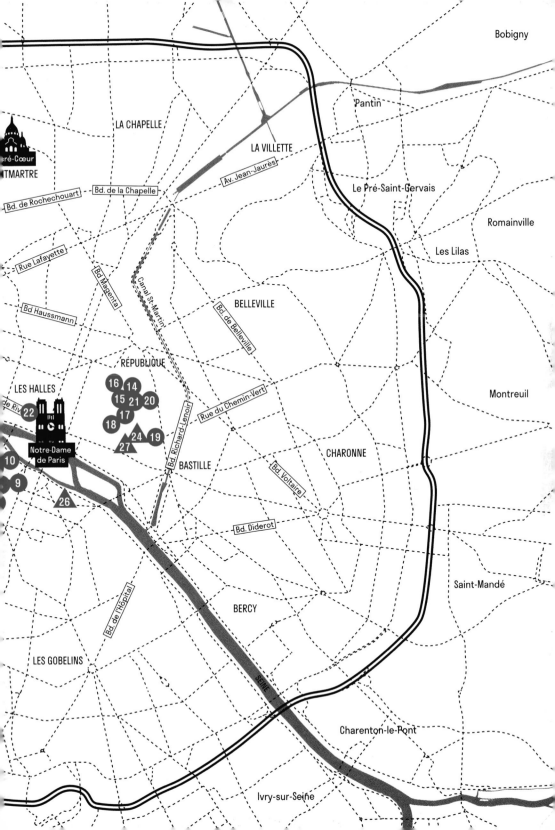

THE INTELLECTUAL IN PARIS

Starting in the seventeenth century, writers, philosophers, and budding revolutionaries settled on the Left Bank of the Seine. Mere steps separate the Latin Quarter from the site of the Revolutionary Tribunal, and Danton and Robespierre would regularly set off on rabble-rousing business from their usual haunt, the Procope, the oldest literary café in Paris. Several centuries later, Lenin and Trotsky—before things turned sour between them—hunkered down at the Closerie des Lilas to play chess and plot. After World War I, the lively Montparnasse neighborhood, with its many music halls, theaters, and cabarets, became a haven for penniless painters who ate and drank on credit in establishments that have since been lost to posterity. Fitzgerald, Stein, and Hemingway, for whom Paris was *A Moveable Feast*, found inspiration in this band of creative bohemians. As Paris was recovering from the German Occupation, a black-clad Juliette Gréco put the Tabou on the map, a jazz club frequented by Boris Vian and Miles Davis. In 1968, the Sorbonne, the prestigious university harking back to the Middle Ages, was the scene of historic student protests. Older students rounded up their younger peers from surrounding high schools; soon the entire neighborhood bristled with barricades, and the uprising spread throughout the rest of France. Today, it remains a favorite *quartier* for respected publishing houses and top universities, but the area is slowly being eaten up by luxury brands and banks. Yet it still manages to capture the imagination of those who long for the legends of yesterday.

THE PERFECT INTELLECTUAL LANDMARK?

1 **LE CAFÉ LA PALETTE,** a little 1930s gem adored by Picasso, Jim Morrison, and Paul Auster, is the perfect place for having an (expensive) drink, talking into the wee hours, and being scolded by the waitstaff.
43, rue de Seine, Paris VIe

OUT AND ABOUT WITH THE INTELLECTUALS

This tribe remains partial to the Saint-Germain-des-Prés and Montparnasse neighborhoods, but its intellectual comfort zone has expanded to include the Marais, where it mingles with the young and hip.

IN SAINT-GERMAIN

The *quartier* where Descartes is buried, Hemingway scribbled, and Miles Davis serenaded Juliette Gréco is full of alluring addresses to tempt you away from your books.

2 **DRAPE YOURSELF IN GOLD** with bangles by Adelline, a Parisian designer who divides her time between India and Paris and offers a selection of jewelry created in her workshops in Jaipur. Cabochon rings, cuffs, and chain necklaces in simple precious metals make you want to drop everything and ride off into the sunset.
54, rue Jacob, Paris VIe

3 **FORGET THE FLORE AND HEAD TO BRASSERIE LE ROUQUET,** a 1950 masterpiece once frequented by literary-minded diners. The wall lamps and crazy neon lighting alone are worth the visit. While the food is not as delicious as at the Flore, you're sure to run into some literary locals or publishing folk with offices nearby.
188, boulevard Saint-Germain, Paris VIIe
+33 (0)1 45 48 06 93

4 **GO HUNGRY AND GO EARLY** to L'Avant Comptoir, a den of Southwestern French food that goes heavy on the blood sausage and pigs' feet, and where chef Yves Camdeborde reigns supreme.

No reservations, so come early or late (not at 1 p.m.) and you might just get delicious tapas for lunch.
3, carrefour de l'Odéon, Paris VIᵉ
+33 (0)1 44 27 07 50

5 TAKE A (QUICK) STEP BACK IN TIME with dresses created from remnants of vintage silk by designer Charlotte Bialas. They call to mind the exquisitely chic writer and muse Louise de Vilmorin, a strong-minded woman who made frivolity dignified.
67, rue Madame, Paris VIᵉ
+33 (0)1 57 40 69 10
charlottebialas.com

DEVOTE YOURSELF to a morning at La Procure, "the largest Christian bookstore in Europe," after a bitter espresso at Café de la Mairie. This wonderfully preserved bookshop with friendly staff has featured in a number of French films. While brushing up on your bible studies, you can also stock up on secular literature. There's even a corner reserved for a heavenly selection of monastic produce.
6 La Procure
3, rue de Mézières, Paris VIᵉ
+33 (0)1 45 48 20 25
laprocure.com
7 Café de la Mairie
8, place Saint-Sulpice, Paris VIᵉ
+33 (0)1 43 26 67 82

8 PLAY WITH A "PERFUME ORGAN" like a modern-day decadent at cult perfumer Iunx. Sampling the brand's spare, refined fragrances is an experience in itself. The rest of rue de Tournon is lined with elegant specialty boutiques, and is to Saint-Germain-des-Prés what avenue Montaigne is to the sixteenth arrondissement—that is to say, a shopping hotspot.
13, rue de Tournon, Paris VIᵉ
+33 (0)1 42 02 53 52
iunx-parfums.com

MAKE LIKE A CONNOISSEUR at these two Saint-Germain art galleries overseen by the legendary Kamel Mennour, the best contemporary art dealer in the area.
9 47, rue Saint-André-des-Arts, Paris VIᵉ
10 6, rue du Pont de Lodi, Paris VIᵉ
+33 (0)1 56 24 03 63
kamelmennour.com

SCULPT OUT SOME TIME to visit a little haven of green like the one at the Musée Zadkine, dedicated to the talented sculptor Ossip Zadkine. The workshops of Zadkine and sculptor Antoine Bourdelle, two symbols of Montparnasse's golden age, are each perfectly preserved in their respective museums.
11 Musée Zadkine
100 bis, rue d'Assas, Paris VIᵉ
+33 (0)1 55 42 77 20
zadkine.paris.fr
12 Musée Bourdelle
18, rue Antoine Bourdelle, Paris XVᵉ
+33 (0)1 49 54 73 73
bourdelle.paris.fr

13 TURN ON THE CHARM and convince a resident to let you into the cour de Rohan, an exquisite group of historic buildings, some dating back to the Renaissance. Here, Balthus had a workshop, Georges Bataille held some memorable parties, David Hockney painted, Sheila Hicks had an apartment, and the Fondation Giacometti occupies a *hôtel particulier*. At 38, boulevard Raspail, flash those pearly whites again to charm your way into the courtyard and to discover the glass-roofed workshop of fashion designer Rabih Kayrouz, located in a former theater where *Waiting for Godot* was first performed.
Cour de Rohan; enter via rue du Jardinet or cour du Commerce.

IN THE MARAIS
The Bas Marais, or Lower Marais—home to splendid seventeenth-century *hôtels particuliers*, heaps of falafel, the Musée Carnavalet and Musée Cognacq-Jay, famous fashion brands, and the place des Vosges—is certainly wonderful, but it's also crammed with tourists. The Haut Marais, or Upper Marais—the little triangle of the third arrondissement tucked between rue Rambuteau and place de la République—has become sought-after real estate and resonates with an Intellectual spirit that is at once intimate, refined, and conceptual.

14 PLAY THE EXISTENTIAL DIVA at Marilyn Feltz, whose "Edith" suit and "Marlène" dress, along with other well-cut marvels, evoke the sexy and glamorous silhouettes of a bygone age. (They're all made in France, *naturellement*.) The rest of rue Charlot should be explored thoroughly.
28, rue Charlot, Paris IIIᵉ
+33 (0)1 40 26 39 48
marilynfeltz.com

15 BASK IN BEAUTY ON RUE DE SAINTONGE
→ AT NO. 26, Gachon Pothier: This shop run by
two shrewd globetrotters is a well-guarded secret
where locals go for gifts. It carries a large choice
of unique jewelry and original bed linens.
+33 (0)1 42 71 34 15
gachonpothier.com

→ AT NO. 45, Grand Café Tortoni: French beauty
dispensary Officine Universelle Buly dreamed
up a magnificent re-creation of a nineteenth-
century cosmopolitan Parisian café for its flagship
store. Admire the vintage apothecary products
(*pommade virginale* face cream, *opiate dentaire*
toothpaste) that pay homage to Balzac's decadent
perfumer César Birotteau, and try an espresso-
flavored madeleine or a lemonade at the bar.
+33 (0)1 42 72 28 92

16 INDULGE IN EARTHLY DELIGHTS on rue de Bretagne,
the epicenter of fashionable food in Paris.
→ AT NO. 39, MARCHÉ DES ENFANTS-ROUGES: One of
the only markets in Paris where you can really have
lunch. Stop at Madame Kaeko's little shop, which
serves the best Japanese comfort food around.
There's also an annex on nearby rue Pont-aux-Choux.
Pontochoux (Madame Kaeko)
18, rue du Pont-aux-Choux, Paris IIIe
+33 (0)9 86 70 77 00

→ AT NO. 47, CHEZ OMAR: Despite being constantly
swamped, the best couscous restaurant in Paris
has managed to preserve its original bistro decor
and spirit.
Does not accept reservations or credit cards.
+33 (0)9 86 39 91 14

→ AT NO. 57, BONTEMPS: This pastry shop's incredible
shortbread tarts draw cake fans from far and
wide—and for good reason.
+33 (0)1 42 74 10 68

RETURN TO THE ROOTS OF STYLE and escape from
standardized chain-store offerings at Christophe
Lemaire, whose unique designs everyone must
see for real, at least once; at Isaac Reina, whose
minimalist leather bags and clutches are works
of art; and at Studio Marisol, where the stylist
revered by Parisians for her dry haircuts
also exhibits surreal capillary sculptures
in her chic studio.

17 Christophe Lemaire
28, rue de Poitou, Paris IIIe
+33 (0)1 44 78 00 09
lemaire.fr
18 Isaac Reina
12, rue de Thorigny, Paris IIIe
+33 (0)1 42 78 81 95
isaacreina.com
19 Studio Marisol
33 ter, rue des Tournelles, Paris IIIe
+33 (0)1 44 61 18 34
studiomarisol.com

GET YOUR ARTY VIBE ON at the Yvon Lambert
bookstore, which stocks ravishing high-end
magazines and art and photography books
selected by the gallerist himself.
20 14, rue des Filles du Calvaire, 75003 Paris
+33 (0)1 45 66 55 84
shop.yvon-lambert.com

BROWSE THE BEST at Gallery S. Bensimon, dedicated
to creation in all its forms. Enjoy a range of
furniture and objects curated by the keen eye
of Serge Bensimon, a fan of the beautiful and
the rare (and of little canvas tennis shoes).
21 111, rue de Turenne, Paris IIIe
+33 (0)1 42 74 50 77
gallerybensimon.com

22 ELSEWHERE
Hang out at 59 rue de Rivoli, a building
formerly occupied by the Crédit Lyonnais bank
that stood abandoned for years before being
turned into a "squART" in 1999 by a group of
young artists. It has since been recognized as
a bona-fide art institution and converted into
artists' studios open to the public. It hosts
exhibitions in a lighthearted and relaxed
atmosphere, all with the city's blessing.
59, rue de Rivoli, Paris Ier
59rivoli.org

INTELLECTUAL CONFIDENTIAL

TAKE A CEREBRAL STROLL AROUND THESE ROMANTIC ADDRESSES ...

23 WALK IN THE FOOTSTEPS OF GENIUS: On rue Campagne-Première, take time to read the commemorative plaques on the buildings' exteriors. Some of the world's finest writers and artists have stayed here: Aragon wrote poems for his wife, Elsa Triolet, here; Verlaine and Rimbaud loved each other in a squalid little room; and Jean-Luc Godard had Belmondo die here in his film *Breathless*. Other famous residents have included Foujita, Man Ray, Nicolas de Staël, and 1920s It-girl Kiki de Montparnasse.

24 PAY HOMAGE TO PROUST: The Musée Carnavalet, a lovely museum recording the history of Paris and its inhabitants, was conceived by Baron Haussmann in 1866. A rarely visited corner houses a re-creation of Marcel's Proust's bedroom. Yes, the very same one in which he holed up, for years, until his death, writing *À La Recherche*—as it's known by people who have started it (but perhaps still haven't found the time to finish it).
16, rue des Francs-Bourgeois, Paris III^e
carnavalet.paris.fr

25 PRIME YOUR PALETTE: Sennelier, a store founded in 1887, furnished Cézanne, Degas, and Picasso with artist's supplies. You don't need your work to be exhibited at the Musée d'Orsay to fall for a few of their lovely pastel crayons—and the shop itself is fitted out with ancient shelves the artists themselves would have known. Take your fill of the unique ambience and evocative aroma.
3, quai Voltaire, Paris VII^e
sennelier.fr

26 SPLASH AROUND IN STYLE: The pool on rue de Pontoise, in the heart of the Latin Quarter, has retained its original art deco walkways and changing cabins. *Mens sana in corpore sano*, a sound mind in a sound body: Intellectuals like to swim here when they aren't doing tai chi in the Luxembourg Gardens.
19, rue de Pontoise, Paris V^e
parisinfo.com

27 DISCOVER THE SACRED SIDE OF ART NOUVEAU: The spectacular synagogue on rue Pavée in the Marais was designed by famous art nouveau designer Hector Guimard, who transformed the narrow space between two buildings into a lofty masterpiece. The building survived a Nazi blast but today is open for visits only on European Heritage Days during the month of September. However, its façade can be admired from the street.
10, rue Pavée, Paris IV^e

28 ORGANIZE A ROMANTIC RENDEZVOUS: Meet your beloved on the bustling terrace of Treize. This small café/restaurant is always swarming with pretty girls drawn by the two friendly ladies who run the place and the "no-fry fried chicken." Here, a mere stone's throw from the Luxembourg Gardens, they share sizzling secrets over Pimentos (lemonade with spicy ginger) and coffee by local roaster Coutume. The cherry on the cake (which happens to be excellent): offering your date a bouquet from the charming flower bar.
No reservations.
5, rue de Médicis, Paris VI^e
treizebakeryparis.com

THE INTELLECTUAL ONLINE

For a taste of material—but also spiritually fulfilling—pleasures without having to leave your desk, apply your intellect to these stimulating outlets.

JARDINS D'ÉCRIVAINS

These candles are designed specifically for reading in bed. The intensity of their flame is calculated to help you focus during this sacred moment, and each of their fragrances evokes a writer and a place that he or she loved. Colette, Hugo, and Balzac all appear in this olfactory guide to the brightest and best.
jardinsdecrivains.com

PROÊMES DE PARIS

Young, hip Intellectuals love this snobbish little brand, whose ambition is to connect fashion and literature. Besides the very pretty yearly collections, T-shirts with feminist messages like *"Les filles qui lisent sont dangereuses"* (Girls who read are dangerous) are collectors' items.
proemesdeparis.com

PAPIER TIGRE

This stationery brand is dedicated to preserving the written word in an increasingly digital age. Notebooks, calendars, notepads, and irresistible weekly agendas in modern designs offer a serious challenge to the supremacy of electronic planners and stylus-enhanced tablets.
papiertigre.fr

HUGO MATHA

After the success of his micro-bags in wood and plexiglass—admired by beautiful, brainy girls, and perfect for toting around notebooks—Hugo Matha was asked to design the staff uniforms at the iconic Hôtel de Crillon.
hugomatha.com

HAIR DESIGNACCESS

These sublime, French-made metal hair accessories are designed by Sylvain Le Hen, a Beaux-Arts graduate and one of the most well-known catwalk hair stylists. Instead of complicated decoration, he favors clean, contemporary designs like the already legendary Queue de Cheval hair clip, which gives the simplest ponytail a certain studious Latin Quarter charm.
hairdesignaccess.com

DE BONNE FACTURE

This site, which offers a timeless masculine wardrobe, is much adored by Japanese fashionistas, whose sense of style is irreproachable. The materials, cuts, manufacture, and elegant finishes are all carefully thought out and wear well over time. Each French workshop that collaborates with the brand is beautifully presented in prose worthy of a novel.
debonnefacture.fr

THE INTELLECTUALS ON VACATION

HEAD STRAIGHT TO ... PROVENCE!

Or—more precisely—Arles and Avignon, which, for several decades, have attracted the cream of France's cultural scene. A favorite source of inspiration for the photographer Peter Lindbergh and home to the Fondation Luma, Arles enjoys a reputation as a major center for photography and art. As for Avignon, it has hosted the collections of theater director Jean Vilar and gallerist Yvon Lambert, who, no doubt tired of Paris, decided to launch his own foundation there in 2000, tucked into an eighteenth-century former *hôtel particulier*. This corner of Provence combines the practical with the pleasant; from spring till fall, the region's festivals are celebrated to a soundtrack of cicadas under the "yellow

sun" so beloved of Van Gogh. One after another, theater-goers, starlets, music lovers, and discerning spectators populate landscapes immortalized in the films of Pagnol and in paintings by Gauguin, Cézanne, and Matisse. It is hard to avoid running into someone you know from Paris at the Rencontres d'Arles photography festival or the theatrical Festival d'Avignon, both of which are exceedingly popular pilgrimages. Renovated manors and farmhouses welcome these seasonal visitors, who soon find themselves peppering their conversations with all kinds of quaint—and surprising—words of dialect. In this region, where wine has been made since Antiquity, you don't mess with rosé or pastis, which purists revere and serve with nothing more than ice. As a general rule, the regional cuisine is serious business, rich in garlic, fragrant herbs, and olive oil. In other words, this is not the place to start a diet.

ARLES AND THE SURROUNDING AREA
On the program

START THE PARTY EARLY
Have a morning apéro at the Café de la Place in Saint-Rémy-de-Provence.
17, place de la République,
13210 Saint-Rémy-de-Provence
+33 (0)4 90 92 02 13

REPLENISH YOUR STORES
You'll find good olive oil and wine at Château Romanin, conveniently located between Eygalières and Saint-Rémy-de-Provence.
29, route de Cavaillon,
13210 Saint-Rémy-de-Provence
+33 (0)4 90 92 69 57
chateauromanin.com

BE YOUR OWN SWISS FAMILY ROBINSON
Immortalized by photographers Peter Lindbergh and Dominique Issermann, Beauduc Beach is an impressive stretch of sand reached only after bumping down several miles of crazy tracks. In the early 2000s, the local authorities ordered the destruction of the makeshift cabins that had been built on the beach by fishermen, salt manufacturers, and vacationers, but a community group fought tooth and nail to preserve these unauthorized but picturesque constructions. Out of this world and timeless—few maps even mention it—this haven is definitely "worth the detour."
→ TO GET THERE: After Arles, take the D36 toward Salin-de-Giraud. Several miles before the village, head right toward La Belugue, then continue straight until you reach a dirt road about six miles (ten km) long, which leads to Beauduc.

BRUSH ELBOWS WITH GREATNESS
Visit the fifteenth-century Hôtel Léautaud de Donines, the new home of the Fondation Vincent van Gogh, where the work of the famous Dutch master hangs alongside that of contemporary artists.
35 ter, rue du Docteur Fanton, 13200 Arles
+33 (0)4 90 93 08 08
fondation-vincentvangogh-arles.org

STAY AS COOL AS A CUCUMBER
Once you've filled your basket in one of the Alpilles' most picturesque villages, make a Friday visit to the Alchemist's Garden at Eygalières, located a couple of miles from the home of Nostradamus: a mysterious place where mandrakes, helianthus, olive trees, daturas, and hellebores cohabit.
Le Jardin de l'Alchimiste, 13810 Eygalières
+33 (0)4 90 90 67 67

TOAST TO THE ILLUSTRIOUS COMPANY
Over time, the Hôtel Nord-Pinus, a former waystation and one of the city's institutions, became a very bohemian and fashionable rendezvous for celebrities like the matador Dominguín, Picasso, artist Peter Beard, poet and author Jim Harrison, and Christian Lacroix.
14, place du Forum, 13200 Arles
nord-pinus.com

DREAM SWEETLY
Mas Saint-Florent, an eighteenth-century family home surrounded by vast gardens, has become a sought-after guesthouse. Located at the edge of Arles, it is tastefully decorated by Gilbert, the master of the house. Thoroughly in love with the region, he will happily share his favorite addresses, historical knowledge, and tips— all with a smile.
le-mas-saint-florent.com

SAY IT WITH SCENT
Fabienne Brando's lovely Parfumerie Arlésienne stocks vegetable-based soaps, perfume diffusers, and the famed Eaux d'Arles and de Carmague, all wrapped up in charming, understated packaging.
26, rue de la Liberté, 13200 Arles
+33 (0)4 90 97 02 07
la-parfumerie-arlesienne.com

AVIGNON
On the program

STAY IN SEVENTH HEAVEN
The Divine Comédie, an elegant bed-and-breakfast (and paradise on earth), is right next to the old papal city. The exceptional garden includes a swimming pool and a spa area where guests can relax in peace.
16, impasse Jean-Pierre Gras, 84000 Avignon
la-divine-comedie.com

PAY HOMAGE TO JEAN VILAR
The founder of the Festival d'Avignon dreamed of a space dedicated to rehearsals and to artistic endeavor. His wish was fulfilled by La FabricA, which hosts artist residencies. Each July, this six-hundred-seat covered theater welcomes an enthusiastic audience.
11, rue Paul-Achard, 84000 Avignon
festival-avignon.com

REFUEL IN STYLE
La Mirande is the gastronomic restaurant in the hotel of the same name, located in a former private home in the shadow of the papal palace. Enjoy the fragrant garden, where palm, fig, and orange trees shelter you from the brouhaha of festival goers. The service is exquisite, and the food quite wonderful.
4, place de l'Amirande, 84000 Avignon
+33 (0)4 90 14 20 20
la-mirande.fr

BRUSH UP ON YOUR COCKTAILS

The bar at the Hôtel d'Europe, which is also known as "the Roof of Europe," is open every Friday and Saturday evening in summer. Expect cocktails and champagne, cheese by Madame Vigier de Carpentras, photography exhibitions, DJs, and starry nights. Reservation recommended.
12, place Crillon, 84000 Avignon
heurope.com

SHARPEN YOUR SENSES

The elegant and excellent restaurant Christian Étienne is an Avignon institution, now overseen by chef Guilhem Sevin. Dine to the magical sound of trumpets in the courtyard of the papal palace.
10, rue de Mons, 84000 Avignon
+33 (0)4 84 88 51 27
christianetienne.fr

TAKE TIME OUT

Picnic in the shade of umbrella pines in the Rocher des Doms garden overlooking the city. (Ducks and geese might stop by for a chat.)

THE ECO-
WARRIORS

ARE YOU

INTENSELY,

A LITTLE,

VERY,

MADLY,

OR NOT AT ALL...

ECO-WARRIOR?

QUIZ

● I have sheep to mow the lawn for me.
● My budget for essential oils could feed a family of four. ● My youngest child collects Greenpeace posters. ● Quinoa is good, but Ethiopian teff is even better. ● The weeds in my garden often end up on my plate. ● I avoid supermarkets like the plague.
● I clean my teeth with a miswak twig. ● I can never have enough decorative wooden crates. ● I haven't eaten cow's milk yogurt since 2002. ● I'm trying to persuade my girlfriends to switch to a menstrual cup.
● I made the building co-op install beehives on the roof. ● I force my kids to read Colette, Ralph Waldo Emerson, and Jean-Jacques Rousseau.

→You checked 7 to 12 statements. You are an ultra-Eco-Warrior. But you might discover a few more ideas for living the slow life in this chapter.

→You checked between 3 and 6 statements. You're on the right path, but striving for a little more green in your life wouldn't hurt.

→You checked 2 or fewer statements. All right, calm down. Take a deep breath and realign your chakras by reading the following chapter.

BACKSTORY

"Nature never deceives us; it is always we who deceive ourselves."
—Jean-Jacques Rousseau.

Eco-Warriors have sown organic seeds, cultivated their community gardens, let their country roots grow, ploughed the way for all things healthy, and brought yoga to France.

Eco-Warriors are the modern, urban, and rather glamorous heirs to the first ecologists. They've made quite the comeback. Their quest for physical and spiritual well-being in a country where herbal tea is referred to as *pisse-mémé* (for its diuretic effect on elderly women) made them the butt of many jokes. In France, a Cartesian country resistant to finicky alternative lifestyle choices, yoga was long considered a kind of water aerobics without water, and quinoa a habit reserved for grain-eating snobs. Eco-Warriors were an easy target. In the 1990s, on their return from trips to New York, London, and Los Angeles, they felt aggrieved: there were no juice bars or health-food restaurants to be found anywhere in France. In the past few years, however, they have achieved a decisive victory: avocado toast now proliferates in Veggietown, the area around the rue du Faubourg Poissonnière and rue de Paradis, where vegan restaurants and organic boutiques have sprung up like mushrooms on a log.

Their art of slow living has gradually colored the habits of city-dwellers across the country, who are dismayed to learn that their children think that fish is caught already frozen, square, and breaded, or scandalized that shopping has become a cultural pursuit. Obviously, Eco-Warriors themselves haven't stopped buying things; they've just started buying better—which is easy to do in a land of plenty like France. They have an exhaustive knowledge of untreated almonds from the Roussillon region, organic spirulina from Provence, and beer brewed in Paris—along with just about every other locavore (and Visa-vore, when you consider how much it costs) marvel. Between their appointments at the naturopath, they enjoy biking to pick up their weekly basket of seasonal vegetables, a "green" subscription they received as a Christmas gift from their other half—even if, deep down, they can't help but think, "Oh no, not chard again."

Having done a lot of jogging, gym, water aerobics, and Pilates, Eco-Warriors have turned to flexing their karma: like their peers in other developed countries, they have taken to yoga in massive numbers. It's impossible to avoid Instagram profiles of recent yoga converts striking ecstatic expressions. Pictures of children imitating their mothers—and there are many—really rack up the likes. The French high priestesses of yoga—from former *Elle* journalists or models like Caroline

ZEN ICONS

Alexandre Jollien, Matthieu Ricard and Christophe André: these masters of mindfulness and spirituality teach the Eco-Warrior how to cope—philosophically and without meltdown—with traffic jams, strikes, and their mother-in-law.

GOURMET ICON

Alain Passard: In 2001, determined to show the French that vegetables can be creative, the Michelin-starred chef at Arpège in Paris took red meat off the menu, working instead with produce from his own gardens. At first roundly mocked, today he is celebrated as a pioneer of vegetarianism.

GREEN AND
GLAM ICONS

Angèle Ferreux-
Maeght, Agathe
Audouze, and
Catherine Kugler:
These chefs have
conquered Parisian
appetites, encouraging
healthy eating in
their restaurants and
influencing shoppers'
tastes in the aisles
of the local health-
food store.

Benezet—regularly share their insights in the media and at shrines like the very popular Tigre Yoga Club in Paris. Thank goodness Eco-Warriors no longer need to take the plane to devote themselves to kundalini and similar exotic disciplines.

The organized exploitation of the planet obviously enrages this family: they are ready to do just about anything to acquire objects with irreproachable origins, ranging from upcycled goods (water glasses made from vintage bottles) to those Made in France (tote bags made of Carcassonne hemp) and everything low-tech (yes, darling, you can have fun playing with a wooden car!). Run-of-the-mill globalized merchandise is not their cup of maté; but the beautiful and the unique? Oh, yes. To be honest, French Eco-Warriors are more preoccupied with "egology" than ecology—but it's hard to hold it against them when they're responsible for reviving the entire central France lumber industry in Limousin.

This tribe dresses "sustainably," with fair-trade principles always in mind—but they have their limits. Natural fibers are fine, but you won't find them at the local environmental flashpoint protesting a new airport. They'll consider switching to vegetable leather only after they've given up eating roast chicken (which is proving difficult). And yet, when it comes down to it, they're not all that interested in fashion. They would rather invest in ecologically responsible vacations and sleep in a yurt equipped with a hay bath—the ultimate anti-stress treatment, apparently—in the middle of nowhere. They also thrill at the idea of a trip into the wilderness to gather wild herbs with a paleo chef. They like to schedule downtime as a family, getting away from the city's pesky particle pollution and brushing up on their vegetable gardening skills. The youngest adolescents, converts to the Zero Waste movement, try to convince their parents, without much success, that showering once a week "is much better for the planet." The older ones nag if their parents don't take reusable containers to the organic market (not that they'd actually go themselves, of course). As for the youngest child, who can already identify six types of heritage tomato—his parents are as proud of him as if he were a virtuoso pianist.

CODE OF CONDUCT

Eco-Warriors have contributed to three cultural revolutions in France.

Complain about your plumbing in public

Talking about one's physical woes used to be frowned upon. The obligatory "How are you?" usually required nothing more than a simple "Fine, and you?" in return. But the many self-diagnosed intolerances unearthed by the Eco-Warriors fly in the face of this unspoken rule. Explaining in detail that lactose makes you sick or that gluten gives you gas is now a very fashionable way of catching up with other people—and, astonishingly, it seems they're actually interested.

Throw a tantrum at the table

The Eco-Warriors' sometimes radical dietary choices—raw food only; no meat, dairy products, or gluten; a little fish from time to time, etc.—often challenge traditional French attitudes toward food. Once upon a time in France, anyone over the age of two ate everything without invoking his or her personal preferences. The opposite attitude is now completely acceptable. Coming up with a dinner menu to suit all guests has become an extremely delicate task.

Shun car ownership

The automobile has long been a symbol of freedom, even gratification (in the case of the most beautiful or powerful cars), for the French, a Latin people who used to get rather excited by driving. Eco-Warriors have shattered this image: having a car is uncivil, and traveling alone in one is practically a crime against humanity. It doesn't matter if you've got tons of stuff or elderly parents to drive around: it's just plain BAD.

I'D RATHER DIE THAN ...

Delegate control over the juice extractor

Cook eggs in a scratched Teflon pan

Wear T-shirts from H&M

Replace those soap nuts with something that actually cleans laundry

Run out of turmeric for that daily glass of "golden milk"

Miss the annual neighborhood yard sale

Admit that low-energy light bulbs are a pain

Take a twelve-hour flight to veg out under a coconut tree

Miss Saturday sound bath at the yoga studio

Roast an industrially farmed chicken

Buy Nile perch or Kenyan roses

Admit that I just bought a new smartphone

THE ECO-WARRIOR: A WELL-GROUNDED ARTISAN

There was a time when the French mocked the baba cools: hippies and utopian thinkers sporting long locks and goat-hair jackets who settled on remote hilltops to raise sheep. But with the rise of the Eco-Warriors, they have more followers than ever.

GARDENER PRINCES

Marie Antoinette, often and incorrectly described in the French national narrative as a featherbrained nut, was criticized for wanting to play the farmer's wife in a reconstructed hamlet, complete with beribboned sheep and well-groomed pigs. Perhaps to avenge this reputation, a multitude of Eco-Warriors have become top bananas in truck farming. Louis Albert de Broglie—pronounced "Broy"— founded the oh-so-French brand of gardening supplies Le Prince Jardinier. He is also the current owner of the fourteenth-century Bourdaisière château in Touraine. After cleaning out the gutters, he started the National Tomato Conservatory and a micro-farm based on permaculture techniques, with coaching from Maxime de Rostolan. The conservatory features a Tomato Bar where 700 heritage varieties can be tasted and hosts a tomato festival each September.

Another figure with Eco-Warrior tendencies was the Princess Constance de Polignac, who managed her Kerbastic estate in Brittany. This haughty septuagenarian was close friends with Pierre Rahbi, the graying, charismatic pioneer of the French organic movement, who always wears sandals and a straw hat. (They made an unusual pair.) Guided by Pierre, Constance practiced agroecology on her estate and held a weekly market on the property. She even reintroduced saffron and hemp cultivation.

As for the eminent Aristo Chic writer and farmer Valentine de Ganay, she supplies locavore stores and restaurants in Paris with vegetables that she grows on the 1,200 acres (500 hectares) surrounding her Courances château south of Paris. You can even rent a vegetable patch on her land and follow its evolution remotely via the smartphone app Tomato & Co.

WOODLAND ICON

Ernst Zürcher: The German forester's book *The Hidden Life of Trees* became an international bestseller. Did one of his trees tell him about Ernst Zürcher's earlier book in praise of trees?

AQUATIC ICON

Maud Fontenoy: Having triumphed over the seas, this yachtswoman now fights to preserve the ocean.

HIGH-FLYING ICON

Yann Arthus-Bertrand: This activist has proven his affection for the planet by photographing it from every angle, from top to bottom.

A NEW GENERATION OF FARMERS: *NÉO-PAYSANS*

Overqualified and often very well integrated into society, Eco-Warriors nevertheless deem their lives so void of meaning that they abandon their dream jobs to become vegetable farmers. These ex-members of upper management have found a way to avoid the rat race:

**LES LABORATOIRES
DE BIARRITZ**

This cosmetics
company is committed
to protecting the
oceans and specializes
in sun products that
don't pollute the water.
Its Nomas cleansing
powder, developed
for trailblazers,
is 100 percent
biodegradable and
practical: it fits
in a backpack
and saves water.
laboratoires-biarritz.fr

CORSICA BEAUTY

Created by two sisters
in May 2014, this
website carries the
best of Corsican beauty
products. Goat-milk
moisturizing cream
by A Fughjina, myrtle
exfoliating mask by
Realia, helichrysum
and citron restorative
oil by Scentseas, and
citrus soap by the
Savonnerie du Nebbiu
will fill any bathroom
with the wholesome
scent of maquis
shrubland.
corsicabeauty.com

return to the earth to work the land. But not in any old way: the land must be treated with respect. The idea that a better society is possible through better food is gaining ground in France. After decades of junk food and overconsumption, some have decided to roll up their sleeves and get down to business. This new generation of farmers—or *néo-paysans* (new peasants), as they're sometimes called—go back to school to get an alternative education, where they learn to grow food without having to spray crops dressed in full-body protective gear. These innovative farmers, who are also concerned about air quality and building social cohesion, are mocked by politicians.

Large chemical companies also fight these dangerous visionaries, who replace nitrates, fertilizer, and insecticides with plant-based concoctions, insects, earthworms, and even music. As for traditional farmers—who have long since forgotten that we used to hoe, weed, and dig without poisoning ourselves— they watch these anti-sulfate revolutionaries with curiosity. The *néo-paysans*, who have abandoned revolutionary slogans like *"Sous les pavés, la plage"* (Under the cobblestones, the beach) for hoes and permaculture, have recently become the heroes of mainstream culture. The successful documentary *Tomorrow*, by Cyril Dion and Mélanie Laurent, and the essay *Les Néo-Paysans*, by Gaspard d'Allens, record these adventurers who commune with the land.

THE BOURGEOIS RURALISTS

Professional people-watchers have identified a new breed on the block: amateur fans of the ecological trend who, try as they might, never quite succeed in swapping their bourgeois backgrounds for the full rural experience. They want to leave the city and cultivate a garden, but they don't want to get their hands too dirty. Instead they commission ingeniously self-sufficient houses with solar panels or, even better, futuristic homes made from recycled shipping containers. Their certified-organic children, grain-fed and free-range, can entertain themselves all day long without ever getting near a computer. In any case, playing on the seesaw, jumping in puddles with friends, and chasing chickens is way more fun than staying inside all alone on your PlayStation—especially when the internet connection is so bad.

URBAN FARMERS

These clever devils have managed to combine urban practicality with the country pleasantries, by converting underground parking lots into mushroom farms, the walls of buildings into vertical gardens, and city rooftops into vegetable patches. La Caverne, the first organic urban garden in Paris, grows oyster and shiitake mushrooms and endives beneath the Paris streets, and delivers them to clients by bike (of course). These pioneers are greening the city one block at a time. Some restaurants, like the Grands Verres at the Palais de Tokyo and Sur Mesure by Thierry Marx at the Mandarin Oriental, have their own vegetable and herb gardens. Mushrooms proliferate on coffee grounds in Parisian apartments thanks to the start-up Prêt à Pousser, which sells mushroom-growing kits. And that's just the beginning.

ECO-WARRIOR FLORA

Concerned about toxic ingredients present in industrial cosmetics, little by little, Eco-Warriors have adopted natural beauty products. At first, these were met with sneers: frankly, the honey face mask and the goat-milk moisturizer sounded more like a decadent afternoon treat than a beauty potion for harried urbanites. Today, it is the ultimate in chic to brush, clean, shine, scrub, and chase away wrinkles with a green conscience.

BERTHE GUILHEM

This brand celebrates goat milk in all its forms. Recognized for its moisturizing properties, goat milk is even said to help with acne and eczema. No itch or dry patch is too much for these balms, creams, and soaps. *bertheguilhem-cosmetique.com*

APOLDINE

This fashionable new brand specializes in plant-based creams, oils, and lotions that are both extremely effective and totally safe. Its products for babies are fast becoming favorites among Eco-Warrior moms. And the vintage apothecary bottles look great in the bathroom. *apoldine.com*

LA COMPAGNIE DE PROVENCE

This company was the first to sell good old-fashioned *savon de Marseille* in a liquid version, then in flakes. Since then, it has expanded its product line to include simple, natural, and effective beauty products, which also appear in the company's signature pared-down packaging. *compagniedeprovence. com*

ECO-WARRIOR "MUST HAVES"

A selection of strictly well-intentioned items for mind, body, and spirit, wherever you are.

① MANTRA BRACELETS

Bracelets worn in bunches (there's no point in wearing fewer than five) are everywhere. Chain-link versions by Arthus Bertrand, festooned with pendants engraved with the names of one's children, cluster alongside bracelets by Jean Dinh Van. While rock 'n' roll tokens—like cute little twinkling skulls—and Brazilian charms embellish the wrists of the Modern Bourgeois, the Eco-Warrior prefers to display the attributes of a rich interior life. As the early years of the twenty-first century draw to an end, the Eco-Warrior likes to give the impression of being calm and full of good intentions—both for him- or herself and the rest of humanity. Enter the mantra bracelet, bearing glittering messages of positivity. "Hope," "Love," "Joy," and "Peace" whisper from the delicate wrists of the Eco-Warrior Girl. None of which, of course, prevents her from swearing at other drivers on the rare occasions when she takes her Smart car to her phytotherapist's appointment.

THE ICONIC BRAND: MIMILAMOUR

Created by Gérard Gourdon, this Made-in-Paris brand with a dedicated workshop-boutique wears its name—cute love—well. The bearded and friendly Gourdon is *the* guru of bracelets proclaiming optimistic messages. His motto, "I have to tell you I love you," appears on his jewelry, T-shirts, Instagram account, and even on the buildings of Paris during Fashion Week.

mimilamour.com

WE LOVE … the knockout hashtag pieces in gilded brass: #saimer, #sepanouir, and #sourire ("love yourself," "flourish," and "smile"). They sell out regularly, so keep an eye on the website.

② THE CANNING JAR

Eco-Warriors take great pleasure in lining their pantry shelves with colorful jars of tomatoes, green beans, or lacto-fermented beets. This domestic art has come a long way since confectioner Nicolas Appert perfected the art of food sterilization in 1795. Glass jars and rubber lids made the process much safer—cases of food poisoning used to be common—and, in the first half of the twentieth century, ushered it into homes with vegetable gardens. After a period of unpopularity, when everyone wanted canned or frozen foods, homemade preserves have made a strong comeback, thanks to their natural (no-additive) character and Do-It-Yourself appeal.

THE ICONIC BRAND: LE PARFAIT

Created in the early 1930s in Reims, this brand has always made its products in France and today manufactures its renowned jars in the Auvergne region. Once present in every village hardware store, these marvels of vintage design (the Le Parfait signature is inscribed in the glass) are etched in the memories of every French family. Everyone, at one time or another, has struggled to open a jar of foie gras, pulling mercilessly on the orange rubber tongue in the hope of hearing that liberating "pop!"

leparfait.fr

WE LOVE …
the Parfait Super: the classic one-liter model benefiting from a new double-tongued rubber seal that makes it easier to open. Even if you don't rate your jam-making skills, it makes a lovely vase for wildflower bouquets and would fit perfectly in a bohemian-chic interior.

③ HERBAL TEA

Beneficial herbal infusions were handed down from the Druids, they say. But for a long time the Gauls considered them nothing more than a beverage for hypochondriac spinsters or, as becomes their venerable age, grandmothers keen on herbalism. In other words, herbal tea has never been glamorous; everyone would laugh when, as dinner came to an end, the hostess passed around her sachets of chamomile. But that's all changed. These days you'd have to be crazy—like the smokers out on the balcony—to ask for a coffee and/or an Armagnac. Everyone else just accepts their cup of lemon balm or spruce tips with good-humored grousing.

THE ICONIC BRAND: LES DEUX MARMOTTES

This company, created in the Alps in the late 1970s, is a perfect example of herbal tea's rehabilitation in France: once relegated to ski-station supermarkets, the company's retro-chic boxes and quirkily named infusions are now found everywhere.

les2marmottes.fr

♥ WE LOVE …
"Peace Mémé," made from cherry stems and blackcurrant leaves and boasting a detoxifying and diuretic effect—as its punning name so elegantly suggests.

④ KITCHEN STONEWARE

Butter dishes, pitchers, baking dishes, and pickle jars in beige or brown stoneware, once common in French homes, have found a new lease on life thanks to the Slow Food movement. The stoneware industry flourished in "Ceramic Valley" in Burgundy in the late nineteenth century, when this sturdy, non-reactive glazed material was considered ideal for cooking and preserving food. It has since encountered countless modern rivals, but none has proven nearly as effective. Today, low-tech enthusiasts are stocking up at concept stores made to look like old-fashioned hardware purveyors.

THE ICONIC BRAND:
MANUFACTURE DE DIGOIN
This family company, founded in 1875 near Paray-le-Monial, in Burgundy, has been making durable and "meaningful" everyday objects for 140 years. Expecting a yogurt pot to make a worthwhile contribution to your existence is a big ask, but since 2014, and a skillful takeover, the firm's cookware is once again sought-after by consumers who like its uncomplicated domestic vibe.

manufacturededigoin.com

WE LOVE …
the water jug in the MD 1875 Collection (an "homage to the company's roots"). The shape hasn't changed since it was first created, but the jug now comes in bright, sunny yellow and indigo blue.

⑤ THE K-WAY

The K-Way, a nylon windbreaker well known among baby-boomers and indispensable for outdoor activities, was created in 1965 in the north of France. Inspired by Breton fishermen's sweaters, flexible as origami, light as a feather, and tucked away in a fanny pack in sunny weather, this coat revolutionized rain gear. The K-Way was given an American-sounding name to attract the kids, and after a slow start sales sky-rocketed: more than forty million were sold worldwide over the next twenty-five years. Sophie Marceau conquered the hearts of French teenagers as a fourteen-year-old in a navy-blue K-Way in the cult 1980s film *La Boum*. In 2006, it got top-billing in a stand-up show by comedian Dany Boon, who looked back nostalgically at his "K-Way Years." Often imitated but never duplicated, the K-Way is so famous in France that it was even added to the *Larousse* dictionary. After many ups and downs, it is once again on the road to success. Reinterpreted by Marc Jacobs in 2011 and frequently the focus of collaborations with leading brands such as A.P.C. and New Balance, it once again hangs in the wardrobes of the fashionable, alongside Lafont overalls and Aigle boots.

k-way.fr

WE LOVE ...
the classic Vrai Claude, in Rip-Stop nylon with heat-sealed seams. Nothing can match its cold-fighting power.

⑥ SOPHIE LA GIRAFE

More than fifty million Sophie the Giraffes have been sold since the toy was created in the 1960s—on May 25, 1961, to be exact, the feast day of (you guessed it) Saint Sophia. The toy encourages babies to use all five senses (the sound of the squeaker hidden inside has entertained generations of newborns) and has proven to be an unbeatable aid against teething pains for over four decades. Its 1960s design and nearly artisanal construction (which includes more than fourteen manual operations) explain why it remains beloved by French families. Sophie's rustic design and the safe, comfortable feel of natural rubber appeal particularly to young Eco-Warrior parents, who are careful to protect their newborns from endocrine disruptors. Made in the Savoy region by the family-owned Vulli company, Sophie gives Eco-Warriors everywhere an inexpensive alternative to toys made in China.

sophielagirafe.fr

 WE LOVE ...
the original Sophie. Don't bother with the spin-offs, which are far less convincing.

THE GOURMET ECO-WARRIOR

Of all the French families, this is the one that has most allowed international influences to sneak into its recipes. Ten years ago, kale, seaweed, and pumpkin seeds were unknown in the French culinary repertoire. But the Eco-Warrior also knows how to make the most of France's more traditional ingredients. The country has a long and wholesome rural tradition of broth (the first proletarian restaurants were known as *bouillons*, or broth houses) and vegetable soup (with a touch of butter, of course)—a habit that's now spread to the city. After a period of ill repute (soup was for grannies and broth brought on indigestion), these two pillars of the French detox diet have regained their rightful place on modern dining tables and at more festive occasions. There's not a chef who hasn't included one or the other, or both, on their menu. The brilliant William Ledeuil, author of a book dedicated to the subject, has made a name for himself with the sophisticated broth he serves in his restaurant, Kitchen Ter(re).

LE IT-WEB SITE

CHIC DES PLANTES

Health-minded ladies love the 100 percent organic "earth to cup" teas made by this brand, which creates every form of infusion. The "Enraciné," the "Robuste," and the "Effeuillé" are the French answer to the hegemony of green tea. You can even subscribe to receive new creations in the mail each month.
www.chicdesplantes.fr

This cold soup is a French classic. It has everything going for it, provided the vegetables are organic and the fatal (for the lactose-intolerant) butter-and-cream combo is replaced by olive oil and coconut milk.

Serves 4
Ingredients
→ 1¼ lb (600 g) potatoes
→ 1 cup (300 g) chopped raw leek
→ a little olive oil
→ 6¼ cups (1.5 l) water
→ salt to taste
→ coconut milk
→ chervil

Method
❶ Peel and wash the potatoes.
❷ Sweat the leek in olive oil in a casserole.
❸ Add the potatoes, salt lightly.
❹ Cover with water and cook for twenty minutes or until the potatoes are soft.
❺ Purée thoroughly.
❻ Add a good dose of coconut milk.
❼ Once the soup has cooled, refrigerate and serve cold, topped with chervil.
❽ Sit back as the compliments roll in.

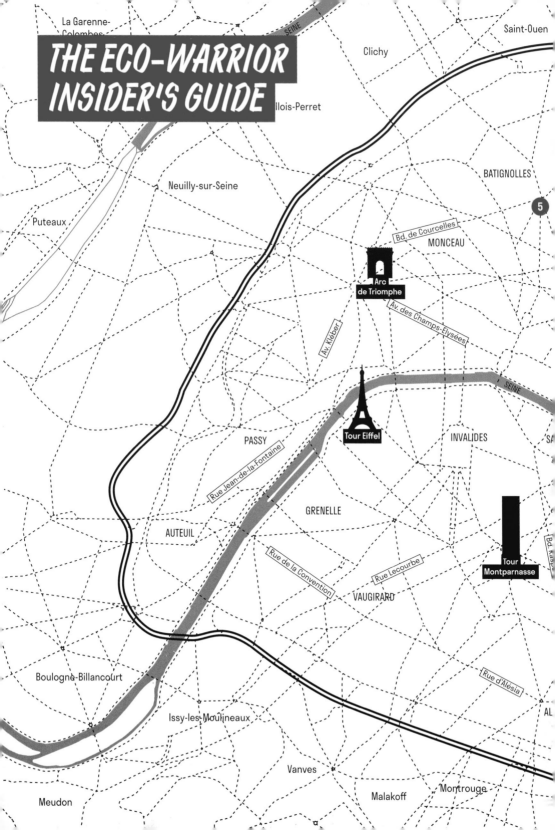

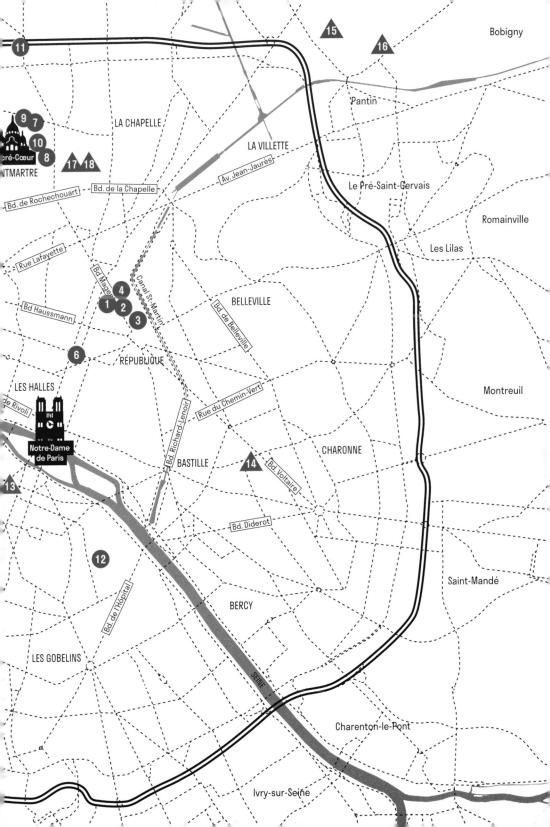

THE ECO-WARRIOR IN PARIS

In the 1990s, Eco-Warriors began to settle in the area around the Canal Saint-Martin, where the picturesque bridges, locks, and cobblestone quays create an airy urban landscape with an aquatic view that is quite unique in Paris. They cycled along the canal's banks way before the Vélib' bike-sharing system existed, and they have long practiced the art of "street fishing"—truly an urban luxury—in the canal near the Récollets Basin. Eco-Warriors are particularly enamored with the history of this corner of Paris: in the nineteenth century, it was a hub for river traffic that nearly rivaled Le Havre in importance. They are eternally grateful that, under President Pompidou, the Canal Saint-Martin escaped a harebrained project to turn it into a high-speed traffic artery—a real victory for conservation over creeping asphalt. Eco-Warriors created the city's first community gardens, and now nearly 150 vegetable varieties are grown at the Poireau Agile, a bucolic parcel of land accessed from 4, rue des Récollets in the tenth arrondissement. Eco-Warriors are also proud to have known the pioneers of "Veggietown," where Paris's first fashionable vegetarian restaurants cropped up. Sol Semilla, specializing in organic power food since 2007, remains the favorite. Today, the neighborhood residents call "Saint-Martin Village" by has an official guidebook (a bilingual French–English publication by Editions Michel Lagarde), and in good weather its trendy canal-side terraces, niche boutiques, and galleries attract families and young couples keen to spend time in the great Parisian outdoors.

THE PERFECT ECO-WARRIOR HANGOUT?

A LE BICHAT is a modern, relaxed eatery, and was the first to introduce Parisians to the concept of the "bowl" as a unit of dietary measurement. Its organic, homemade bowls are popular with the young professionals who work at nearby start-ups.

11, rue Bichat, Paris Xe
+33 (0)9 54 27 68 97
lebichat.fr

OUT AND ABOUT WITH THE ECO-WARRIORS

Eco-Warriors like to do their shopping on foot. The area around their coveted Canal Saint-Martin is now as stuffed as an (organic) pepper, so their stomping ground has shifted closer to place de la République. In a flash, the rue du Château d'Eau and neighboring streets in the hippest part of the tenth arrondissement have become the place to be. This area is a mecca for wandering among specialist design boutiques, vegetarian-friendly restaurants, record stores, and fine-foods shops. The walk, below, features little fashion and nothing of significant cultural interest. The magnificent Récollets Convent nearby should satisfy those who need a daily dose of history, but overall the ambiance is more conducive to wandering around and having delightful encounters with a new generation of shopkeepers who love talking about their locally sourced products (and their lives!). This is a slice of Paris as it really is: modern and cool.

① GET WARMED UP ...
FOR A STROLL ALONG RUE DU CHÂTEAU D'EAU

→ **AU 3, LA BOURSE DU TRAVAIL:** This imposing nineteenth-century building—home to the labor exchange, which provides support and solidarity for workers—is a reminder of the neighborhood's proletarian past, and protests and demonstrations regularly take place at "Répu" (place de la République).
+33 (0)1 44 84 50 21
boursedutravail-paris.fr

→ **AT NO. 6, ATELIER COURONNES:** This unassuming (and very reasonably priced) concept store stocks jewelry made on site, as well as stationery, ceramics, and candles by the vanguard of Parisian design.
+33 (0)1 40 37 03 54
atelier-couronnes.com

→ **AT NO. 11, LA TRÉSORERIE:** The best of mostly retro-chic homeware made in France and elsewhere in Europe is artfully displayed ... in this former tax collector's office (what a change of atmosphere!). The tiny café next door is also delightful.
+33 (0)1 40 40 20 46
latresorerie.fr

→ **AT NO. 15, POMPON BAZAR:** Here, the founder, Corinne, speaks passionately about her selection of objects, carpets, and dried flowers. And she has every right to: with her keen eye, she has picked out the best from France, Africa, and Asia.
+33 (0)1 83 89 03 66
pomponbazar.com

→ **AT NOS. 16–18, LES RÉSISTANTS:** This restaurant, as the name indicates, is intent on resisting the siren song of intensive farming, and prides itself on a cuisine made from carefully chosen ingredients sourced from thoughtful producers. The legendary brunch, served in an ultra-Zen but welcoming setting, has a regular following.
+33 (0)1 77 32 77 61
lesresistants.fr

→ **AT NO. 24, H24:** This rock 'n' roll concept store stocks pajamas in printed silk, exotic bags by Claris Virot, and a little bazaar that looks like a charming cabinet of botanical curiosities.
+33 (0)6 64 88 22 46

→ **AT NO. 28, MAMAMUSHI:** The ethical and shamanic (yes, you read that right) brand created a buzz with its glamorous take on the zip-up jumpsuit. There's something for the boys here, too.
+33 (0)1 40 34 36 07
mamamushi.com

→ **AT NO. 29 BIS, CHICH:** This welcoming Israeli vegetarian cafeteria offers a range of delicious, aromatic dishes.
No reservations.
+33 (0)1 42 00 96 14
chicheparis.fr

→ **AT NO. 30, ASBYAS:** Under the guidance of a Parisian who looks to Africa for inspiration, this shop has an intriguing range of cosmetics and interior design that fuses French and South African sensibilities.
asbyas.fr

② TITILLATE YOUR TASTEBUDS ON RUE DE LANCRY
→ **AT NO. 23, FINE:** The Italian take-away is delicious and the selection of organic French products is exciting. There is always someone setting out samples of their wares: expect to try fresh apple juice or a delicious fish paté.
+33 (0)9 81 75 22 76

→ **AT NO. 25, HOUSE OF THREE BROTHERS:** Mirko Schmitt, an ex-stylist, has given up the frantic world of fashion and now specializes in comfort food with a capital "C." Neighborhood families drop in to his restaurant for the soup, salads, pastries, jams, and generous cakes served in a stylish cafeteria setting.
+33 (0)1 80 06 14 11
houseofthreebrothers.com

→ **AT NO. 38, VIANDE & CHEF:** This creative butcher's shop does unbeatable homemade sliced ham and dried meats. Eco-Warriors may occasionally eat meat, but it must always come from "happy animals." The young butchers who listen to Talking Heads as they work would agree. The weekend sausage-making workshops are very popular.
+33 (0)9 81 87 01 30

③ THERE'S LOTS TO DO ... ON RUE YVES TOUDIC
→ **AT NO. 22, HORTICUS:** This romantic florist's shop also collects the kind of vintage crystal vase that once appeared on every wedding registry. Upcycling is good for your carbon footprint.

→ AT NO. 25, ESPACE MODEM: A former hot-air-balloon factory that hosts all kinds of events, from art exhibitions to fashion fairs. The space alone is worth a visit.
+33 (0)1 48 87 08 18
modemonline.com

→ AT NO. 34, DU PAIN ET DES IDÉES: This cult bread and pastry shop, located in a wonderfully restored nineteenth-century bakery, is famous for its flaky *pain au raisins*.
+33 (0)1 42 40 44 52
dupainetdesidees.com

→ AT NO. 37, MACON & LESQUOY: Marvel at the huge range of colorful, hand-embroidered badges and patches in this boutique. Eco-Warriors might choose to adorn their lapels with a bunch of vegetables, for example, but there are myriad fun designs available.
+33 (0)9 80 74 11 53
maconetlesquoy.com

4 BASK IN THE BEAUTY of the Green Factory, that specializes in "glass gardens." These stylish terrariums house ravishing, almost autonomous, ecosystems that rely on photosynthesis and their own humid microclimates—a lasting alternative to the ephemeral bouquet.
17, rue Lucien Sampaix, Paris X^e
+33 (0)1 74 64 56 15
greenfactory.fr

THE BEST GREEN ADDRESSES: A BIT FURTHER OUT, BUT ESSENTIAL

5 PLAY THE VINTAGE BOTANIST at the Grande Herboristerie near place de Clichy. Created in 1880, it is one of the oldest herbalists in Europe, and stocks a selection of over nine hundred dried plants sold in bulk, alongside teas and remedies made on-site. The period decor is simply spectacular.
87, rue d'Amsterdam, Paris VIII^e
+33 (0)1 48 74 83 92

6 DRINK UP THE BEST IN NATURAL TIPPLES at the Herbarium, a cocktail bar located in the Hôtel National des Arts & Métiers. The bartender has distilled nineteen essences using plants, flowers, and spices, and invites clients to sniff tester strips before they (mindfully) imbibe. See? Green can be fun, too!
243, rue Saint-Martin, Paris III^e
+33 (0)1 80 97 22 80
hotelnational.paris

SIP A SUSTAINABLE COFFEE at the Abattoir Végétal, a modern, organic vegan restaurant located in a former butcher's shop (!). The neighborhood is also worth a detour: you'll find modern bistro cuisine at La Traversée, interior design at La Manufacture Parisienne, and flowers at Mémé dans les Orties ("Granny among the Nettles").

7 L'Abattoir Végétal
61, rue Ramey, Paris XVIII^e
+33 (0)1 42 57 60 62

8 La Traversée
2, rue Ramey, Paris XVIII^e
+33 (0)9 54 86 79 95
latraverseeparis.com

9 La Manufacture Parisienne
93, rue Marcadet, Paris XVIII^e
+33 (0)1 42 64 76 29
lamanufactureparisienne.fr

10 Mémé dans les Orties
12, rue Ramey, Paris XVIII^e
+33 (0)9 72 43 14 37

11 STAY ON THE RIGHT TRACKS at this former railroad station turned ethical community project. Abandoned buildings—postal sorting centers, deserted hospitals, and depots of all kinds—have always been cool, especially when occupied by art or youth collectives as they await demolition. They are also almost always temporary—except, that is, for La REcyclerie, located in the former Ornano train station. There's a café, vegetable garden, fine-foods store, and bar, which, when the weather is nice, hosts vegetarian dance parties on the train tracks, DIY workshops, and other activities popular with Eco-Warriors.
83, boulevard Ornano, Paris XVIII^e
+33 (0)1 42 57 58 49
larecyclerie.com

12 FOLLOW IN THE FOOTSTEPS OF GREAT FRENCH NATURALISTS in the vast grounds of the Jardin des Plantes, that surround the Musée National d'Histoire Naturelle and the impressive Grande Galerie de l'Évolution (Gallery of Evolution). The wonderful nineteenth-century greenhouses are highly atmospheric, with their retro exoticism and muggy atmosphere redolent of distant tropical forests. Parisian families flock here in winter for a change of scenery.
57, rue Cuvier, Paris V^e
+33 (0)1 40 79 56 01
jardindesplantes.net

ECO-WARRIOR CONFIDENTIAL

SECRET SPOTS FOR BODY AND SOUL.

13 **PROTECT CITY-DWELLER SKIN**
Make an appointment at Laboté for a personalized diagnosis and preparation of custom-made products using 100 percent fresh and cruelty-free medicinal plants.
11, rue Madame, Paris VI^e
+33 (0)1 45 48 97 48
labote.paris

NAB SOME URBAN NECTAR
Collected on the rooftops of the Paris Opéra, Miel Béton ("concrete honey") is arguably the most tasteful honey in the world. Available at the opera-house gift store, it commands a price justified by its rarity and legendary sweetness. If you can't snag a jar, many other honeys are produced in Paris (there are more than seven hundred active hives in the city), on the roofs of historic buildings like the Hôtel de la Monnaie. These honeys are also available at the Opéra boutique.
boutique.operadeparis.fr
lemieldeparis.com

14 **DRESS TO IMPRESS (WITH A CLEAR CONSCIENCE)**
Manifeste011 is the only Parisian boutique dedicated entirely to fashion that contains not a hint of leather, wool, or silk. Worried about looking like a dreadlocked hippy? Don't be. Only the finest eco-chic brands are sold here. The two founders have devised an eco-friendly lighting system and recycle their packaging, which is printed with vegetable-based ink. It's pure nirvana.
14, rue Jean-Macé, Paris XI^e
+33 (0)1 56 58 21 76
manifeste.manifeste011.com

HOP OUTSIDE THE CITY LIMITS
Brewing beer is possibly the Eco-Warriors' favorite DIY activity. Even if you can't come home with your own concoctions, you'll still enjoy a visit to one of Paris's most famous micro-breweries, located in Pantin (just outside the city) in a very post-industrial space where they once made gas compressors. The beer tasting is well worth the trip, and also gives you the chance to discover this part of "Grand Paris," where the city's working-class history is still very much alive. It's also home to the enormous Galerie Thaddaeus Ropac, located in a former ironworks.

 Brasserie La Parisienne
29, rue Cartier-Bresson, 93500 Pantin
+33 (0)9 52 34 94 69
brasserielaparisienne.com

 Galerie Thaddaeus Ropac Pantin
69, avenue du Général Leclerc, 93500 Pantin
+33 (0)1 55 89 01 10
ropac.net

FIND AN OASIS IN THE GOUTTE D'OR
Sandwiched next to fabric stores and a hair salon, Le Myrha serves 10-euro organic dishes among lovely flea-market decor. A little postprandial visit to Maison Château Rouge, a socially engaged fashion label founded in 2015, is obligatory. Sales of their irresistible streetwear-styled sweatshirts in wax prints support small businesses in Africa.

17 **Le Myrha**
70, rue Myrha, Paris XVIII^e
+33 (0)9 73 21 78 43

18 **Maison Château Rouge**
40, rue Myrha, Paris XVIII^e
maison-chateaurouge.com

THE ECO-WARRIOR ONLINE

When you've decided to go green, it helps to be able to order your favorite products without increasing your carbon footprint.

LA SEINE & MOI
Fake fur as chic and as haute couture as anything on the wildest runways? That's what this Parisian brand, the recipient of a PETA prize, has achieved. They wrap and accessorize fashionistas in colorful, stylish pieces without touching a single animal. In other words, their faux fleeces won't make you look like a Furby.
laseinetmoi.com

JEANNE PARIS
Poetic arrangements and "wall hangings" by this dried-flower specialist have captivated design magazines the world over. The everlasting bouquet, even when sent from across the Atlantic, is an improvement over the waste left behind with fresh cut flowers.
jeanne-paris.com

APIS CERA
These handmade candles are made of pure, natural beeswax, smell like honey, and are sold in pretty custom sets. Rumor has it that Brigitte Bardot is a loyal customer.
apiscera.com

MEDECINE DOUCE
Giving jewelry is a good way to improve morale —or so this brand, created in 2001 by Marie Montaud, would have you believe. Everything is made in France, and some of it in the boutique itself, on the rue de Marseille in Paris.
bijouxmedecinedouce.com

THE ECO-WARRIOR ON VACATION

HEAD STRAIGHT TO … CORSICA!

The island of Corsica, protected within the immense Parcu Naturale Reghjunale di Corsica (Corsican Regional Nature Park), remains a preferred destination for thrill-seekers and wilderness enthusiasts. Hikers flex their calves on the legendary GR20, a challenging hiking path that winds its way across the island from north to south, while cyclists in neon lycra strain with masochistic joy up the winding roads that ascend the island's peaks. Canyoners and rafters glide alongside rocks and plunge blissfully into freezing-cold natural pools. Botanists enjoy studying any of the three thousand native plants that appeared 21 million years ago when Corsica, in a first move toward independence, broke away from the European continent. For avid fans of postcard paradise, untouched coves with white sandy beaches and clear turquoise waters guarantee a change of pace. Foodies will not be disappointed either: there are many local wines, beers, and even sodas—Corsica Cola, for instance—to quench your thirst, while sea urchins, crayfish, river trout, chestnuts, citron, *brocciu* sheep cheese, honey,

veal from the exotically named breed of "tiger" cows, and, of course, the renowned authentic Corsican charcuterie will delight your taste buds.

Corsica has resisted the rampant development that has afflicted its Mediterranean neighbors. Though home to few big businesses, in recent years the island has become a shining example of organic farming. Countless farmers and farms paid no mind to the critics and now supply the best restaurants on the island and a certain Grande Épicerie in Paris (at the Bon Marché, of course). Several delightful cosmetic brands were among the first to launch all-natural product lines that draw on the island's naturally diverse flora, making the region a source for beauty addicts the world over.

UPPER CORSICA

HIT THE HIGH ROAD
Along with the Inzecca Pass, the D344, a former logging road, offers one of the most spectacular drives on the island and leads to the charming village of Ghisoni. Thrills guaranteed!

SPLASH IN A MOUNTAIN STREAM
Look for the pine tree with the split trunk (it's impossible to miss, located a mile or two outside Ghisoni), and make your way down on foot to this spot favored by locals. A good pair of hiking shoes and sense of balance are needed to reach this—very chilly—river paradise.

SCALE THE SLOPES
Mountain guide Jean-Luc Gaillot has a wealth of activities up his sleeve: discover Corsica's lakes, hike in the Pozzo Valley, escape to Monte Renoso, refuel on cheese at sheep farms, and swim in secret rivers.
+33 (0)6 87 85 71 93

FAMILY-STYLE DINING
At A Stazzona, Catherine cooks up fried zucchini, pizza topped with mint, homemade nougat ice cream, sautéed veal, and wild-boar terrine, while her parents take care of the service. Jean-Pierre, ever ready with a joke, also runs the small fine-foods store across the street, where he stocks local produce and delicious charcuterie prepared by his son.
Avenue de Vadina, 20227 Ghisoni
At the entrance to Ghisoni village
+33 (0)4 95 56 00 11

DINE ON THE WATERFRONT
On the quiet and wildish Chiola Beach, a little hut called Palauma Plage will put a smile on your face. Good food made from local produce, charming waitstaff, tables with a view, and a hammock where you can sleep off lunch—you'd think you were on vacation.
Chiola Beach, Ghisonaccia, 20240 Solaro
+33 (0)6 95 96 25 28
palauma.com

CRACK FOR A PITCHER
Deep blue, turquoise, sea green, golden brown: the colors of Leonelli pottery are bright, refined, and finely crafted. Hidden at the end of a small narrow alley in the center of Corte, the oven and boutique are open to visitors and Marie, the potter, is always up for a chat.
4, quartier Chiostra, 20250 Corte
+33 (0)4 95 46 19 53

TRY THE "LITTLE CORSICAN PIGGIE" DIET
An incredible selection of essential Corsican goodies awaits the visitor to U Muntagnolu, a fine-foods store and shrine to island gastronomy run by Antoine Filippi. Here you can find unmissable local produce including goat cheese made with unpasteurized milk by Albertini, olive oil, *figatellu* salami (available from November), *limoncellu* (lemon liqueur), modern, seasonal conserves by Anatra, tomato ketchup perfumed with Corsican myrtle liqueur by O Mà!, and lemon meringue cream by confectioner Carole Sarossy. A word to the wise: one taste and you'll be hooked forever.
15, rue César Campinchi, 20200 Bastia
umuntagnolu.com

SAMPLE CORSICAN PASTA
Pascal Orsini, nephew of the former owner, welcomes diners at Chez Marie en Corse in a decor reminiscent of the bar in *Amélie* (*Le Fabuleux Destin d'Amélie Poulain*)—a mix of family boardinghouse, bar, and smoke shop. The pasta here is as Italian as chef Sergio Risdonne, who learned his craft with master chefs Michel Rostang and William Ledeuil. He serves up real carbonara—with no crème fraiche, of course—a treat for connoisseurs. The "mezzi rigatoni," is an emulsion with egg, pepper, and well-grilled diced "nustral" Corsican pork cheek—there's nothing better!
Bravone, Route 10, 20230 Linguizzetta
+33 (0)4 95 38 81 85
www.chezmarieencorse.fr

SOUTHERN CORSICA

FOLLOW THE HERD
Descended from a general who served under Napoleon III, the members of the Abbatucci family all share a love of good food. At his restaurant Le Frère, Henri cooks marvelous "tiger" beef, a specialty of the island, which he pairs with excellent organic wine; both are produced by his older siblings. The wines—which proudly display their Corsican heritage, right down to the Second Empire design on the bottles—can hold their own against anything made on the mainland.
→ Domaine Abbatucci
 Musulello, 20140 Casalabriva
 +33 (0)4 95 74 04 55
 domaine-abbatucci.com
→ Restaurant Le Frère
 Domaine Kiesale, Pont de Calzola,
 20140 Casalabriva
 +33 (0)4 95 24 36 30
 restaurantlefrere.com

HEAL THYSELF
Corsica palm essential oils feature in many of the products made by La Maison des Senteurs: lotions, creams, herbal distillates, and balms are all available in the store or on the company website. A special mention for Huile des Boxeurs (Boxers' Oil), which works wonders on bruises and should be in every vanity case.
La Maison des Senteurs, Salvadorajo, 20117 Ocana
+33 (0)4 95 23 81 88
corsicapam.com

THROW YOURSELF INTO THE DEEP END
And do it in style, wearing a colorful, graphic swimsuit by Calarena, a label created in 2004 by Marie-Luce de Rocca Serra. The brand makes reversible one-piece suits, bandeau bikinis, sunglasses, beach cover-ups, tote bags, and sandals—everything a beach bum needs.
12, rue du Général Leclerc, 20137 Porto-Vecchio
+33 (0)4 95 21 88 39
calarena.com

SET SAIL
Admire the Calanques de Piana, jewels of the Corsican coastline, with Corse Adrénaline. Sculpted by the wind, salt, and rain, these pink granite mountains take on a foreboding air at sunset. For the ultimate experience, hire a boat and picnic in a spot known only to the captain, François-Xavier, a local who was born and raised here, and whose grandfather was a fisherman.
Rue de la Tour, 20115 Piana
+33 (0)6 23 06 44 93
+33 (0)7 82 59 98 08
corseadrenaline.fr

WARD OFF THE *OCHJU* (EVIL EYE) WITH A CORAL CHARM
Martelli, who has worked as a jeweler for thirty years, specializes in carving crosses, charms, and amulets from the so-called "red gold" of the Mediterranean. *Che Dio ti benedica!*
15, cours Napoléon, 20000 Ajaccio
+33 (0)4 95 21 70 90

SLEEP IN A TREEHOUSE
But if you don't have a head for heights, A Pignata also offers accommodation on *terra firma* in the form of seventeen rooms spread around the estate, all decorated with rustic sophistication. You won't find steak-frites here, but traditional Corsican cuisine, prepared using whatever vegetables are in season in the organic garden. The homemade charcuterie and olive oil are produced on the family farm.
Route du Pianu (off of the Route des sites archéologiques de Cucuruzzu), 20170 Levie
+33 (0)4 95 78 41 90
apignata.com

THE
FOODIES

ARE YOU

A LITTLE,

VERY,

INTENSELY,

MADLY,

OR NOT AT ALL ...

A FOODIE?

QUIZ

● I'll travel over 100 miles (180 km) to test a new restaurant. ● I know the difference between shortbread and sweetbread. ● I hide the instant pudding behind the organic yogurt in the fridge. ● When someone mentions Opera, I immediately think of a French pastry. ● I have twenty-four kinds of pepper in my pantry. ● I'm on a first-name basis with the cheesemonger and swap gossip with my greengrocer. ● I traded in my bouillon cubes for dashi. ● I'm more impressed with a Michelin chef's three stars, than a military general's five. ● In a blind taste test, I never mistake Vittel for Evian. ● I read more cookbooks than crime novels. ● I love extreme eating experiences. ● My three-year-old eats stinky Munster cheese.

→You checked 7 to 12 statements. You probably suspected as much: you are Foodie to the core! But just how far will you go? Find out in this chapter.

→You checked between 3 and 6 statements. You waver between pride in your Foodie credentials and fearing that others will find you a little obsessive. This chapter will help you decide, once and for all.

→You checked 2 or fewer statements. You are hopeless when it comes to food and you know it. The good news? You can fix that in no time, if you have the appetite for it.

BACKSTORY

For centuries, Foodies have been subjected to relentless teasing. "He sure likes to eat," people said. But they've gotten their revenge, and now boast a thoroughly enviable lifestyle.

Y ou just sat down to eat ... and someone starts waxing poetic about the potato-and-cheese *aligot* hand-whisked by the hosts. Another guest, his voice quavering with emotion, begins to describe the "magnificent" sausage a great little producer sends him, vacuum-packed, straight from his Noir de Bigorre pig farm in the Pyrenees. Others recount with passion how they discovered this or that incredible little restaurant, or a foie-gras market that is absolutely "unbelievable." The wine flows, and the conversation continues, on and on, about food and its pleasures and the best ways to procure it.

If this scenario rings true, there's no doubt about it: you are breaking bread in the company of Foodies, the family of French hedonists that love nothing more than to talk about eating before, during, and after every meal. French people from every social class have always loved epic dining. To understand this phenomenon, read the account of working-class feasting in Zola's *L'Assommoir*, or Alphonse Daudet's *Les Trois Messes Basses* (The Three Low Masses), a national classic that takes place in seventeenth-century Provence, where a gluttonous bishop, distracted by Christmas Eve dinner, is sent to hell for rushing his prayers. Then there's the sensuality of Colette, who writes, "If I had a son to marry off, I would say to him, 'Beware of the young lady who likes neither wine, nor truffles, nor cheese.'" In present-day France, *gourmandise* (originally "gluttony," one of the seven deadly sins) has become a symbol of enviable sophistication. The image of the greedy, potbellied bishop has gradually morphed into the svelte and stylish Foodie. Today, there is no shame in enjoying food, or in turning eating into a pastime. These neo-gourmets devote a significant amount of time and energy—as they will tell anyone who listens—to hunting down the ultimate foodie artisans: they'll cross the city for an exceptional turmeric bread, a premium *pâté en croûte*, or an incredible fennel sorbet. Their Instagram accounts are sprinkled with images of dishes and stuffed with photogenic grocers. Painfully up-to-speed on the latest news regarding restaurants and the career moves of the best chefs, they will make reservations at recommended restaurants three months in advance, just like their parents once reserved for the theater. It is not uncommon for friends to engage in a little under-the-table reservation-swapping.

ALSATIAN ICONS

Chefs Paul Haeberlin, Hubert Maetz, and Antoine Westermann are regional treasures, as cherished by locals as Alsace's famous storks.

Foodies are compulsive consumers of highly specialized cooking utensils such as mandolins, high-end gratin dishes, and glasses perfect for their biodynamic wines. Good food is meant to be shared, and they host often. The under-25s have caught the bug, also organizing and dissecting dinners between friends. You'll never see them commit a sacrilegious offense like dumping cream in the pasta carbonara: Junior Foodies know their basics. Food is a national sport practiced at a very high level and televised accordingly: countless television shows compete to name the next Top Chef or the Best Young Pastry Chef, a sort of reality TV version of the prestigious Meilleur Ouvrier de France (Best Craftsperson of France) competition. A selfie with the charismatic and media-friendly Jean Imbert or Christophe Michalak is almost as sought-after as an "Insta" with any soccer star.

Chef of the century Paul Bocuse, who graced almost as many magazine covers as Kate Moss, paved the way for celebrity chefs in the 1960s. Thanks to him, great cooks emerged from behind their stoves and became creative geniuses, presenting new collections twice a year, just like designers at Fashion Week. It is quite acceptable to have a child who is gifted in the kitchen, a successful new-generation cheesemaker, a Michelin-crowned pastry chef, or the founder of an artisanal coffee roaster, even in social milieus that have traditionally looked down on manual trades. Foodies would much prefer to have an enologist for a daughter than yet another product manager at L'Oréal.

THE NOTORIOUS NOUVELLE CUISINE

Up until the 1950s, chefs were considered good technicians and nothing more. Hidden behind their stoves, they followed Auguste Escoffier's turn-of-the-century recipes down to the ounce; lobsters were always Thermidor, and tournedos could only be Rossini. Fernand Point, a towering six-foot-tall chef, was the first to take liberties with this dogmatic tradition in his restaurant La Pyramide, near Lyon: he developed the concept of the set menu and began to propose lighter dishes, like his famous carrot and green-bean mousses. He was on to a winner, and he kept his three Michelin stars for over fifty years. His former students, with Bocuse leading the way, decided to

continue the revolution. They wanted to concentrate on ingredients. Down with complicated sauces and convoluted recipes: a new era of simple flavors had arrived.

Michel Guérard, in the vanguard of the new movement, grew tired of boring green salad with vinaigrette and decided to mix crunchy green beans with slivers of foie gras: nouvelle cuisine (new cuisine) was born. Food critics Henri and Christian Millau came up with this name while eating another green-bean salad at Paul Bocuse's restaurant in Collonges-au-Mont-d'Or in Lyon. The Troisgros brothers followed suit, dreaming up a novel dish of salmon escalope with sorrel, followed by Jacques Pic, the Haeberlin brothers in Alsace, the gifted chef Alain Chapel, and many others; all of them participants in and ambassadors of a revolution that continued until the 1980s. Although nouvelle cuisine has fallen out of favor in recent years, it remains a reference for an entire generation of aspiring hosts.

CODE OF CONDUCT

A few Foodie rules to stop you from putting your foot in your mouth.

Cheeses

An uneven number of different cheeses, but always between three and nine (the maximum), are served. Why? We've no idea, but respecting this precept proves that you are one of the rare few who know of its existence. Conventionally, guests are expected to serve themselves just once, and to take no more than three cheeses, but this bourgeois rule is never respected by Foodies, who would be irritated if their guests did not enjoy to the fullest their lovingly curated cheese boards.

Hands

In France, hands should be placed on either side of one's plate. In times gone by, this would have indicated to your hosts that you were unarmed and that the meal could be eaten in peace. Of course, you should never put your elbows or forearms on the table, and you should sit up straight, without slouching. *Bon déjeuner!* (NB: Sticklers for proper etiquette never say "bon appétit.")

Forks

In France, forks are always placed on the table with their prongs facing down: in the old days, the family crest was stamped on the back of forks and could thus be admired. In England, however, the coat of arms was placed on the front, so the situation was reversed. You could argue that there's not much point worrying about it anymore, but knowing how to lay silverware *à la française* remains a sign of good upbringing.

I'D RATHER DIE THAN ...

Badmouth Pierre Hermé

Skip the crêpes Suzette

Add ices cubes to my wine

Not make my own foie gras

Open a can of ravioli

Subject oysters to shallots and vinegar

Serve linguine any other way than *al dente*

Tolerate a chalky camembert

Buy waxed, plastic-wrapped apples

Admit that I hate coriander

Forget a splash of balsamic vinegar on the strawberries

THE FOODIE:
A TIRELESS TASTE-TRACKER

The French reality TV series *Un dîner presque parfait* (An Almost Perfect Dinner), which pits amateur cooks against each other to the delight of most French households, is the epitome of kitsch to a true Foodie. And yet, when Foodies invite their friends over for dinner, they undergo —in their unceasing quest for perfection—a torture similar to that experienced by the candidate trying to seduce his "jury of peers" with fancy cooking and an elegantly laid table.

Before the real business of cooking can begin, they embark on an exhausting shopping pilgrimage in search of exceptional products, indispensable to the Foodie's reputation: the cheese comes from a young *affineur* (who is responsible for maturing the cheese) who sprinkles za'atar on his goat cheese; the beef has been prepared in an herbed salt crust by an elite butcher; and the cakes come from a boutique specializing in éclairs or madeleines, or from a pastry chef with a résumé as long as your arm.

Foodies whip themselves into a froth when it comes to putting their menus together. They continue a venerable tradition of elite curiosity—their elders, as we've seen, liked nouvelle cuisine and Bertillon sorbets—and they enjoy breaking new ground. They'd rather die than serve a tagine with prunes (too 1976) or foie gras on gingerbread (so 1991)—and don't even get them started on those *terrible* appetizers served in miniature glasses!

That being said, these born pioneers are proud to have been the first to put matcha and yuzu in everything. Today, inspired by Parisian "bistronomy," an urbane culinary movement that feigns casual simplicity, they spend hours making Basque lomo chips to go with their stone bass, a common fish from the southwest of France that they made popular (and brought to the brink of extinction). In the kitchen, they struggle to insert Cantabrian anchovies into a lamb shank massaged with an exquisite spice powder by chef Olivier Roellinger.

Accompanied by a side of mashed Vitelotte potatoes—a variety with a lovely violet color—it will elicit "oohs" and "ahs" from around the table.

Phew.... All that remains for our solicitous host to do is set a (deceptively) simple table. The plates and glasses may not match, but that's not the result of some catastrophic accident. No, this hodgepodge is a carefully thought-out aesthetic choice. And the black salt? It's from Iceland, if you need ask.

MELODIOUS ICON

Éric Sanceau: Popular with leading chefs, this farmer raises his cows and chickens to a backdrop of calming classical music, letting them frolic in freedom.

FOODIE "MUST HAVES"

This family loves things that are as beautiful as they are tasty

① PIMENT D'ESPELETTE

A sixteenth-century Basque explorer brought this spice back from the West Indies as a replacement for black pepper, which was expensive at the time. Basques born and bred in Espelette and the surrounding area harvest and hull the pepper by hand. Since its return to favor in the 1990s, you can now find it flavoring a variety of products: salt, mustard, oil, vinegar, and even, for the daring, jellies and jams. Popularized by Basque chefs with impossible-to-pronounce names (Iñaki Aizpitarte, Philippe Etchebest), it is rubbed on sheep cheese, kneaded into butter, sprinkled on lamb or cod, and even hidden in chocolate fondant. It receives star treatment during the Fête du Piment, held in Espelette the last weekend of October, and several cookbooks have been written about it. A trade group defends its claim to AOP and AOC status (*Appellation d'Origine Protégée* and *Appellation d'Origine Contrôlée*) —certifications that guarantee the authenticity of the best French agricultural produce. Don't forget to bring some piment d'Espelette back home to spice up your burgers and homemade dark-chocolate cookies.

THE ICONIC BRAND: LA MAISON DU PIMENT
Since 1996, Vincent Darritchon has grown and harvested six varieties of pepper—including Espelette—and sells all kinds of delicious and tempting Basque specialties via his online store.

lamaisondupiment.com

♥ WE LOVE ...
the little pots of powdered dried pepper, which must be kept out of sunlight to prevent it from going stale and fading from bright vermilion to drab yellow.

② HOUSEHOLD LINENS

Long considered so precious that they constituted a large part of a young woman's dowry, linens were passed down from mother to daughter and counted as property. Beautifully folded sheets and well-organized linen cabinets scented with lavender brought joy to generations of housewives. The wealthier the family, the whiter and more decorative their linens. In the Middle Ages, lords feasted at vast banquets and wiped their hands and mouths with gusto on luxurious tablecloths. During the Renaissance, large, perfumed linen napkins were tied around the necks of handsome gentlemen, who wore impressive lace ruffs with pride. Tying a napkin was so complicated that a valet was charged with performing the task. In the seventeenth century, ladies of the house wove their own bedsheets and embellished their linens with delicate embroidery. In fact, all girls learned embroidery until the mid-twentieth century. In the 1960s, household linens were still immaculately white. It wasn't until the 1970s that designers finally brought color into bourgeois bedrooms and dining rooms.

THE ICONIC BRAND: MAISON MOUTET
For five generations, the Moutet family has made traditional Basque linen in Orthez, in the Béarn region of southwest France. Official supplier to large museums and châteaux, including Vaux-le-Vicomte, the brand brightened up household linens by offering vibrant colors and pretty patterns, some of them rather quirky.

tissage-moutet.com

WE LOVE …
the classic Iraty tablecloth, with its vintage look. Like all of the brand's tablecloths, it's customizable.

③ THE LARGE CASSEROLE DISH

This hefty, paunchy symbol of comfort food, made of glazed cast iron, appeared in the early twentieth century, and nearly every family has one. Its casualness—put it on the table and everyone digs in—was indeed a revolution: it embodied the appearance of modern relationships, no longer defined by unthinking respect toward the head of the household but instead nourished by cooperation and communication. Perfect for a thousand filling, home-style dishes that the French love to hate when they're on a diet but continue to make when they're depressed. Foodies often add international touches to the contents of their casserole, but whether the dish is fusion or French, they love setting it triumphantly on the table, singing out "Help yourself!"

THE ICONIC BRAND: LE CREUSET

The casserole is such a part of French life that several brands contend for the title of most emblematic. Along with Staub's iconic models, Le Creuset's "volcanic" orange version has held pride of place in French cupboards for decades. Its special model for cooking fondue *Bourguignonne* (beef fondue cooked in oil), created in the 1970s, still brings tears to the eyes of baby boomers. The company was founded in 1925 by Belgians Armand Desaegher and Octave Aubecq, and has operated out of Fresnoy-le-Grand in the Aisne region ever since. Though the company has added countless novelties to its product line—how about those casseroles shaped like hearts or soccer balls?—its main product is still made in France and a wildly successful export.

lecreuset.fr

♥ WE LOVE ...
the 14-inch (35-cm) oval model with a metal knob, in Mist Gray, a very elegant choice that you're not likely to get sick of (which can't be said of all the fourteen available colors). For first-time buyers, black is always a good choice.

④ CONFITURE

Jam, a staple of any French breakfast, continues to trump granola in many homes. There's no better way to start the day than with a hunk of yesterday's baguette toasted and slathered with jam and fresh butter. Jam first appeared in France at the time of the Crusades, when returning soldiers brought back sweet foods to Europe. The French word for jam, *confiture*, refers to fruit confections cooked in honey or syrup. Electuaries—jellied medicinal preparations made with honey and highly regarded in medieval medical circles—most resembled our modern jams. In 1555, Nostradamus, more commonly known for his hair-raising predictions, published *Traité des Fardements et des Confitures* (Treatise on Cosmetics and Jam), which laid the foundation for the art of jam-making—a skill that eventually became the domain of housewives rather than apothecaries. The discovery of beet sugar in the nineteenth century democratized the process. Despite the ready availability of mass-produced products, jam-making is a talent still appreciated in French households, regardless of social class.

THE ICONIC BRAND: LA CHAMBRE AUX CONFITURES

A new movement of free-thinking jam-makers, who prefer reduced sugar levels and shorter cooking times, is modernizing the manufacture of preserves. They are behind the jewel-colored jars of raspberry and apricot jam that some would deny are true *confitures* (according to strict French rules, *confiture* must contain 50 percent sugar), but these pioneers couldn't care less. La Chambre aux Confitures, created in 2011 by Lise Bienaimé, herself the great-great-granddaughter of a confectioner, is a leading figure in the new jam movement. Her chic boutiques are laid out like concept stores, and the clever recipes (which include up to five variations on the same citrus fruit) make them perfect gifts. All can be sampled, so go for an afternoon snack to really appreciate her endeavor.

lachambreauxconfitures.com

WE LOVE …
the limited editions, which showcase rare seasonal fruit (bitter orange, wild strawberries, etc.)—a concept Foodies love.

⑤ THE PROFESSIONAL KNIFE

For their slicing, mincing, and peeling needs, Foodies will not settle for cheap, poor-quality tools made in distant countries. But they're in luck: high-end French cutlery has a shining reputation. Since the fifteenth century, the city of Thiers in Auvergne has been the region's knife-making capital, assisted by the Durolle, a torrential river that supplies the constant energy this skill requires. In the seventeenth century, knives from Thiers were exported all the way to the Levant. But it was in the nineteenth century that the industry really gained an edge: in 1855, it employed 25,000 people who supplied wholesale ironmongers in France, to Navarre, and beyond. Today, companies in Thiers and the surrounding region produce 70 percent of the table-, pocket-, and professional knives purchased in France.

THE ICONIC BRAND: OPINEL

There are many prestigious brands in France, like the magnificent Laguiole from Aveyron, but owning an Opinel remains the ultimate fantasy of French kids everywhere. They still beg their parents for one, even if they no longer need it to cut slices of sausage at recess. This foldable pocket knife, created in 1890 by Joseph Opinel, son of a blacksmith from Savoy, has been improved over the years, perhaps most famously with the addition of the Virobloc locking system in 1955. But the basic design hasn't changed and remains an example of instinctive perfection. It is displayed in the Victoria and Albert Museum in London as one of the hundred best-designed objects in the world, alongside the 911 Porsche and the Rolex watch.

opinel.com

♥ WE LOVE …
the Plumier No. 8, designed specifically for mushrooms. The oak handle is equipped with a practical little brush, which comes in handy when gathering morels, ceps, chanterelles, black trumpets, and boletes of all kinds—a leisure activity popular with Foodies on country weekends.

⑥ THE VEGETABLE MILL

Though small children remain fascinated by the mystery of dehydrated potato flakes that transform with the addition of water or milk, everyone knows the only mashed potato worth eating is the homemade variety. Joël Robuchon's version—a half pound of butter for a pound of potatoes—is sinfully creamy. Though French families may use less fat, mashed potatoes nevertheless require a healthy dose of elbow grease: it's common knowledge that they turn to glue in the food processor and need to be mashed by hand. Enter the famous vegetable mill, equipped with a sieve and crank handle. It works wonders. For vegetables other than potato, the electric Moulinex does the job with less muscle.

THE ICONIC BRAND: MOULINEX

A self-taught inventor tired of his wife's lumpy mash, Jean Mantelet invented the crank-handled vegetable mill in 1932. It was an immediate success and spawned many variations. In the early 1950s, inspired by his motorized bicycle, Mantelet replaced the handle on his coffee mill with a little motor, creating the first electric coffee grinder. He named it Moulinex (a contraction of "Moulin Express"), which became the company's name. In the 1960s and 1970s, the Charlotte and Marinette food processors could be found in every French household—"Moulinex liberates women," cried the advertisements. This golden era came to an end in the 1980s, and the shuttering of Moulinex factories remains a painful example of the collapse of industry in France. Bought in 2001 by its competitor, SEB, the company still exists, but has retained little of its former glory. Nonetheless, it still occupies a special place in French hearts.

moulinex.fr

♥ WE LOVE ...
the original (and much imitated) hand-cranked model in stainless steel, with a 9½-inch (24-cm) diameter, the largest. Who makes just one serving of mashed potatos?

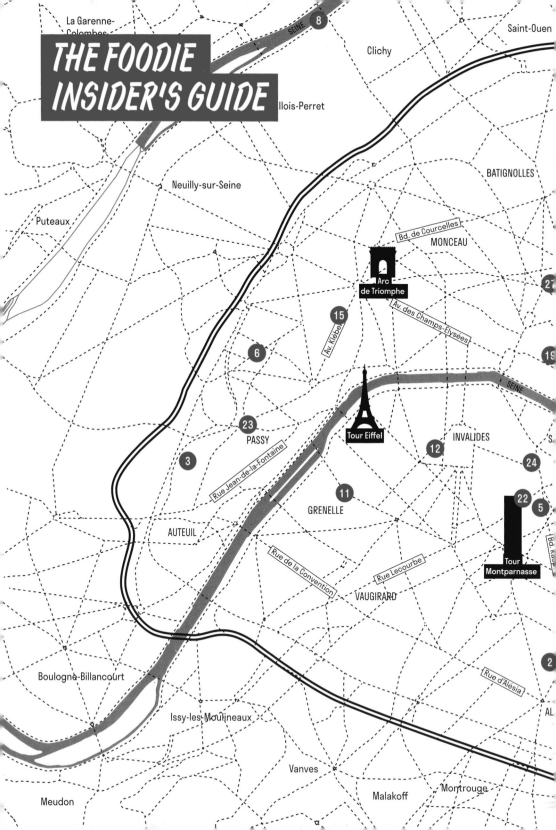

THE FOODIE INSIDER'S GUIDE

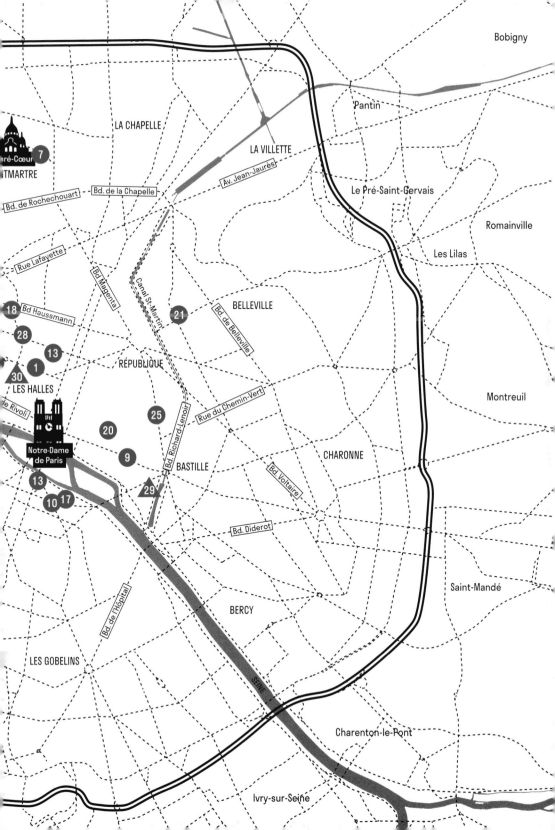

THE FOODIE IN PARIS

Way back in the Middle Age, before Les Halles became, in the 1980s, a center for the New Wave, gay and punk cultures, underground boutiques, eccentric hairstyles, and hipness in general, this part of the city center was known as the "Belly of Paris." Before 1959, this neighborhood, teeming with people, laughter, garbage, noise, foodstuffs from all over France, bad odors, small cafés, and bistros, was the capital's sole source of food. From as early as four in the morning, elegant night owls and artisan butchers, bakers, and florists met over meat broth: for some, the night was just coming to an end, while for others the day was just getting started. In the 1970s, the twelve superb wrought-iron pavilions built by the architect Victor Baltard under Napoléon III to house Paris's principal market were demolished. Young designers and partiers turned the gaping hole that remained into the new epicenter of Parisian life. Les Bains Douches, a famed 1980s nightclub, and the Royal Mondétour brasserie were host to a diverse and mega-stylish clientele. Prince, Jean-Paul Gaultier, Christian Louboutin, and the beautiful Eva Ionesco could all be found here, partying the night away. Wine and cheese wholesalers gave way to designers like Elisabeth de Senneville, Claude Montana, and Thierry Mugler, who set up shop near Studio Berçot, a fashion school and incubator for new talent. On rue du Jour, Agnès B. sold dozens of snap-front cardigans that later became famous. Forty years on, the neighborhood is a den of fashion brands, and Foodies head elsewhere in the city to satisfy their cravings.

THE PERFECT FOODIE HANGOUT?

1 LE PIED DE COCHON: For many years, transvestites, models, and bourgeois kids came to slum it at this restaurant that opened in 1946, making it a major Parisian nightspot. After a rough patch, the "PDC" has regained its luster. Young actresses and TV and rap stars once again occupy its tables into the wee hours of the morning. Open 24 hours.

6, rue Coquillière, Paris 1er
+33 (0)1 40 13 77 00
pieddecochon.com

OUT AND ABOUT WITH THE FOODIES

The Foodie has a personalized map of Paris peppered with key destinations that, though often far flung, are all equally indispensable to his or her survival. There is usually a nice market and several fine food shops in the Foodie's own neighborhood: after all, Paris is a city where it is extremely easy to eat well. A bit of a snob, the Foodie prefers new, lesser-known addresses to proven classics. Many a career has been launched by word-of-mouth recommendations from one member of this tribe to another.

FAVORITE FOODIE SUPPLIERS

MEAT
High-flying carnivores idolize three handsome rock 'n' roll butchers. Their shops are worth a visit, if only to feast your eyes.

HUGO DESNOYER: He has two butcher shops, the Docteur-Blanche address also features an eat-in table d'hôte. The choice (cut!) is all yours.
hugodesnoyer.com

2 45, rue Boulard, Paris XIVᵉ
+33 (0)1 45 40 76 67

3 28, rue du Docteur Blanche, Paris XVIᵉ
+33 (0)1 46 47 83 00

4 **ALEXANDRE POLMARD:** This sixth-generation artisan, descended from a dynasty of breeder-butchers, offers what might called "haute-couture" meat (and some legendary tartares).
2, rue de l'Abbaye, Paris VIᵉ
+33 (0)1 43 29 76 48
polmard-boucherie.com

YVES-MARIE LE BOURDONNEC: A proponent of slow-aging meat—for up to sixty days—Le Bourdonnec is a self-proclaimed "Beef Maker." His four stores display beef ribs as if they were works of modern art worthy of the Centre Pompidou; some are even labeled "Price upon request."
le-bourdonnec.com

5 43, rue du Cherche-Midi, Paris VIᵉ
+33 (0)1 42 22 35 52

6 172, avenue Victor-Hugo, Paris XVIᵉ
+33 (0)1 47 04 03 28

7 25, rue Ramey, Paris XVIIIᵉ
+33 (0)1 42 64 78 71

8 4, rue Maurice-Bokanowski, 92600 Asnières
+33 (0)1 47 93 86 37

CHEESE
Classic cheeses, yes, but also several bizarre varieties (the weirder the better). Follow your nose to:

LAURENT DUBOIS: In addition to his perfectly aged cheeses, this nationally recognized artisan likes to customize his offerings. His Comté marinated in yuzu, *bleu* with pear jelly, and goat cheese in argan oil are renowned.

9 97–99, rue Saint-Antoine, Paris IVᵉ
+33 (0)1 48 87 17 10

10 47 ter, boulevard Saint-Germain, Paris Vᵉ
+33 (0)1 43 54 50 93

11 2, rue de Lourmel, Paris XVᵉ
+33 (0)1 45 78 70 58
fromageslaurentdubois.fr

12 **FROMAGERIE GRIFFON:** The nougat made with aged gouda, almonds, hazelnuts, walnuts, pistachios, and raisins, and the little "eggs" of peppered Tomme de Brebis cheese bring anyone with a modicum of taste running to this talented cheesemaker's shop.
23 bis, avenue de la Motte-Picquet, Paris VIIᵉ
+33 (0)1 45 50 14 85

CAKES
Paris is brimming with specialized pastry chefs. The Foodie is finicky and finds some places too common, such as the mini chains specializing in eclairs or cakes that come in one form only. And then there are others that have the Foodie's enthusiastic approval.

CHOUX
13 **ODETTE PARIS:** These exquisite choux pastries—a homage to the shop's namesake, the owner's grandmother—can be enjoyed while admiring an unbeatable view of Notre-Dame.
77, rue Galande, Paris Vᵉ
+33 (0)1 43 26 13 06
odette-paris.com

14 **LA MAISON DU CHOU:** You got it—cream-filled choux pastry is having a moment in Paris. Here is another place to enjoy the bounty.
7, rue de Furstenberg, Paris VIᵉ
+33 (0)9 54 75 06 05

MADELEINES
15 **MAD'LEINE:** Available in flavors like active charcoal and orange, or honey and jasmine, these madeleines (small pot-bellied sponges) by chef Akrame Benallal are phenomenal.
53, rue Lauriston, Paris XVIᵉ
+33 (0)9 50 93 42 44
madleine.fr

16 **MESDEMOISELLES MADELEINES:** This is a far cry from your run-of-the-mill madeleine. Filled with vanilla, coffee, or pistachio cream, or assembled into grandiose cakes, Stéphane Bour's madeleines are a modern, decadent twist on a classic.
37, rue des Martyrs, Paris IXᵉ
+33 (0)1 53 16 28 82
mllesmadeleines.com

SPECIAL DIETARY NEEDS

Unlikely as it may seem, young pastry chefs are finally taking into account modern dietary intolerances. Yes, you can have your cake and eat it!

17 **LES BELLES ENVIES:** Those who can't enjoy the sticky pleasures of sugared patisserie should try these sumptuous cakes with a low glycemic index. You'd never know the difference.
3, rue Monge, Paris Vᵉ
+33 (0)1 42 38 01 41
lesbellesenvies.com

18 **NOGLU TAKE-AWAY:** Located in the Passage des Panoramas (which is worth a visit in its own right), this gluten-free bakery has a selection of small tarts, strawberry slices, and shortbread cookies to delight the gluten intolerant (and everyone else).
16, passage des Panoramas, Paris IIᵉ
+33 (0)1 40 26 41 24
noglu.fr

SUGARY STARS

19 **CÉDRIC GROLET:** Elected "best restaurant pastry chef in the world" in 2017 by a jury of renowned colleagues, this prodigy has finally opened a take-away in the Meurice hotel, where he presides. Five kinds of signature pastry are available in individual portions every day, including the famous trompe-l'oeil Citron and Pomme Rouge creations. If, regrettably, you are obliged to share, the famed Rubik's Cake remains unequalled for its eye-catching appearance—and the price is equally unforgettable. The pastry shop closes as soon as the day's wares have sold, so get there at noon when it opens.
6, rue de Castiglione, Paris 1ᵉʳ
+33 (0)1 44 58 10 10

YANN COUVREUR: With two stores and a space in the gourmet food section of the Galeries Lafayette department store, this inspired thirty-something has a firm grip on the classics. Executed with great skill and finesse (some are made on demand), his interpretations have conquered Parisian hearts. Chocolate éclairs, rum babas, strawberry cream sponges, rounds of Paris-Brest, mille-feuille vanilla slices—all are to die for (but what a way to go!).
+33 (0)6 05 97 63 01
yanncouvreur.com
20 23 bis, rue des Rosiers, Paris IVᵉ
21 137, avenue Parmentier, Paris Xᵉ

THE FOODIE'S FAVORITE PLAYGROUNDS

While some drag their families to bizarrely themed amusement parks, Foodies make regular weekend pilgrimages to these culinary shrines.

THE SELF-DECLARED BOURGEOIS OPTION

LA GRANDE ÉPICERIE in the Le Bon Marché department stores stuffs tantalizing offerings from around the world into two fancy fine-food outlets. French ingenuity is well represented by an irresistible selection of fine produce, canned goods, and preserves. The in-house brand is also excellent. For a very Parisian experience, eat a snack or simply wander the aisles in either of the beautiful branches. We recommend the "original" Left Bank location.
lagrandeepicerie.com
22 38, rue de Sèvres, Paris VIIᵉ
+33 (0)1 44 39 81 00
23 80, rue de Passy, Paris XVIᵉ
+33 (0)1 44 14 38 00

24 **BEAUPASSAGE,** a newly opened traffic-free space shaded by trees and lined with contemporary artworks, is a foodie haven teeming with chic and hungry locals. Top chefs including Anne-Sophie Pic, Yannick Alléno, and Olivier Bellin have set up shop here, alongside a selection of excellent suppliers (artisan butcher Polmard, Thierry Marx bakery), all offering on-the-spot terrace dining.
53–57, rue de Grenelle, Paris VIIᵉ

THE TRENDY BOHEMIAN OPTION

MAISON PLISSON: With their flagship located a stone's throw from the concept store Merci, this fine-food emporium follows the same codes. Here, everything is calm, luxurious, pleasurable—and all very well heeled. The producers are on the ball—the cheese and charcuterie selection is simply beautiful—and are happy to share stories with their customers, most of whom are local. The sales staff wear delightful old-fashioned cotton aprons, and the place is piled high with wooden crates overflowing with vegetables. The second branch aims even higher, with its extensive selection of cookware, interiors, and hardware, and an in-store restaurant offering excellent teatime treats.
maisonplisson.com

25 93, boulevard Beaumarchais, Paris III^e

26 35, place du Marché Saint-Honoré, Paris 1^{er}
+33 (0)1 71 18 19 09

THE FOOD-WITH-A-VIEW OPTION

27 **LE PRINTEMPS DU GOÛT:** This is the closest you'll get to a French version of Eataly. In addition to the niche food finds, you can eat on the fly with French take-out (the spectacular ham, butter, and Comté sandwiches at the Gontran Cherrier stand, for instance, or the truffle-scented *croque monsieur* at Maison Balme), browse the lovely book section (specialized, of course), and admire the panoramic view from the ninth-floor terrace (with outdoor tables in good weather).
59, rue de Caumartin, Paris IX^e
printemps.com

THE URBAN FARM OPTION

28 **LA RUE DU NIL, Paris II^e:** Under the guidance of two passionate entrepreneurs, the founders of Terroirs d'Avenir, this street has become to food what avenue de Montaigne is to fashion (in other words, the *crème de la crème*). The butcher, baker, fishmonger, grocer-cum-dairy, take-out places, and restaurants have transformed this formerly seedy street—part of Paris's seventeenth-century "court of miracles"—into a slice of country living in central Paris.
terroirs-avenir.fr

THE MICHELIN GUIDE
The Michelin brothers, founders of a tire company, came up with the idea for a guide emblazoned with their emblem, the jolly Michelin Man. The first edition appeared in 1900. Its goal? To provide cyclists and the first automobilists with a list of quality establishments where they could dine and rest on long journeys (motorized vehicles were slow and often broke down in those days). In the 1920s, the best addresses along the Nationale 7, at the time the only highway connecting Paris to the Côte d'Azur, received between one and three stars depending on how good they were. Since the inception of the famous little red book, its legendary grading system—which spawned our current obsession with two- and three-star chefs—immediately became the industry gold standard for rewarding and classifying the best in the field. And thus, the gastronomic restaurant was born. Almost immediately, three chefs began a friendly battle for the highest honors on the holiday highway: Fernand Point at the Pyramide de Vienne was the first to receive the ultimate three-star accolade in 1933; André Pic in Valence was anointed in 1934; and Alexandre Dumaine, chef at the Côte d'Or in Saulieu and known as "Le Magnifique," earned his in 1935. In 1940, the German army invaded France equipped with incredibly precise and detailed Michelin Guides. Today, the guide is one of the most widely recognized publications in the world, but some chefs, like Marc Veyrat, Olivier Roellinger, and Joël Robuchon, have decided to go their own way and turn down stars in order to continue delighting customers without the additional pressure that a Michelin rating entails.

THE ALL-POWERFUL *LE FOODING*
The young *Le Fooding* collective was created in 2000 to break the rules of French gastronomy, loosen up the definition of a "good" restaurant, and give chefs more freedom. This band of epicureans has succeeded beyond all expectations. Their bilingual French-English guide to restaurants in Paris and the rest of France has become much more than just a reference for Foodies. Despite a few quirks and a takeover by its more classic precursor (Michelin), it remains the best way to find modern, pleasant, and innovative good restaurants. Though Foodies like to complain that "*Le Fooding* isn't what it used to be," they consult it religiously and do everything they can to secure an invitation to its legendary annual party.
lefooding.com

FOODIE CONFIDENTIAL

SECRET, MOUTHWATERING ADDRESSES IN WHICH TO ...

TAKE A BREAK FROM THE ORDINARY: Every month, the gang at the Tablées Cachées organizes secret dinners in unusual places, orchestrated by brilliant young chefs for twenty guests. There is no shortage of gustatory excitement and unexpected encounters.
tableescachees.com

29 SWIM IN CAVIAR: You don't have to be a Russian oligarch to enjoy the pleasures of La Manufacture, a superb atelier showcase for renowned French brand Kaviari. The space hosts tasting workshops and is equipped with a refrigerated boutique (bring a sweater) and a table d'hôte, available for private events.
13, rue de l'Arsenal, Paris IVᵉ
+33 (0)1 44 78 90 52
kaviari.fr

RESTAURANT-HOP: Feel like having a Corsican *apéro* in one spot, filling up like a true Parisian at a second address, and eating dessert somewhere else entirely? The team behind Ici Là Là organizes three-part dinner walks (no more than a ten-minute stroll between each establishment)

for those who enjoy discovering several places at once. Good for groups, girls' nights out, and private parties.
icilala.com

CRASH A CELEBRITY TABLE: Céline Pham, a Franco-Vietnamese chef, hands out her exact address—in the tenth arrondissement— to just a happy few subscribers.
Reservation by email:
jaifaim@celinepham.com

30 PLAY THE CHEF: Get lost in a chaos of professional cooking equipment at E. Dehillerin, founded in 1820 in the center of what was once the huge Halles market. An enormous copper stock pot (or is it a kiddie pool?) may not be the most urgent item on your shopping list, but there are many other, smaller accessories available for perfectionists.
18–20, rue Coquillière, Paris Iᵉʳ
+33 (0)1 42 36 53 13
edehillerin.fr

FOODIES ONLINE

A selection of epicurean websites so that you can savor France without ever leaving your kitchen.

CULINARIES
Vegetables, dairy products, meat, charcuterie, herbal tea, seeds, jam, flour: the best French producers are all here. Instead of celebrities (which is reflected in the reasonable prices), you'll find a selection of people passionate about products that are well made, well raised and well grown. For now, only dry foods, preserves, and wine (not a bad start) are available for international delivery. Fresh products should follow shortly.
culinaries.fr

MALLE W. TROUSSEAU
Assemble your very own Foodie toolkit! Here is an exhaustive collection of everything humans have ever invented for the purposes of slicing, peeling,

browning, brushing, and roasting: forty-three tools organized in self-contained compartments, all housed in a magnificent valise. Items can also be purchased à la carte.
mallewtrousseau.com

O MÀ! GOURMANDISES
A line of products concocted with love in Paese, Corsica, by Jean-Michel Querci, the self-taught chef at La Rascasse in Saint-Florent. Crustacean oils, *brocciu* preserves, black olives (we'd do anything to get our hands on those), white onion and fig ketchups, white vinegar cream with hazelnuts: everything is imaginative, surprising—and delicious.
oma-gourmandises.com

CHARVET EDITIONS

The Rolls Royce of aprons—and a graceful way to protect against stains—is made from a blend of washed linen and cotton spun in northern France. Go with the indigo-colored "Professional" model, which has a large front pocket perfect for carrying spatulas. This stylish and practical accessory has a history spanning a century.
charveteditions.com

LA BROSSERIE FRANÇAISE

Good oral hygiene is essential for sustained feasting. The "Édith" (as in Piaf) toothbrush, with its reusable beech handle, is made in France in Beauvais, near Paris. It's 100 percent recyclable and can be personalized with the name of its happy owner. Most importantly, the head can be replaced every two or three months through a subscription service (the brusher decides how often to receive home deliveries).
bioseptyl.fr

MAISON FRAGILE

This porcelain brand was created in Limoges by Mary Castel, who, as the great-great-granddaughter of a factory manager, is carrying on the family tradition. The pieces are produced using traditional methods, but their design has been entrusted to French artists including Nicolas Ouchenir, Vaïnui de Castelbajac, and Sonia Sieff, and dancer Marie-Agnès Gillot. The Elysée Palace ordered a series of cups that Brigitte Macron uses during working lunches.
maisonfragile.com

A FOODIE TOUR OF FRANCE

Foodies do not shirk from traveling miles to ferret out exceptional products or local must-trys. They will turn a simple weekend with friends in Alsace or a romantic escape to Saint-Jean-de-Luz into a gourmet treasure hunt. They find it impossible not to fill their bags or the trunks of their cars chock full of regional specialties, all of which clearly taste better because they were bought locally. They'll show off their treasures with the excitement of a teenager boasting to their best friend about their high score on Candy Crush Saga.
You'd better act excited.

THE BEST OF ALSACE, ONCE YOU'VE FILLED UP ON *CHOUCROUTE* AND PRETZELS

ZE PRODUCT

According to legend, the *kouglof*, a brioche studded with raisins soaked in kirsch and much appreciated by Marie Antoinette, was prepared for the first time for the Three Wise Men. Once reserved for special events, it is now available in all the local pastry shops, lighter than before but still baked in a curious braided terra-cotta mold made in Soufflenheim.
Pâtisserie Oppé
29, rue du Maréchal Foch Hauptstross,
67190 Mutzig
+33 (0)3 88 38 13 21

ZE BOUTIQUE

The Nouvelle Douane, a cooperative of local producers, stocks the best of Alsace, including the region's famed foie gras, developed by the Jewish community in Strasbourg, who were experts in gorging geese long before the farmers and breeders in the Southwest. That made at Schmitt's farm is incredible. You'll find it, along with brandy and gingerbread, in a kitsch but oh-so-delicious gourmet basket that epitomizes this land of excess.
1A, rue du Vieux Marché aux Poissons,
67000 Strasbourg
+33 (0)3 88 38 51 70
lanouvelledouane.com

ZE RECIPE

Pâté en croute—meat enveloped in flaky crust—is found in every local restaurant. Le Comptoir à Manger offers an updated vegetarian version made of colorful root vegetables.
Le Comptoir à Manger
10, petite rue des Dentelles, 67000 Strasbourg
+33 (0)3 88 52 02 91
lecomptoiramanger.com

ZE EXPERIENCE

Follow in the rubber-booted footsteps of a local expert for a weekend fishing expedition, basing yourself at La Cheneaudière, a stylish but casual hotel, and take advantage of the wood-paneled rooftop suite—with private terrace and jacuzzi— or the spectacular "nature spa."
3, rue du Vieux-Moulin, 67420 Colroy-la-Roche
+33 (0)3 88 97 61 64
cheneaudiere.com

ZE SOUVENIR

The Baeckeoffe, a terra-cotta dish made in Soufflenheim, is hand-painted with old-fashioned (i.e., very trendy) bucolic motifs. It's perfect for cooking a three-meat-and-potato ragout, so typical of the local cuisine, which stews in the oven for hours— heavy, but entirely worth it. (A little like the Baeckeoffe itself.)
My Elsass
20, rue Haute, 67700 Haegen
+33 (0)3 88 03 35 39
myelsass.com

ZE PLACE TO SLEEP

The ancient, superb Cour du Corbeau inn, with its sixteenth-century timbering, is hard to miss, located as it is in the heart of Strasbourg. In such a historic setting you can easily imagine bumping into one of the ghostly "white ladies" who feature in local folklore.
6–8, rue des Couples, 67000 Strasbourg
+33 (0)3 90 00 26 26
cour-corbeau.com

THE BEST OF THE RIVIERA AND MARSEILLE (NOT COUNTING THE YACHTS, MARSEILLE'S OLYMPIQUE SOCCER TEAM, PASTIS, AND BOUILLABAISSE)

ZE PRODUCT

The recipe for Lérins liqueur—either the smooth verbena version or the skillful assembly of forty-four plants that makes up the famous Lérina Jaune—is passed from monk to monk in one of the last existing Cistercian abbeys. Simply divine.
Abbaye de Lérins
Île Saint-Honorat, 06414 Cannes
+33 (0)4 92 99 54 32
excellencedelerins.com

ZE BOUTIQUE

Julia Sammut, a taste-hunter and former food journalist, opened her own boutique, L'Idéal, in the Noailles neighborhood of Marseille. Its distinguishing features? A mouth-watering selection of Mediterranean products that aren't necessarily expensive; the fact that there's no website; and an aversion to trendy name dropping. How's that for a change?
11, rue d'Aubagne, 13001 Marseille
+33 (0)9 80 39 99 41

ZE RECIPE

The true tarte tropézienne—two kinds of cream sandwiched between two layers of brioche— can be devoured in the shop run by brothers Thierry and André Delpui. Invented by Alexandre Micka, this sponge cake was christened by France's very own Brigitte Bardot, who came up with the name during the filming of And God Created Woman in 1956.
Aux deux frères
3, rue des Commerçants, 83990 Saint-Tropez
+33 (0)4 94 97 00 86

ZE EXPERIENCE

Kick back at La Petite Calanque, a picturesque Creole-style inn built by a ship's captain as a gift for his young West Indian wife. Its 1930s bathtub, veranda, magnificent exotic garden, and sea view contribute to a spice-laden turn-of-the-century atmosphere, making any stay here feel like a step back in time.
22, boulevard la Calanque de Saména, 13008 Marseille
+33 (0)6 12 03 18 43
lapetitecalanque.com
If that doesn't float your boat, try a night in the back room of Maison Empereur, a legendary hardware store that rents out a "vintage" apartment to lovers of all things retro chic.
4 rue des Récolettes, 13001 Marseille
+33 (0)4 91 54 02 29
empereur.fr

ZE SOUVENIRS

Often imitated but rarely equaled, the authentic water (or cocktail!) pitcher made by the family firm of Biot, characterized by its colorful bubbled glass, prevents ice cubes from falling out when it's poured. It has embodied Riviera cool since the 1950s.

5, chemin des Combes, 06410 Biot
+33 (0)4 93 65 03 00
verreriebiot.com

The white glazed "Pivoine" plate by the famed Vallauris Bleu d'Argile pottery works is supremely elegant. It owes its refinement to being hand-crafted on original molds.

30, rue Georges Clemenceau, 06220 Vallauris
+33 (0)4 93 64 82 07
bleudargile.com

ZE PLACE TO SLEEP:

The Hôtel Le Corbusier is located in the Maison du Fada, the nickname for the famous Cité Radieuse, which the French state commissioned Le Corbusier to construct as public housing after the war. Long criticized by the stuffier residents of Marseille, this temple to 1950s design was classified as a UNESCO World Heritage Site in 2016. Today, it houses a hotel and one of the city's best restaurants, Le Ventre de l'Architecte, furnished with tables by Charlotte Perriand, lamps by Gae Aulenti, and chairs designed by the master himself. For something entirely different, La Mercerie, a trendy neighborhood restaurant, draws everybody who's anybody in Marseille.

Hôtel Le Corbusier
280, boulevard Michelet, 13008 Marseille
+33 (0)4 91 16 78 00
hotellecorbusier.com

Le Ventre de l'architecte
+33 (0)4 91 16 78 23
hotellecorbusier.com/restaurant

La Mercerie
9, cours Saint-Louis, 13001 Marseille
+33 (0)4 91 06 18 44
lamerceriemarseille.com

THE BEST OF BORDEAUX AND ITS REGION, ONCE YOU'VE SIPPED A PÉTRUS, DEVOURED CHOCOLATE PASTRIES, AND GOBBLED OYSTERS FROM ARCACHON

ZE PRODUCT

In the thirteenth century, sugar cane, rum, and vanilla, brought from the West Indies to the port of Bordeaux, inspired the local nuns to make *canelés*, cylindrical sponge cakes baked in an unmistakable copper mold. They are best eaten warm, while they're soft on the inside and still crunchy on the outside. Everyone seems to have their favorite variety.

Canelé Lemoine
56, rue Baudin, 33110 Le Bouscat
+33 (0)5 56 43 11 33
canele-lemoine.pagesperso-orange.fr

ZE BOUTIQUE

The new Halles de Bacalan, located on the water's edge, has stolen the spotlight from the traditional Marché des Chartons. There are twenty-one stands representing the best of southwestern gastronomy, a stylish but affordable brasserie, a Spanish tapas stall, and numerous dishes conjured up by butchers and fishmongers, perfect for eating on long tables outside, just opposite the Cité du Vin—whose architecture divides the locals.

149, quai de Bacalan, 33300 Bordeaux
+33 (0)5 56 80 63 65
biltoki.com

ZE RECIPE

Lamprey, a fish caught in the Dordogne river, is cooked in its own blood with a little Bordeaux wine and served in a creamy sauce accompanied by garlic croutons. It's definitely one for special occasions (and adventurous stomachs).

Brasserie Le Noailles
12, allées de Tourny, 33000 Bordeaux
+33 (0)5 56 81 94 45
lenoailles.fr

ZE SOUVENIR

Saint-Émilion *macarons* are made of ground almonds, pure and simple. They are still baked in this legendary winemaking town according to an age-old recipe developed by the local Ursuline sisters. This is the authentic, old-fashioned *macaron*.

9, rue Guadet, 33330 Saint-Émilion
+33 (0)5 57 24 72 33
macaron-saint-emilion.fr

ZE EXPERIENCE

Discover the "French Paradox" and the top-notch Vinothérapie Spa at Les Source de Caudalie, a hotel on the Château Smith Haut Lafitte domaine. The famous southwest diet (two glasses of wine

a day, the key to a long life) reigns here. There's an organic vegetable garden, contemporary art, cooking classes, rooms overlooking the vines, enology cabanas, and, of course, the spa.
Chemin de Smith Haut Lafitte,
33650 Bordeaux-Martillac
+33 (0)5 57 83 83 83
sources-caudalie.com

ZE PLACE TO SLEEP
The Château du Taillan, also known as the "Dame Blanche" (White Lady), is one of most beautiful

châteaux in the whole of the Médoc region, with its gracious eighteenth-century façades, fine park (complete with a rose-marble altarpiece functioning as a garden ornament), and extensive cellars. The domain offers visits to the warehouse (Sunday by appointment), daily winemaking workshops (assemblage or harvesting), and family activities (picnics among the vines).
56, avenue de la Croix, 33320 Le Taillan
+33 (0)5 56 57 47 00
chateaudutaillan.com

THE BEST OF LYON, ONCE YOU'VE FILLED-UP IN THE LOCAL EATERIES, GOTTEN LOST IN THE PASSAGEWAYS, AND PERUSED THE CONTEMPORARY ART BIENNALE

ZE PRODUCT
It has to be the *quenelle*, of course—the local specialty! The modern quenelle with its spoon-molded shape is said to have been invented in 1920 by Joseph Moyne, son of a charcutier. The mixture, composed of flour, butter, and milk (the lactose-intolerant should abstain) is enriched with crawfish, pike, Comté cheese, vegetables, or spices. Quenelles are poached, then baked in sauce, when they double in volume as they brown. The Giraudet stand in the Halles de Lyon has a spectacular variety of colorful *quenelles*.
102, cours Lafayette, 69003 Lyon
+33 (0)4 78 62 34 05
boutiqueleshalles@giraudet.fr
halles-de-lyon-paulbocuse.com/com/giraudet

ZE LEGENDARY RESTAURANT
Tuck into classic Lyon fare at La Voûte Chez Léa (come with an appetite!) where every meal feels like a good Sunday lunch in the country.
11, place Antonin Gourju, 69002 Lyon
+33 (0)4 78 42 01 33
lavoutechezlea.com

ZE BOUTIQUE
Rosanna Spring, a Lyon-based brand that produces its own range of decorative objects, is displayed in this pretty concept store, alongside pieces from designers selected by the owner. Her collection of French-made "Loves les p'tites bêtes" kitchen towels, printed with stunning scarabs and beetles, will add a touch of poetry to any kitchen.
19, rue Longue, 69001 Lyon
+33 (0)4 78 39 25 18
rosannaspring.com

ZE RECIPE
Tarte aux pralines, an old-fashioned bright-pink pastry tart reinterpreted in the 1970s by chef Alain Chapel, owes its color to pralines from Saint-Genix-sur-Guiers in the Dauphiné region. Sugar-coated almonds are cooked in thick cream until they form a rich yet crunchy filling.
Chocolaterie – Pâtisserie Sève Musco
324, allée des Frênes, 69760 Limonest
+33 (0)4 69 85 96 38
boutique-seve.com

ZE EXPERIENCE
Explore centuries of refined dining by wandering through the sumptuous dining rooms at the Musée des Arts Décoratifs. The adjoining Musée des Tissus offers a fascinating insight into the heyday of Lyon's silk industry.
34, rue de la Charité, 69002 Lyon
+33 (0)4 78 38 42 00
mtmad.fr

ZE SOUVENIR
A small, extra-creamy Saint-Marcellin goat cheese, from the Dauphiné region, wonderfully aged at Mère Richard's establishment. Renée Richard herself passed away in 2014, alas—but don't panic, the business is in good hands. A sinful truffled version is also available (a gift perhaps best reserved for the initiated).
Halles de Lyon Paul Bocuse
102, cours Lafayette, 69003 Lyon
+33 (0)4 78 62 30 78
halles-de-lyon-paulbocuse.com/com/mere-richard-fromage-saint-marcellin

ZE PLACE TO SLEEP

The Fourvière Hôtel, off the beaten track but close to Vieux Lyon, the historic city center, is located in the former Couvent de la Visitation, built in 1854 by Pierre Bossan, the architect who designed the famous Fourvière basilica nearby. The Argentinian artist Pablo Reinoso set up a spectacular installation there, and the restaurant Les Téléphones, which opens onto the cloister garden, serves modern bistro cuisine typical of Lyon.
23, rue Roger Radisson, 69005 Lyon
+33 (0)4 74 70 07 00
fourviere-hotel.com

THE BEST OF BURGUNDY, ONCE YOU'VE DONE A STAGE OF THE CAMINO DE SANTIAGO PILGRIMAGE, DOWNED AN ALIGOTÉ KIR (OR TWO), AND OVERCOME YOUR FEAR OF SNAILS

ZE PRODUCT

Jambon persillé, a delicacy consisting of diced ham enveloped in a parsley jelly, is required eating in Burgundy. The Ferme des Levées and its owner, Jacques Volatier, make an exceptional version (and it's organic).
Les Levées, 21360 Lusigny-sur-Ouche
+33 (0)3 80 20 28 89

ZE BOUTIQUE

Maison Romane in Vosne-Romanée, and the thirteenth-century cellars belonging to Oronce de Beler, a proud and passionate winemaker, are unforgettable. The sight of him working the land astride a Percheron work horse, just like in the old days, will make for a good story back home.
2, rue Sainte-Barbe, 21700 Vosne-Romanée
+33 (0)3 80 61 17 45
oroncio-maisonromane.com

ZE RECIPE

In the 1970s, *crème de cassis* was the ultimate in chic; mixed with white wine, it became the famous kir. Today, artisanal versions made with hand-picked fruit are sipped after a meal, garnished with a simple ice cube. Easy as pie.
Liqueur Jean-Baptiste Joannet
4, rue Amyntas-Renevey, 21700 Arcenant
+33 (0)3 80 61 12 23
cremedecassis-joannet.com

ZE EXPERIENCE

The best poultry from the famous Bresse region can be tasted at the Ferme de la Ruchotte, an inn operated by Frédéric Ménager, who is as resplendent as his organic vegetable gardens. **Reservation required.**
La Ruchotte, 21360 Bligny-sur-Ouche
+33 (0)3 80 20 04 79

ZE SOUVENIR

Burgundy mustard, an authentic local product, is made with AOC (*Appellation d'Origine Contrôlée*, a certification of origin and symbol of quality) mustard grains and white wine produced in Burgundy. The Maison Fallot in Beaune, which has been independently owned since 1840 and which champions regional produce, features a museum and holds tasting sessions that are guaranteed to leave a (pungent) impression.
31, rue du Faubourg-Bretonnière, 21200 Beaune
+33 (0)3 80 22 10 02
fallot.com

ZE PLACE TO SLEEP

Live it up in an aristocratic setting at the Chandon de Briailles guesthouse, run by the Nicolaï family and located in the eighteenth-century Parc de la Folie, in Savigny-les-Beaunes. The vineyard happens to have an excellent reputation; ask to visit the cellars and taste the biodynamic premier cru called Les Lavières.
1, rue Sœur Goby, 21420 Savigny-lès-Beaune
+33 (0)3 80 21 50 97
gitechandondebriailles.com

THE BEST OF LILLE, ONCE YOU'VE POLISHED OFF THE SHRIMP CROQUETTES, DINED ON *CARBONNADE FLAMANDE*, QUAFFED A BEER ON THE GRAND'PLACE, AND TOURED AN EXHIBITION AT LE TRIPOSTAL

ZE PRODUCT

The "Dix" beer is produced by Célestin, a micro-brewery located in the historic heart of Lille. It's open for tours, and visitors can learn everything there is to know about hops, beer, and brewing. Which is only to be expected: the owner comes from a long line of brewers stretching as far back as 1740.
19, rue Jean-Jacques Rousseau, 59800 Lille
+33 (0)9 82 22 39 40
celestinlille.fr

ZE BOUTIQUE

Legendary cheeses from the north of France (maroilles, boulette d'Avesnes), along with very old Goudas (which are labeled "from Holland"), lend their aroma to Les Bons Pâturages, a shop and cheese-ripener located in a lovely cobblestoned street. Fans of "real" cheese will find it intoxicating. The shopkeepers are happy to let you sample their wares.
54, rue Basse, 59800 Lille
+33 (0)3 20 55 60 28

345, rue Léon Gambetta, 59000 Lille
+33 (0)3 20 40 23 05

ZE RECIPE

The *potjevleesch* (or potch for short) is a "little pot" of various meats: tasty rabbit, chicken, pork, and veal served in a slightly vinegary jelly. Eaten cold with fries and a beer, it is an irresistible local delight.
Au Vieux de la Vieille
2, rue des Vieux-Murs, 59000 Lille
+33 (0)3 20 13 81 64
estaminetlille.fr/auvieuxdelavieille

ZE EXPERIENCE

Bloempot, the most elusive Flemish canteen in the city (it's easy to miss), puts a fun organic twist on local classics. The space is attractive, especially since it doesn't pretend to be an ersatz tavern (which is rare here). **Reservation required.**
22, rue des Bouchers, 59800 Lille
+33 (0)3 20 00 00 00
bloempot.fr

ZE SOUVENIR

Méert *gaufres* (waffles)—thin, gooey, flavorful masterpieces—made even the dour General de Gaulle swoon. Be sure to get the original version (created in 1761), made with Madagascar vanilla. The store and tea room are Lille institutions that have preserved their impressive nineteenth-century decor.
Méert
27, rue Esquermoise, 59000 Lille
+33 (0)3 20 57 07 44
meert.fr

ZE PLACE TO SLEEP

The Villa Paula guesthouse, located in an art deco *hôtel particulier* in Tourcoing, is known for its sophistication, its breakfasts, and its mini concept store selling decorative items. The guesthouse is located near the spectacular Musée de la Piscine and the Villa Cavrois, a modernist masterpiece by French architect Robert Mallet-Stevens.
44, rue Ma Campagne, 59200 Tourcoing
+33 (0)6 12 95 97 97
villapaula.fr

THE BEST OF BIARRITZ AND THE SOUTHWEST, ONCE YOU'VE MASTERED PELOTA, DODGED A FEW COWS, AND EATEN *CHIPIRONS* AT THE OLD PORT

ZE PRODUCT

The raw-milk sheep cheese Ossau-Iraty is as representative of the Basque Country as its rugby players, but much easier to take home. It should be eaten with black cherry jam and has previously carried off the title of Best Unpasteurized Cheese at the World Cheese Awards—proof that Anglo-Saxons, too, have fallen for raw-milk cheese.
La ferme Kukulu
900 Kukuluiako Bidea, 64250 Espelette
+33 (0)5 59 93 92 20
fromagekukulu.com

ZE BOUTIQUE

The Halles de Biarritz is a hub of Basque cool, buzzing with conversation, glittering with fresh fish, glistening with shiny ham hocks, and stunning shoppers with miles of farmhouse sheep cheese. Be sure to turn up hungry, especially since the neighboring bars are likely to tempt you in for a snack and a glass of wine.
11, rue des Halles, 64200 Biarritz
+33 (0)5 59 41 99 91
halles-biarritz.fr

ZE RECIPE

The *gâteau Basque* (Basque cake) is a regional treasure, featuring a golden, crispy crust enveloping a filling of cream, black cherry jam, or—O tempora, o mores!—a citrusy mixture. The almond cream version generally wins the traditionalist vote. One thing is for sure: the best are made by Pariès.
paries.fr
14, rue du Port-Neuf, 64100 Bayonne
+33 (0)5 59 59 06 29

1, place Bellevue, 64200 Biarritz
+33 (0)5 59 22 07 52

ZE SOUVENIR

Romain Chapron handcrafts his fine UhainaPo surfboards in light, sturdy, and rot-resistant red cedar. Even wave dodging non-surfers can always hang one on the wall, turn one into a living-room table, or opt for a set of "hand planes"—mini-boards Chapron has developed for bodysurfing.

114, avenue de l'Adour, 64600 Anglet
+33 (0)6 89 17 25 64
uhainapo.com

ZE EXPERIENCE

On his Egiategia estate, where the vineyards grow on cliffs overlooking the Basque coast, Emmanuel Poirmeur immerses his bottles in the bay of Saint-Jean-de-Luz, creating the only wine in the world to be aged at fifty feet (15 km) below sea level. Apparently this technique allows otherwise-impossible flavors to develop. Thankfully there's no need to don a diving suit to imbibe.

5 bis, chemin des Blocs, 64500 Ciboure
+33 (0)5 59 54 92 27
egiategia.fr

ZE PLACE TO SLEEP

The Hôtel du Chêne, located in the very charming village square at Itxassous. The hotel may not be the most luxurious, but a room overlooking the bell tower of the most beautiful church in the Basque Country and pigeon salami eaten in the shade of a wisteria are priceless.

Quartier de l'Église, 64250 Itxassou
+33 (0)5 59 29 75 01
lechene-itxassou.com

INDEX

Note: Roman numerals refer to arrondissements in Paris.

FASHION AND BEAUTY

FASHION

JEWELRY

PURSES AND BAGS

SHOES

GOURMET SHOPPING

MARKETS

PÂTISSERIES

WINES AND SPIRITS

RESTAURANTS, BARS, TEA ROOMS

TEA ROOMS

SHOPPING

LEISURE, HOBBIES, AND CRAFTS

SIGHTSEEING

GARDENS

LANDMARKS, WALKS, AND GUIDED TOURS

MUSEUMS

TRAVEL

LODGING

VACATION SPOTS

ZE FRENCH DO IT BETTER

ACKNOWLEDGMENTS

Our very frenchiest thanks to Anne de Marnhac, who introduced us to our favorite editors—Gaëlle Lassée, Kate Mascaro, and Florence Lécuyer—with whom we drank a lot of tea, laughed out loud, and cooked up this user's guide on our grumbling, slightly boastful, but always surprising compatriots.

Thanks also to: Antoine Choque, who thought of suggesting his son Donald—and his sidekick Yoann Le Goff—as the book's designers; Mme Proust, guide and historian, for her list of places to visit in Paris, many of them little known; and Hubert Poirot-Bourdain, for his charming illustrations. Last but not least, we owe a big debt of thanks to friends and partners who contributed, in ways great and small, to the present book.

Valérie de Saint-Pierre is a journalist and contributor to the lifestyle section of *Madame Figaro*. She has previously worked for *Elle* and *Vogue Hommes*, and is author, alongside Marie-Odile Briet and François Raynaer, of *Pour en finir avec les années 80* (Calmann-Lévy, 1994), an examination of 1980s trends and attitudes. She has also launched "Le Futiloscope," a humorous newsletter deciphering the habits of high-end consumerism.

A native Parisian, **Frédérique Veysset** has worked for many prestigious magazines, including *Vanity Fair*, *Glamour Italia*, *Grazia Italia*, and *Madame Figaro.* She is the author of *EDaho dans tous ses états* (Les Humanoïdes Associés, 1991), and is co-author, with Isabelle Thomas, of the phenomenally successful *Paris Street Style: A Guide to Effortless Chic* (Abrams, 2013) and *Paris Street Style: Shoes* (Abrams, 2015).

Follow us on Instagram to discover even more tips, addresses, anecdotes, and ideas!
www.instagram.com/ze_french_do_it_better

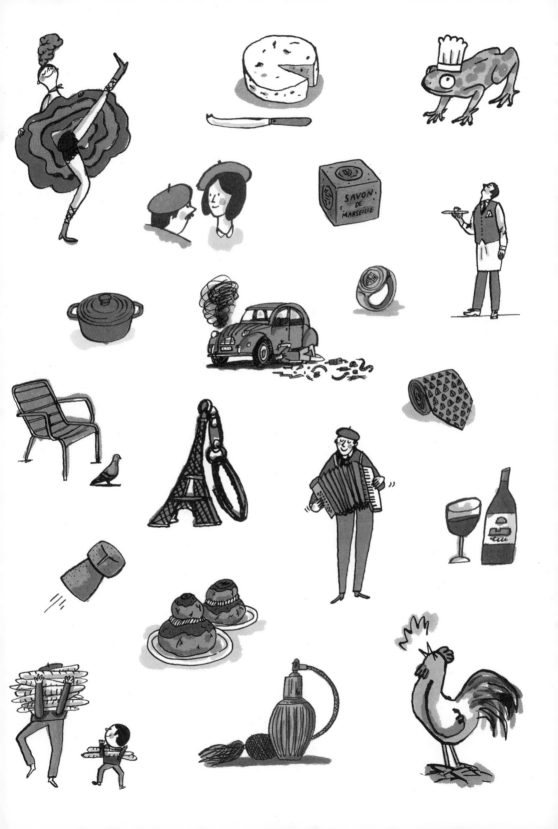

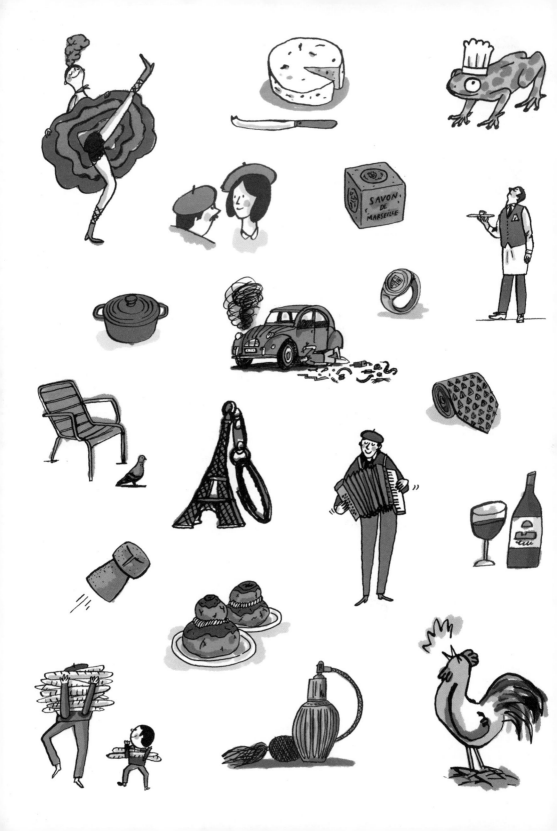